T0043592

"Skin is attached to a person, a sensibility, a personality, a history, an attitude."

— Ed Hardy

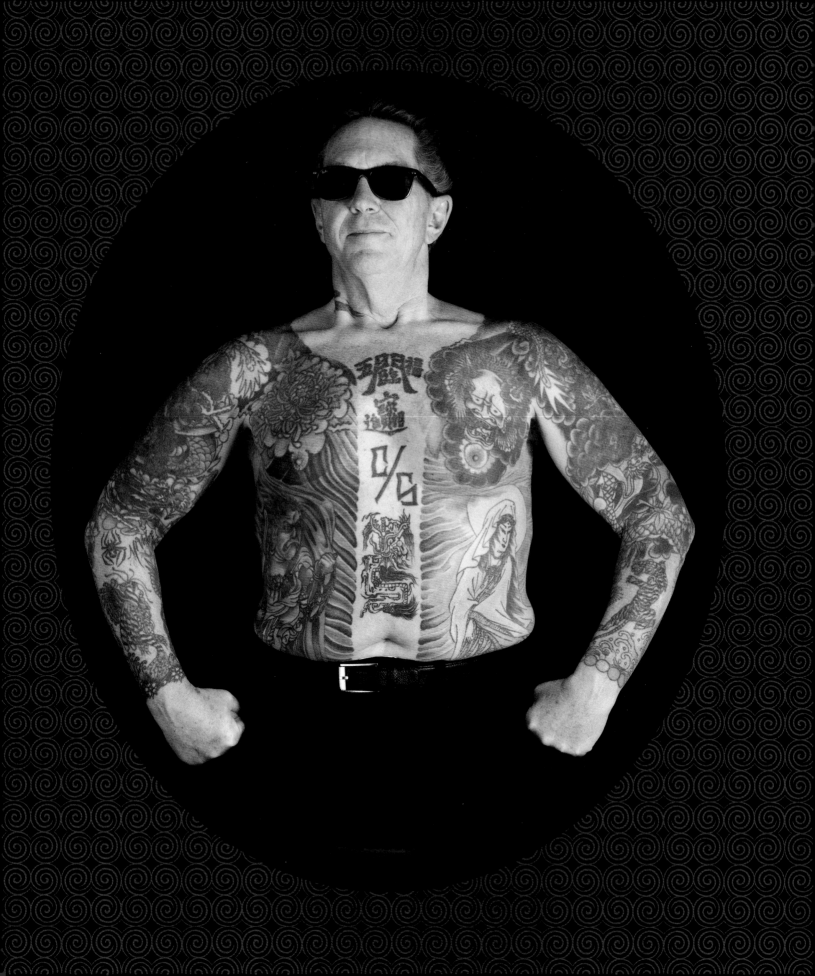

Ed Hardy Deeper than Skin

Art of the New Tattoo

Karin Breuer

Sherry Fowler with Dale Slusser
Jeff Gunderson
Ed Hardy
Joel Selvin

**de Young **
\ Legion of Honor fine arts museums
of san francisco

RIZZOLI Electa

Foreword

Thomas P. Campbell
Director and CEO
Fine Arts Museums of
San Francisco

Don

Ed Hardy's first introduction to the collections of the Fine Arts Museums of San Francisco was in the mid-1960s, when he was a student at the San Francisco Art Institute.

At the urging of his instructor Gordon Cook, Hardy visited the Achenbach Foundation for Graphic Arts, the Museums' department of works on paper, at the Legion of Honor. There he discovered the prints of the old masters including Albrecht Dürer and Rembrandt, as well as etchings by Francisco Goya and Giorgio Morandi.

Viewing the art in our collections was a powerful experience for the young artist, and one that inspired him to become a printmaker. Hardy was further drawn to the democratic, non-elitist nature of the medium in which multiple impressions of an image can be produced for and owned by more than one person. In the counterculture zeitgeist of 1967, it was not a long reach for him to apply those sentiments to the art of the tattoo, which he had been fascinated with since childhood and which became a lifelong avocation. Through innovations in the tattoo medium and his practice, Hardy transformed the world of tattooing and achieved his long-held goal to elevate the genre from its subculture status to the cultural phenomenon that it is today.

The Museums are grateful that Don Ed Hardy retained almost every print he produced in those early years of his education along with impressions of the many prints he has created

since 1992, when he resumed the practice after twenty-five years of active tattooing. We are deeply appreciative that he remembered our Museums in 2017 with the gift of 152 of these prints, many of which are included in the exhibition—Hardy's first museum retrospective.

Organized by Karin Breuer, curator in charge of the Achenbach, *Ed Hardy: Deeper than Skin* is an extensive overview of Hardy's entire career as an artist, which began when he was a ten-year-old activist for the tattoo craft. Spanning his early years as a young practitioner through the 1970s and 1980s, when he revolutionized tattooing with his Japanese-inspired designs and custom tattoo work, the exhibition covers more than fifty years of innovation. For many of our visitors who know him only as a tattoo visionary, this will be a first exposure to Hardy's fine art practice. We hope our audience will be delighted to discover that tattoo imagery has been—and remains—central to the development of Hardy's subjects and compositions.

The Museums thank The Herbst Foundation, Inc., for its major support of the exhibition. We are also grateful for the many loans of artwork from Hardy's personal collection that he has carefully archived over many years. His paintings, drawings, and three-dimensional works have greatly enriched our presentation. Above all, we thank him for this special opportunity to enrich our public's understanding of the art of tattooing and its place in Hardy's art and in contemporary world culture.

◎◎◎

CAT OUT OF HELL

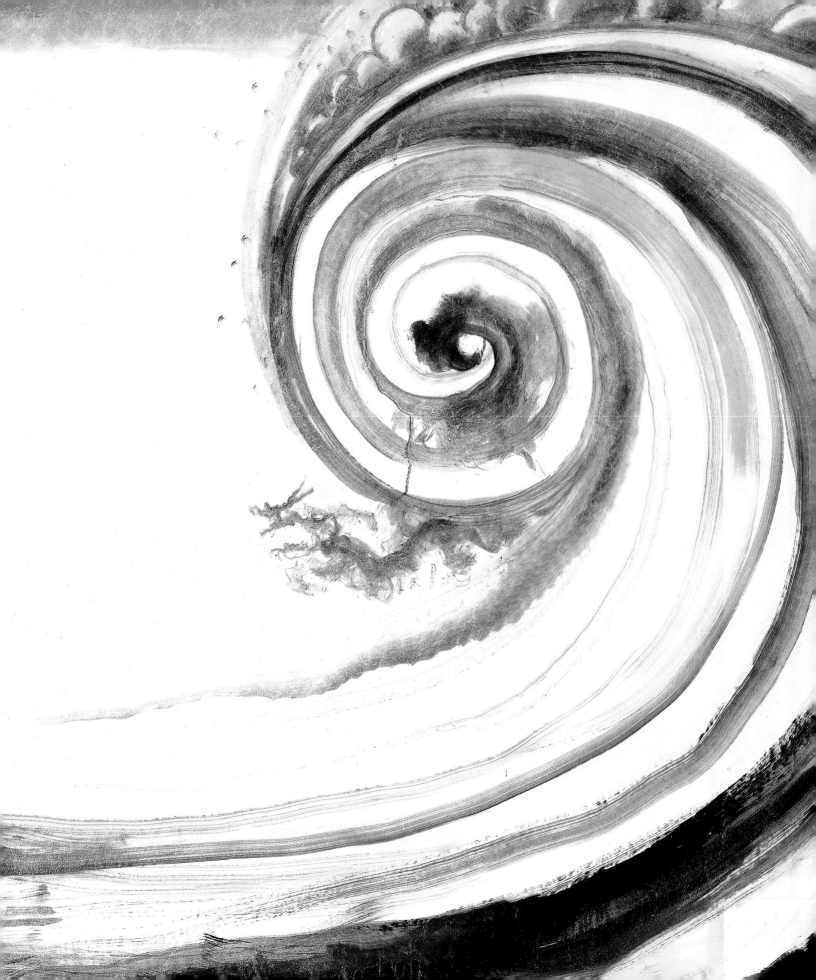

Essays

Ed Hardy and the Tattoo Renaissance

Joel Selvin

The great American tattoo renaissance began with the career of Don Ed Hardy. In 1968, when he opened his first tattoo studio, tattoos were strictly relegated to the outskirts of American society, and the only people getting them were either sailors or motorcycle-gang members. His first professional commission was tattooing a Bugs Bunny on a junkie's stomach.

Before Hardy, there was no such thing as tattoo art. Tattooing was a rich, robust folk tradition that had been practiced through the centuries in every corner of civilization but had gone unrecognized as an art form in Western society. Although American tattoo artists had developed an especially powerful style over the course of the twentieth century, the medium's skilled practitioners never aspired to the realms of fine art. But Hardy always knew that tattoos were art. The ideal person to open up the tattoo world to the rest of society, he mixed his childhood fascination with the craft and his scholar's instinct in the subject with his training in multiple mediums and art history at the San Francisco Art Institute (SFAI) to lead the tattoo world out of the underground into the light of day.

1
Ed Hardy painting a
tattoo on a friend, 1956
COLLECTION OF DON ED
HARDY

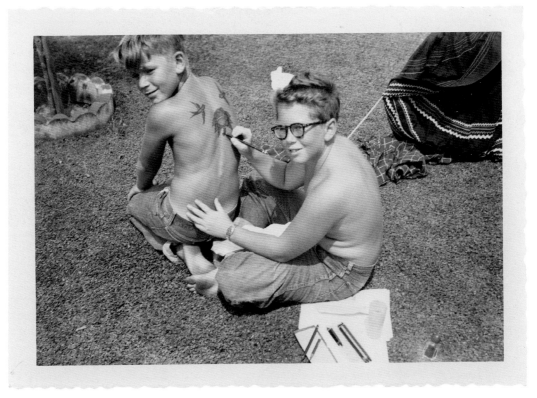

He established the first tattoo exhibitions and trade shows, published magazines and books devoted to the subject, and pioneered incursions into the most sacred provinces of the art world—galleries and museums.

Over his career, Hardy left no corner of the tattoo world unexplored. In addition to introducing the Japanese tattoo tradition to the United States, he had his fingerprints all over the introduction of "tribal" tattoos in the 1980s, a style he helped revitalize with designer Leo Zulueta and fellow tattooer Michael Malone, who tattooed in Honolulu under the name Rollo Banks. In the 1980s he became absorbed with the fine-line black-ink tattoos most commonly found in prisons, investing in an East LA tattoo shop that specialized in the genre and opening his own San Francisco studio devoted to the style. And during the 2000s, his designs and drawings went absurdly aboveground on a massively popular line of T-shirts, trucker caps, and assorted casual wear that spread the name "Ed Hardy" around the world.

Growing up in the 1940s and 1950s in Corona del Mar, an Orange County beach community south of Los Angeles, Hardy was obsessed with tattoos. First struck by the ones he saw on the arms of his friend's father, a World War II veteran, young Hardy started to watch for tattoos on the beach. He painted temporary tattoos on the neighborhood kids and set up a pretend tattoo studio in his parents' den (figs. 1, 28; pls. 3, 4, 6). At age ten, he was taking the bus twenty-five miles up the coast to the Long Beach Pike to hang around the tattoo parlor run by Bert Grimm, memorizing the tattoo flash on the shop's walls and later drawing it in his notebook (figs. 2, 3; pls. 13–15).

Hardy discovered a gift for art in high school and, encouraged by an enthusiastic teacher, was showing and selling his work almost as soon as he graduated. He entered art school in La Jolla and frequented the LA gallery scene before moving to San Francisco and enrolling at SFAI for the fall semester of 1963. There Hardy took classes with notable artists and made exciting work of his own. His 1964/1998 etching *San Francisco from Twin Peaks* (fig. 4) is a marvel of hand-eye coordination, made by the artist sculpting tiny details into a broad panorama of the city as seen from above. Upon graduating, Hardy earned a fellowship in printmaking to the

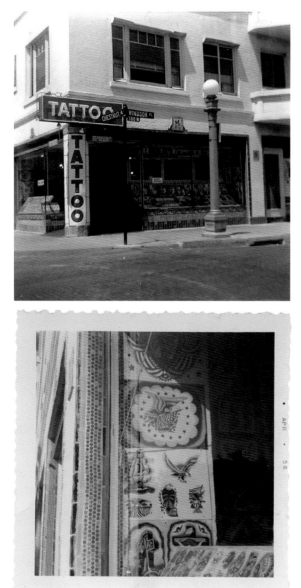

2
Bert Grimm's tattoo
studio at Long Beach
Pike, Long Beach,
California, 1956
COLLECTION OF DON ED
HARDY

3
Flash in window of Bert
Grimm's tattoo studio,
Long Beach Pike, 1956
COLLECTION OF DON ED
HARDY

4
DON ED HARDY
*San Francisco from
Twin Peaks*, 1964/1998.
Etching, 28 x 33 ⅞ in.
(71.1 x 86 cm). Printed by
Paul Mullowney
FINE ARTS MUSEUMS OF SAN
FRANCISCO, GIFT OF THE
ARTIST, 2017.46.31

Sparrow, real name Samuel Steward, was a remarkable character, a former academic who was a far cry from the stereotypically grubby tattoo artist of the time. He knew a lot of tattoo history and filled Hardy with lore. Sparrow did not recommend the profession but reluctantly showed Hardy how to tattoo, relenting only when Hardy threatened to buy equipment through mail order on his own. When Hardy told him he was an art student, Sparrow pulled a slim volume off a shelf and handed it to him. "This is real art," he said. Hardy opened the book, *Irezumi* (1966), by Ichirō Morita and Donald Richie. Inside he saw, for the first time, the grand Japanese tattoos. As he thumbed the pages, he felt his brain catch fire and burn.

With tattoos on his mind, Hardy made a nostalgic return to the Pike, where several tattoo parlors still operated. There he met his next mentor, "Hong Kong" Tom Yeomans, who later visited him in San Francisco to advise on setting up his first studio. Planning to eventually settle and work in San Francisco, Hardy decided to begin his tattoo career in Vancouver, British Columbia, so that when he returned to San Francisco he wouldn't encounter his inept early work walking around town. In March 1968 Hardy opened Dragon Tattoo Shop in Vancouver (fig. 33). Following Sparrow's advice, he didn't use his real name, instead drawing from his middle names to come up with the needle name Ed Talbott.

Opening his own studio with little experience proved precipitous, and six months later Hardy moved to Seattle for a brief apprenticeship under seasoned tattooer Zeke Owen, working out of the back of an adult bookstore. In January 1969

Yale University School of Art, but the offer came too late. He had already rediscovered tattoos. An old friend who had joined the navy had come to one of his art-school exhibitions, decked out in full dress blues, showing off his collection of tattoos from Pacific ports. Instantly, Hardy's old obsession returned. He looked in the phone book under "TATTOOS" and recognized a name from the tattoo brochures he had studied as a kid: Phil Sparrow. That night, he went to Sparrow's shop in Oakland for a tattoo, but it was closed. He later returned and was soon regularly spending time with Sparrow at his shop.

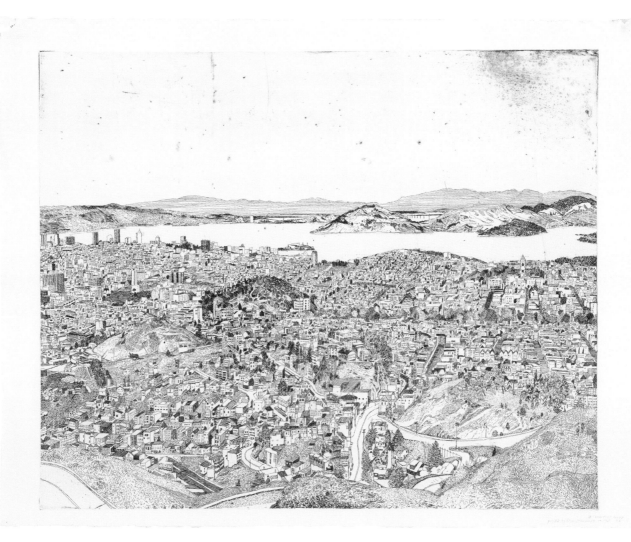

Hardy relocated to San Diego, landing a job through Yeomans with George L. "Doc" Webb, who ran a typical American operation near the docks in San Diego's Sailortown. Hardy went to work stamping Marine Corps bulldogs (pls. 42, 43) and the diminutive devil known as Hot Stuff (pls. 36, 37, 47, 50) on the thousands of sailors and soldiers who streamed through the city's tattoo parlors at the height of the Vietnam War. He slowly slipped some of his own less conventional designs on the walls, like "Big Daddy" Roth–influenced bikers and Japanese-style dragons. Occasionally, he did an ambitious Japanese-style back tattoo on commission.

Hardy started to trade letters with the legendary tattooer Sailor Jerry (Norman Collins), who shared Hardy's passion for the Japanese style of work, and in October 1969 Hardy made his first trip to Honolulu to meet him. In early 1971 Hardy opened his own shop in San Diego's Sailortown called Ichiban Tattoo Studio, but he was still restless. He bounced back and forth to Hawaii, working in Sailor Jerry's Honolulu shop. In December 1972 Hardy went to Honolulu for a summit meeting Sailor Jerry had arranged with several tattooers, including the Japanese tattoo artist Horihide (Kazuo Oguri) (see Fowler, this volume). The first day of the trip, fellow tattooer Malone, who had accompanied Hardy, lay down on Sailor Jerry's living-room floor while Horihide, who did not speak English, first drew a tattoo on him with a toothpick and India ink and then poked it in using traditional hand tools. He put a dragon with chrysanthemums across Malone's

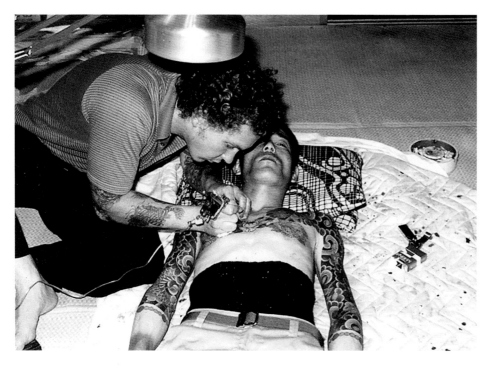

5
Ed Hardy tattooing in
Horihide's studio, Gifu,
Japan, 1973
COLLECTION OF DON ED
HARDY

6
DON ED HARDY
*First Manned
Ascent, Montgolfier
Bros., 21 November
1783* (tattoo on man's
back based on
18th-century
engraving), 1977
COLLECTION OF THE
ARTIST

entire chest, from his upper pectoral down to his elbow. A silence fell over the room as he started to work. They had all been fascinated with the Japanese tattoo tradition, but this was their first chance to witness the work. "Five thousand years on the head of a pin," whispered Malone reverently.

The next day, Horihide sketched out a ghost from a sixteenth-century Japanese woodcut over Hardy's whole back. Overwhelmed by the experience, his longtime obsession with all things Japanese boiling over, Hardy blurted out a request to work with Horihide in Gifu, Japan. Perhaps feeling pressured to return the Americans' hospitality, Horihide agreed.

Japanese society has always been considered highly closed. Prior to Hardy, no Western tattooer had ever been invited to Japan to learn the centuries-old tattoo tradition. At the time of Hardy's trip, tattoos were an underground enterprise in Japan, almost entirely confined to members of the yakuza, the country's organized-crime families (figs. 5, 35). Between culture shock and the language barrier, he had a rocky time adjusting. He had not been in Gifu two weeks when he received word that Sailor Jerry had died of a heart attack. Added to this was the fact that he went broke tattooing in Japan. After several months Hardy returned to San Diego and joined Owen in the back of a penny arcade to quietly plan his next step. He had been profoundly changed by his time in Japan, exposed to techniques and practices as no other Western tattoo artist had. Simultaneously, the word went out in the tattoo community: Hardy had been to Japan.

Hardy built up a bankroll and moved back to San Francisco, where, in June 1974, he opened Realistic Tattoo Studio in a space behind a mattress shop and a dry cleaner on a nondescript stretch of busy Van Ness Avenue. It was the tattoo studio of his dreams (fig. 36). Hardy hung no flash on the walls. He put no neon sign on the street; a small sign read simply "Ed Hardy—Tattoo Artist." He put straw mats on the floor and kept a book of antique Japanese woodblock prints for inspiration. Business was strictly by appointment, and Hardy tried to draw the client into the creative process as much as possible. His first customer wanted him to cover up the signature of tattoo artist Lyle Tuttle, San Francisco's best-known tattooer at the time, that Tuttle had put on the man at a party without asking. He thought this was a good sign.

The first year was slow, but business gradually picked up, and Hardy was doing back-pieces and other large-scale work from the start. Haight-Ashbury hippie honcho Peter Coyote, not

yet a well-known actor, had Hardy put a tattoo of a coyote's head on his chest. Coyote later sent Sweet William (Bill Fritsch) of the Hells Angels to see Hardy. Part beatnik, part ex–armed robber, Sweet William wanted some Buddhist imagery across his chest, a request right up Hardy's alley. That led Jorma Kaukonen of Jefferson Airplane into the shop, and Hardy did giant backpieces on the guitarist and his wife. He was determined that every tattoo at Realistic was a unique artwork, and word was getting out. He never had to do another Hot Stuff tattoo again.

The backpieces were getting to be outrageous. Early on at Realistic, a surgeon from Southern California visited Hardy for a giant squid tattoo that would cover his whole torso and legs, with its tentacles wrapping around his body (pls. 59, 60). At the time, it was the largest single tattoo of modern times. A banker from Saint Louis brought Hardy the menu from the Concorde, which showed an engraving of the first manned flight in a hot-air balloon in 1783. Hardy duplicated the image over the man's entire back, in the process covering up some old, uglier tattoos (fig. 6). Other pieces could be quite lurid. An artist brought Hardy a watercolor he had painted for a backpiece that depicted a Buddhist monk on a lotus throne committing seppuku, cutting his belly open while simultaneously having an orgasm. Hardy's tattoo included the monk's penis, erect and ejaculating. He called the piece *Coming and Going.*

Tattoos were still illegal in several states in January 1977 when Hardy partnered with Malone to organize the first tattoo convention, in Reno, Nevada. Hundreds of tattoo enthusiasts and professionals flocked to the event from all over the world, and media extensively covered the convention. Tattoo culture was peeking out from

the underground. At the convention Hardy and Malone met Jack Rudy and "Good Time Charlie" Cartwright, two tattooers who ran a shop in East Los Angeles specializing in the gray-scale tattoos common in prisons and gaining popularity in the Chicano community. Hardy was immediately smitten. It was the first wrinkle in tattoos that had grabbed him since he learned about the Japanese style, and he dove in. Cartwright put a skull tattoo on Hardy, and in September 1977, Hardy opened a second shop, Tattoo City, in San Francisco's predominantly Latino Mission District, specializing in the unique style (fig. 7). In December 1977 Hardy bought into Cartwright and Rudy's shop in East Los Angeles, Good Time Charlie's. When the business was evicted, Hardy bought a nearby building and opened a new shop, Tattooland.

Leo Zulueta was another tattooer who introduced Hardy to new ideas. Zulueta exposed him to the punk rock scene—they went to the Sex Pistols concert at Winterland together in January 1978—and to a style that Hardy came to call "anthropological tattoos." Characterized by black graphic designs that came largely from Zulueta's imagination, this style of tattoo echoed traditional tattoos of the South Pacific islands. Malone, working out of Sailor Jerry's old shop in Honolulu, had also been experimenting with nostalgic Pacific Islander imagery (he later popularized the Hawaiian, or tribal, band, ubiquitous in the mid to late 1990s). These tribal-inspired designs caught on with the punk crowd, and in November 1982, Hardy held another hugely successful tattoo trade show where he debuted his tattoo magazine, *Tattootime*, with the cover article devoted to the "New Tribalism" (figs. 8, 38).

Tattoo Expo '82 took place aboard the *Queen Mary*, the massive ocean liner permanently berthed in Long Beach, only miles from the Pike, where it had all started for Hardy. Events included talks on symbolism in Japanese tattoos and a lecture by an art historian from the University of California, Los Angeles. However, for Hardy, the most important part was meeting a Japanese publisher who put him on the phone with the elderly, reclusive Horiyoshi II (Tamotsu Kuronuma), one of Japan's greatest living tattoo artists and a key figure in Japanese tattoo history. Hardy asked the publisher if he could come to Japan and meet Horiyoshi II and get a tattoo. To his astonishment, the publisher said yes.

Hardy's return to Japan in 1983 began a period during which he made regular trips to Tokyo. There Horiyoshi II completed Hardy's epic rib piece, and Hardy secretly put small Americana tattoos on Japanese rockabilly kids in a private apartment (figs. 9, 10, 39). After one such trip, Hardy traveled on to Palau, a Micronesian archipelago that was the site of several brutal battles during World War II, running his gear from a car battery and tattooing locals in a parking lot.

In May 1985 Hardy introduced the tattoo renaissance to a global stage with a month-long exhibition at Trajan's Market, a complex of ruins in Rome, Italy. It was attended by Horiyoshi III (Yoshihito Nakano), of Yokohama, Japan, a renowned tattooer of Hardy's generation. Hardy also brought in a master tattooer from Samoa and a man of partial Maōri descent from New Zealand. Zulueta was there to demonstrate the tribal style. Inside this ancient setting, tattooers

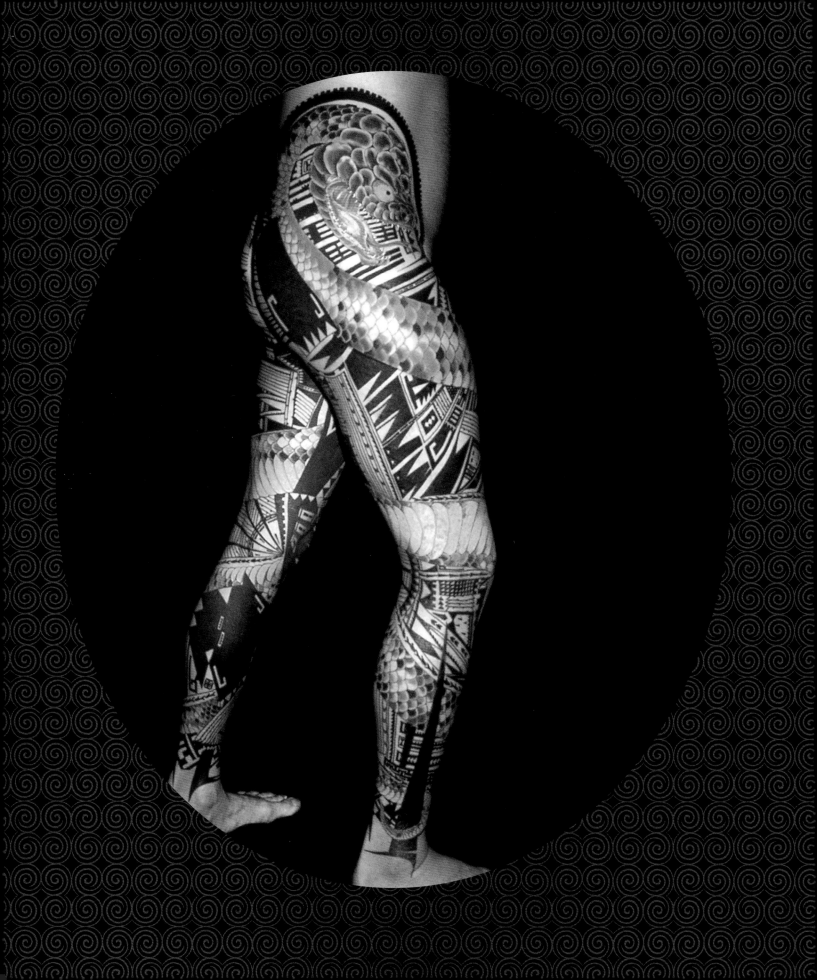

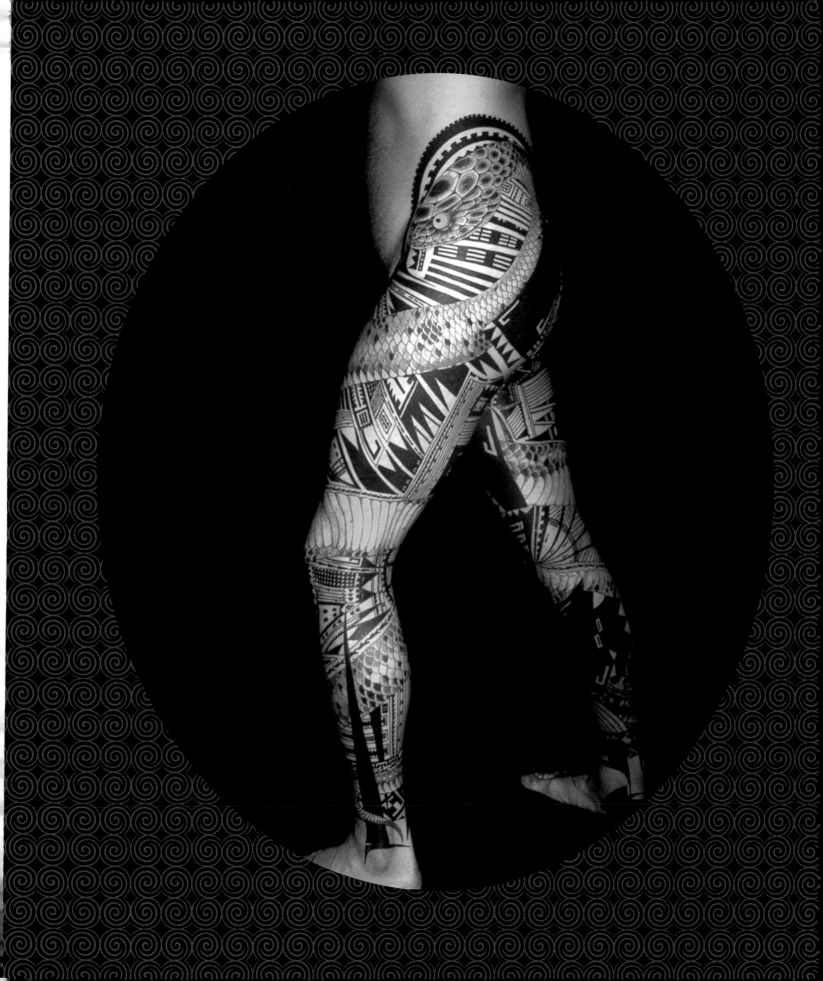

kid painting tattoos on his buddies in Corona del Mar. But what happened next was so far beyond anyone's imagination, it couldn't even have been written as fiction.

In the early 2000s, fresh out of the hospital after suffering a heart attack, French designer Christian Audigier wandered into a Melrose Avenue boutique in Hollywood that was selling a fledgling line of T-shirts featuring some of Hardy's tattoo designs. Audigier bought a couple and came back the next day. A self-proclaimed fashion visionary looking for his next big thing, Audigier saw his future in Hardy's designs, and he pounced. In February 2005 he debuted a new line of Ed Hardy T-shirts at the Las Vegas clothing trade show, and it blew up. Audigier brilliantly promoted the shirts by giving free swag to celebrities and getting paparazzi to photograph them wearing the Ed Hardy brand.

Everybody started to wear Ed Hardy—Steven Tyler of Aerosmith, the cast of reality-TV show *Jersey Shore*, Paris Hilton, Hulk Hogan, Britney Spears (fig. 53). Even Madonna was photographed wearing Ed Hardy (fig. 12). In a New York minute, Ed Hardy had become a fashion fixture. People could dress head to toe in Ed Hardy wear. As sales exploded, Audigier handed out more than seventy sublicenses to producers of everything from air freshener, to suntan lotion, to dashboard protectors. Millions of people were walking around wearing Ed Hardy tattoo designs; it seemed to be an Ed Hardy world.

The high lasted until Audigier made a spectacular gaffe. In August 2009 reality-TV star Jon Gosselin, of the soon-to-be-canceled *Jon & Kate Plus 8*, left his wife and eight children,

the show's fellow stars. Audigier flew Gosselin and his new girlfriend straight to Saint-Tropez and covered him in head-to-toe Ed Hardy gear. As photos appeared on global media of the most hated man in reality TV, the most deadbeat dad of all time, the brand was instantly poisoned. As quickly as the Ed Hardy phenomenon happened, it ended like somebody had turned off a light.

The T-shirts did nothing to expand Hardy's reputation in the tattoo world, where his legacy had long been secure. If anything, the clothing line was the ultimate realization of Hardy's childhood dream that people would someday see tattoos as art and that everybody could have one, even if it was only on a trucker cap. With the Ed Hardy clothing line, the world was filled with tattoos.

Hardy gave his last tattoo in 2008 and retired to concentrate exclusively on his art. His son, Doug Hardy, together with a talented crew, carries on the tradition at Tattoo City, in San Francisco.

@@@

The information in this essay was drawn from interviews with Don Ed Hardy conducted by the author for the writing of *Wear Your Dreams: My Life in Tattoos* (Thomas Dunne Books/St. Martin's Press, New York, 2013), which he coauthored with Hardy.

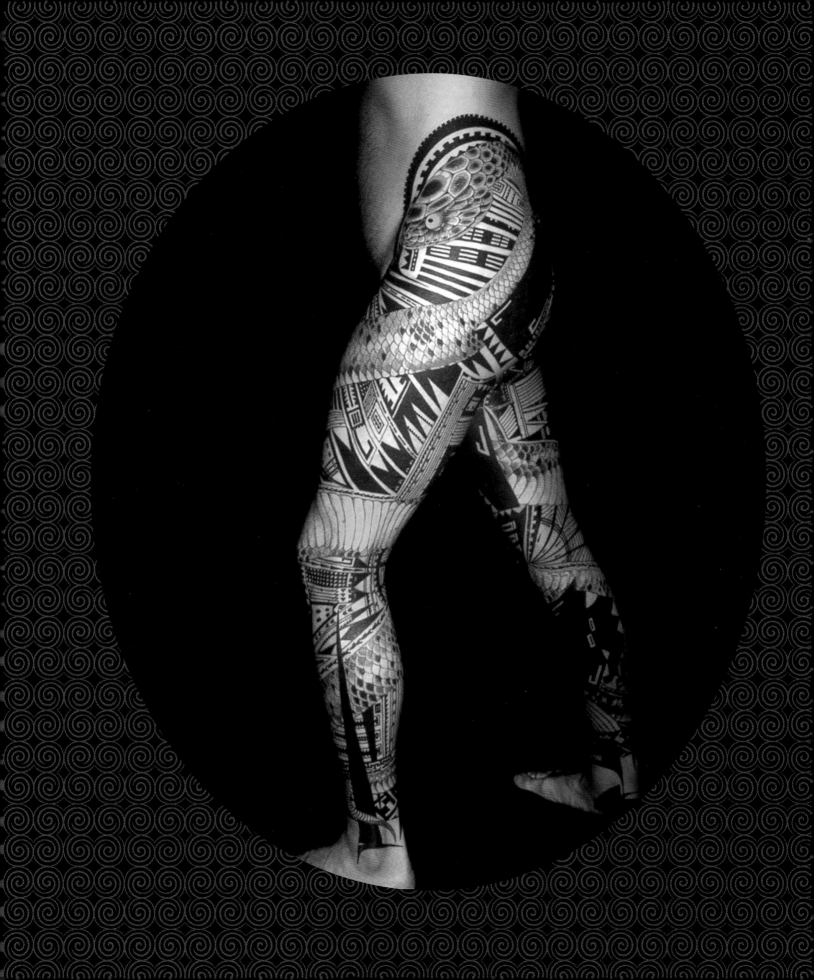

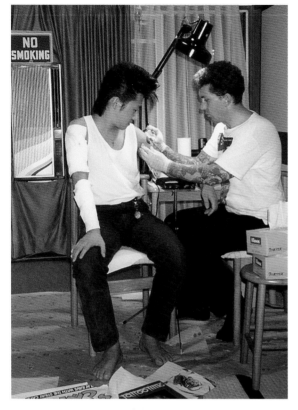

9
Ed Hardy tattooing
client, Tokyo, Japan,
1985
COLLECTION OF DON ED
HARDY

10
DON ED HARDY
Rockabilly-style tattoo
on upper arm, Tokyo,
Japan, 1985
COLLECTION OF THE
ARTIST

11
DON ED HARDY
Installation at Track 16
Gallery, Santa Monica,
California, 2000. *2000
Dragons*, 2000. Acrylic
on Tyvek, 51 in. x 500 ft.
(1.3 x 1,524 m)
FINE ARTS MUSEUMS OF
SAN FRANCISCO, GIFT OF
THE ARTIST, 2019.34

from throughout Europe and the world came
together.

By the dawn of the 1990s, the tattoo
renaissance was in full force. Tattoos had grown
into a widespread social phenomenon, never before
so prominent in American culture. Now tattoo
studios could be found in suburban strip malls.
Hardy had all the work he could handle and more.
He sold his East LA shop, Tattooland, in 1984.
Tattoo City, his second San Francisco shop, in the
Mission District, had already burned down in an
arson fire less than a year after it had opened.

In December 1986 Hardy moved
his home to Honolulu, where he spent long hours
making his personal art, occasionally returning
to San Francisco to tattoo out of his apartment
in the Hamilton, a Manhattan-style apartment
building in the Tenderloin district. After years of
giving tattoos while sitting on straw mats, he had
begun to have problems with his hips and back. In
1991 he opened Tattoo City, in San Francisco's
North Beach.

What really sparked Hardy's interest
and enthusiasm at this stage of his career was
the prospect of bringing tattoos into the world of
galleries and museums. In 1992 he co-curated,
with Santa Monica gallerist Bryce Bannatyne,
an exhibition of tattoo photographs called *Forever
Yes: Art of the New Tattoo*. This was quickly
followed by *Eye Tattooed America*, a group
exhibition of tattoo-inspired art at Chicago's Ann
Nathan Gallery, in 1993. Next was *Flash from
the Past*, a selection of early twentieth-century
flash at the Hertzberg Circus Museum, in San
Antonio, Texas, in 1994. The opening for *Pierced
Hearts and True Love: A Century of Drawings for*

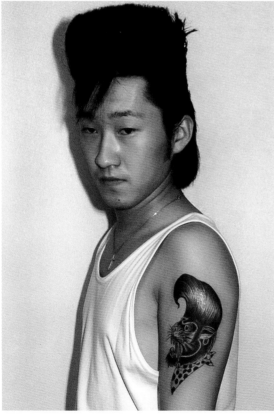

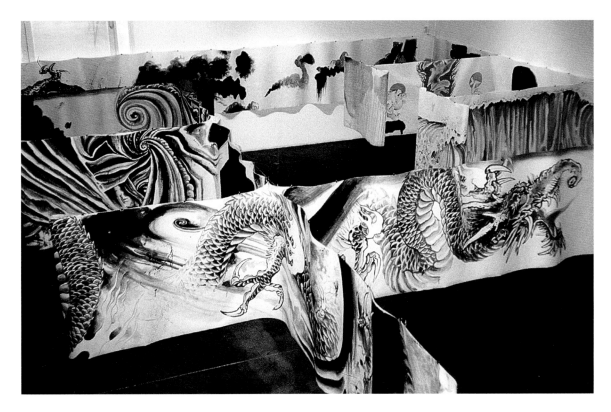

Tattoos, at the Drawing Center, in New York, in September 1995, attracted an overflow crowd that included John Waters and David Byrne.

In 1992 Hardy published *The Rocks of Ages*, a book chronicling his obsession with this vintage tattoo icon. It was followed by an exhibition of the artists featured in the book at La Luz de Jesus Gallery, in Los Angeles. As part of his 1999 exhibition, *Tattooing the Invisible Man*, at Track 16 Gallery, in Santa Monica, Hardy built a "tattoo hut," an installation in an eight-by-ten-foot room intended to evoke the classic tattoo parlors of the past.

After so many years of producing art on demand, Hardy concentrated on his own art during this period, returning to etching and printmaking. In 1997 he and his wife, Francesca Passalacqua, returned to live full-time in San Francisco, and Hardy worked at Tattoo City.

On January 1, 2000, to commemorate the millennium, Hardy began painting dragons on a scroll of Tyvek, the sturdy but flexible material used to make FedEx envelopes. After working for 125 hours on 52 days spread over 7 months, he completed his 2000th dragon. When

2000 Dragons (pl. 151) was finally installed at Track 16 Gallery, in Santa Monica, Passalacqua looked over the intricate, serpentine display hung by wires from the ceiling. "This is the 2001st dragon," she said (figs. 11, 49).

2000 Dragons was a watershed piece for Hardy, not only a self-conscious masterpiece but also a line in the sand. With this major work, he claimed his place in the world of fine art. Around the same time, the tattoo medium was also being embraced by the intellectual art crowd, which regarded it as transgressive contemporary folk art. At the center of this movement—the emergence of tattooing from the underground and the spread of ink in skin across America and around the planet—was Hardy.

At that point, he could have retired and slipped away from tattoos and still be known as the foremost tattoo artist of his generation. He had guided the tattoo world into gaining the broadest possible acceptance and recognition, watching as old prejudices and attitudes evaporated. He saw the tattoo pierce the middle class and spread through the next generation, across socioeconomic divisions. It was the transformation he had dreamed of as a

kid painting tattoos on his buddies in Corona del Mar. But what happened next was so far beyond anyone's imagination, it couldn't even have been written as fiction.

In the early 2000s, fresh out of the hospital after suffering a heart attack, French designer Christian Audigier wandered into a Melrose Avenue boutique in Hollywood that was selling a fledgling line of T-shirts featuring some of Hardy's tattoo designs. Audigier bought a couple and came back the next day. A self-proclaimed fashion visionary looking for his next big thing, Audigier saw his future in Hardy's designs, and he pounced. In February 2005 he debuted a new line of Ed Hardy T-shirts at the Las Vegas clothing trade show, and it blew up. Audigier brilliantly promoted the shirts by giving free swag to celebrities and getting paparazzi to photograph them wearing the Ed Hardy brand.

Everybody started to wear Ed Hardy—Steven Tyler of Aerosmith, the cast of reality-TV show *Jersey Shore*, Paris Hilton, Hulk Hogan, Britney Spears (fig. 53). Even Madonna was photographed wearing Ed Hardy (fig. 12). In a New York minute, Ed Hardy had become a fashion fixture. People could dress head to toe in Ed Hardy wear. As sales exploded, Audigier handed out more than seventy sublicenses to producers of everything from air freshener, to suntan lotion, to dashboard protectors. Millions of people were walking around wearing Ed Hardy tattoo designs; it seemed to be an Ed Hardy world.

The high lasted until Audigier made a spectacular gaffe. In August 2009 reality-TV star Jon Gosselin, of the soon-to-be-canceled *Jon & Kate Plus 8*, left his wife and eight children,

the show's fellow stars. Audigier flew Gosselin and his new girlfriend straight to Saint-Tropez and covered him in head-to-toe Ed Hardy gear. As photos appeared on global media of the most hated man in reality TV, the most deadbeat dad of all time, the brand was instantly poisoned. As quickly as the Ed Hardy phenomenon happened, it ended like somebody had turned off a light.

The T-shirts did nothing to expand Hardy's reputation in the tattoo world, where his legacy had long been secure. If anything, the clothing line was the ultimate realization of Hardy's childhood dream that people would someday see tattoos as art and that everybody could have one, even if it was only on a trucker cap. With the Ed Hardy clothing line, the world was filled with tattoos.

Hardy gave his last tattoo in 2008 and retired to concentrate exclusively on his art. His son, Doug Hardy, together with a talented crew, carries on the tradition at Tattoo City, in San Francisco.

◎◎◎

The information in this essay was drawn from interviews with Don Ed Hardy conducted by the author for the writing of *Wear Your Dreams: My Life in Tattoos* (Thomas Dunne Books/St. Martin's Press, New York, 2013), which he coauthored with Hardy.

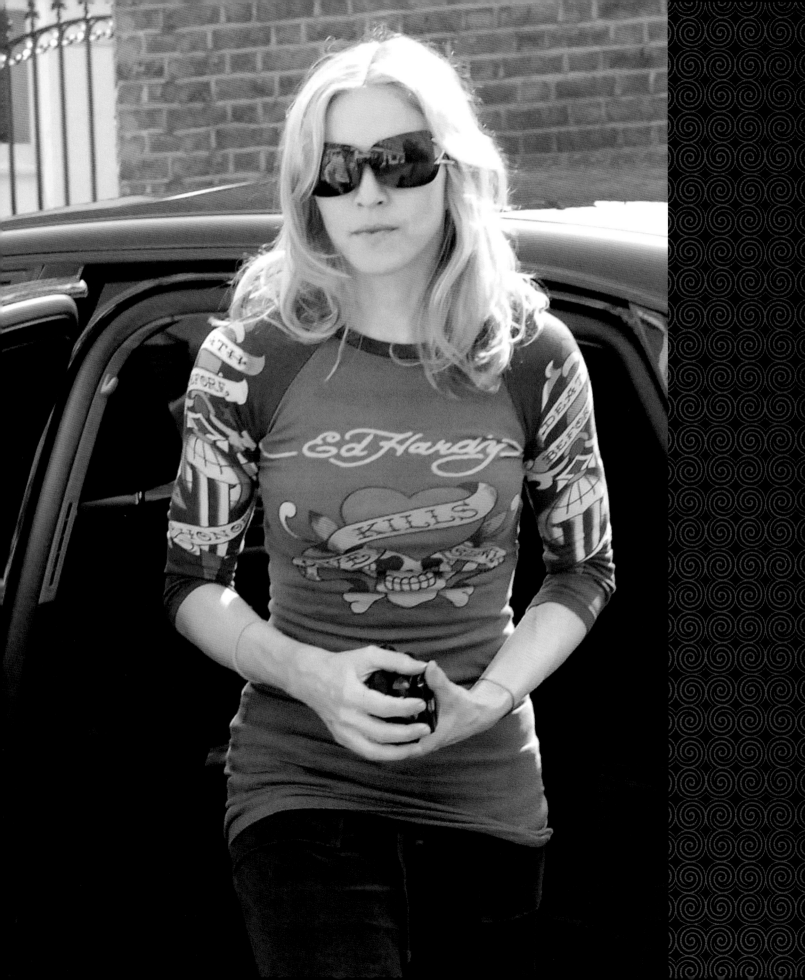

Drawing Embodied: Ed Hardy's East Asian Art Connections

Sherry Fowler
with
Dale Slusser

A raging being with fangs and flaming hair, poised mid-stomp with one arm holding high a three-pronged ritual implement, dominates the central position of the lithograph *Our Gang*, by Don Ed Hardy, printed in 2007 (fig. 13). The white lines on the dark green-gray background not only illustrate the awesome deity Zaō Gongen, from premodern Japanese religion, but also a panoply of figures from pop culture and elsewhere that Hardy has created and re-created in various media over the course of his life. A leader in propelling custom tattooing in the United States and around the world, Hardy has maintained a great passion, curiosity, and quest for East Asian iconography, philosophy, and art, fueled by the rich tradition of graphic design in Japanese tattooing. This essay considers how Hardy's lifelong commitment to the study of East Asian art, alongside his skill, experience, and sense of humor, manifests in his colorful mash-up of personal vision and style through myriad repetitions, reformulations, and reimaginings.

To create *Our Gang*, Hardy faithfully reproduced the Zaō Gongen image from an incised fragment of an unusual large bronze plaque now housed in the Tokyo National Museum. Remarkably, the plaque, rescued from a metal scrapyard in the nineteenth century, has survived since the year 1001, attested by a dated inscription on its reverse.[1] In Japan Zaō Gongen is believed to be a provisional, hybrid manifestation

13
DON ED HARDY
Our Gang, 2007.
Color lithograph,
27 ⅝ x 22 ¼ in. (70.2 x
56.5 cm). Printed by
Bud Shark
FINE ARTS MUSEUMS OF
SAN FRANCISCO, GIFT OF
THE ARTIST, 2017.46.135

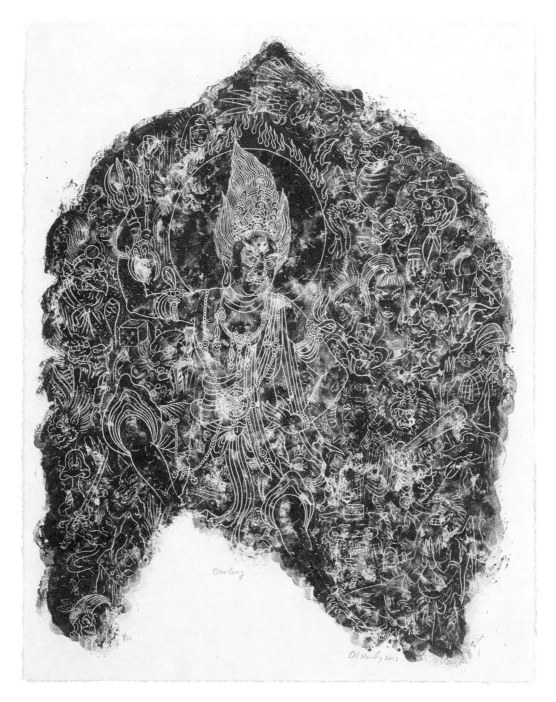

of a Buddhist deity in the form of a native kami who guides the Japanese to Buddhist salvation within the fluid combinatory system of matching Buddhist/Shinto identities. This powerful being is said to reside in the mountains and protect practitioners of mountain asceticism (*shugendō*). Hardy's representation of the relatively obscure Zaō Gongen speaks to his vast mental storehouse of East Asian religious iconography. In the print

Hardy has compressed the shape of the original bronze plaque and replaced Zaō's retinue with a complex stew of beings from his own history. In more traditional company are two *tengu*, supernatural creatures from Japanese religion that also protect monks in the mountains. To the upper left of Zaō is a bird-beaked *tengu* with a headband, while in the lower right, a long-nosed *tengu* is depicted with a wide devious grin and palms

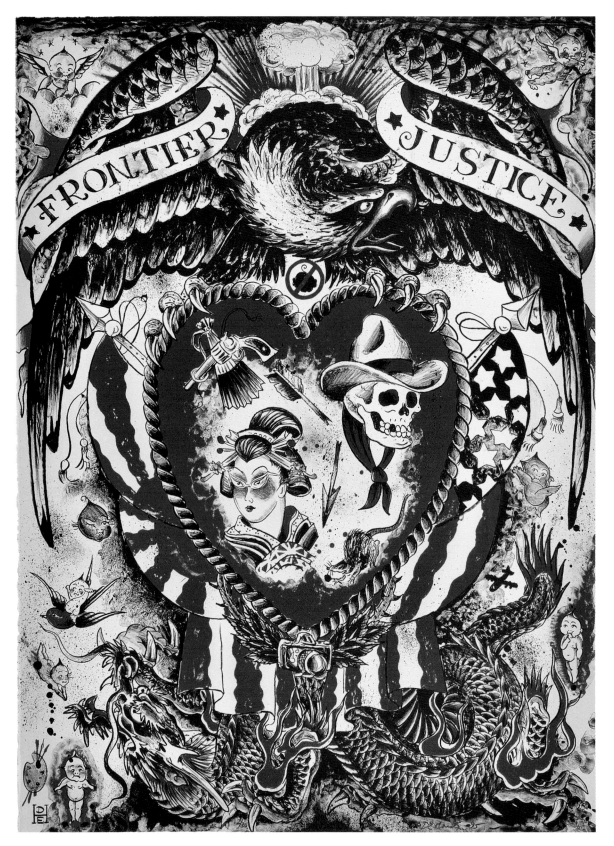

14
DON ED HARDY
Frontier Justice, 1995.
Color lithograph, 30 x
22 in. (76.2 x 55.9 cm).
Printed by Bud Shark
PUBLISHED BY SHARK'S
INK, LYONS, COLORADO

pressed together in adoration.[2] The title *Our Gang* is borrowed from the name of a series of short comedy films (later called *The Little Rascals*) that ran from the 1920s through the 1940s about a motley crew of kids from a low-income neighborhood. Hardy delights in contrasting cultural opposites and mixing the sacred with the silly, as seen in *Our Gang*'s Stinky the Skunk giving us the finger; the "Who me?" duck holding a sword; a gorilla with a baseball bat; Little Devil with his pitchfork; and initialed portraits of his wife, Francesca Passalacqua, in the guise of a googly-eyed puppy and himself as a scraggly rat holding out a big valentine heart. *Our Gang* is emblematic of Hardy's career and a fitting entry point to his mutable work, which is neither monolithic nor stable. Like the eleventh-century plaque that inspired *Our Gang*, Hardy's oeuvre defies categorization—in one sense, it combines fragments of history in an unexpected display that asks us to imagine the missing links between disparate times and places; in another, it is a mirror reflecting a magical cast of hybrid characters whose identities and appearances may morph and change at any moment.

In elementary school Ed Hardy was so obsessed with tattooing that he practiced on his gang of pals with colored pencil and eyeliner at his play tattoo parlor. Their repertoire, rife with eagles, anchors, and arrow-pierced hearts with "Mom" written within them, included the ever-popular Japanese dragon tattoo (pl. 2).[3] Hardy's father, Wilfred Ivan Samuel "Sam" Hardy, went to work in Japan in 1951, during the US occupation. Sam stayed in Japan and, after divorcing Hardy's mother, Mildred Sandstrom,

married Kimie "Bonnie" Hatakayama in 1953. Gifts that Sam sent back home made an impression on the young Hardy. Among them were postwar items representing popular GI culture that resonated with Japanese-style tattoos of the period, including GI silk souvenir jackets (fig. 27). Hardy's intaglio print *Sacred Tiger Ascending* (1995; pl. 106), printed in Japan, echoes the type of tiger imagery commonly embroidered on the backs of such jackets. With a powerful roaring tiger climbing rocks before a dynamic waterfall, the work reaches further into the past, beyond World War II, to borrow traditional elements from East Asian painting.[4] The inky expression of the tiger's fur and elegant modeling of its twisting body share affinities with the works of eighteenth-century Chinese and Japanese painters. But Hardy's wit surprises us, as he suggests a light bulb surrounded by flames and sitting on a lotus pedestal as a new symbol of enlightenment. In 1995, the year Sam passed away, Hardy made a print in his honor: *Frontier Justice* (fig. 14), a red and black lithograph in the form of a nineteenth-century American-style backpiece tattoo with Sam as a skull in a cowboy hat and Bonnie as a Sailor Jerry–style geisha wearing cat-eye glasses.

Hardy's interest in East Asian art was sparked again in 1963, during his first year as a student in printmaking at the San Francisco Art Institute, by a mentor, artist Gordon Cook, who turned him on to Japanese aesthetics and Zen philosophy, fields of thought popularized by Beat culture.[5] During that time Hardy was, remarkably, not interested in Japanese ukiyo-e, or pictures of the floating world, typically color woodblock prints of stylish theater actors,

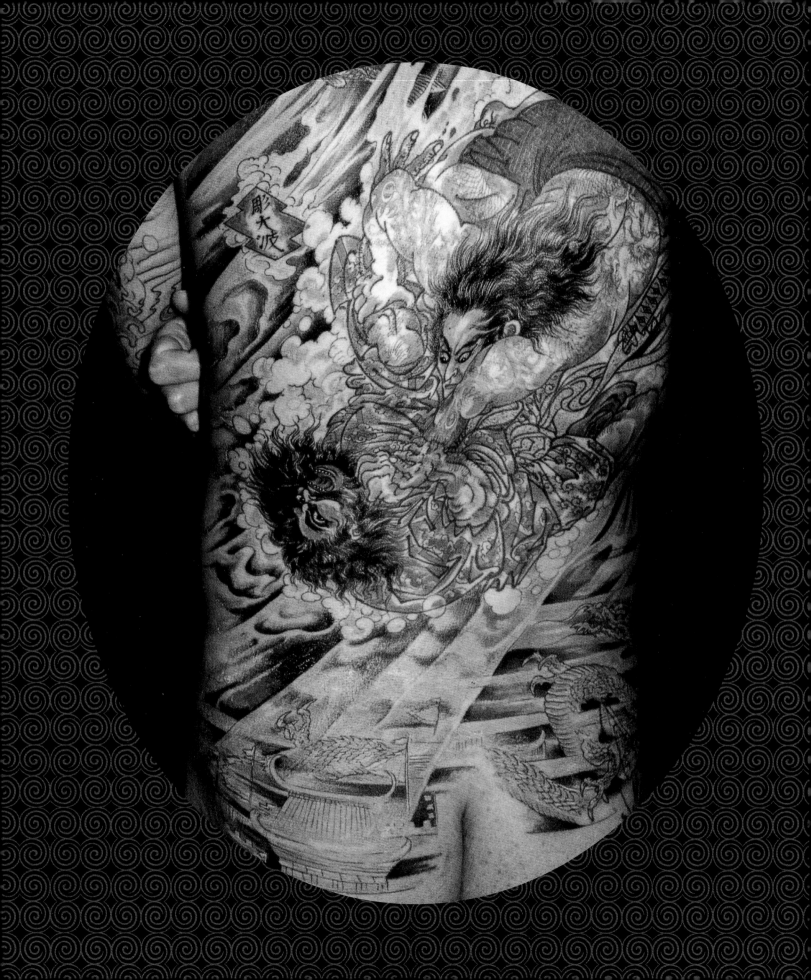

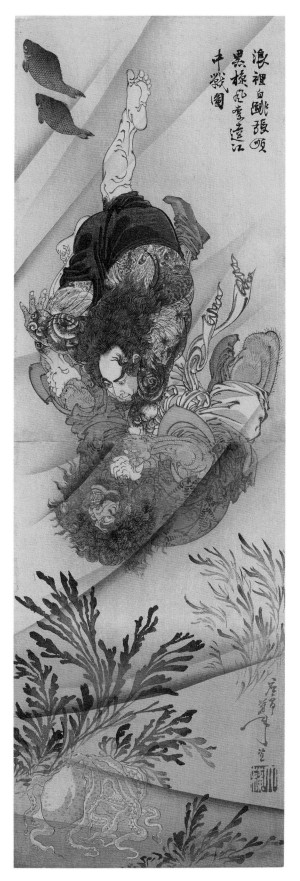

15
DON ED HARDY
Water Margin Fight Underwater (after Yoshitoshi) (tattoo on man's back), 1982–1984
COLLECTION OF THE ARTIST

16
TSUKIOKA YOSHITOSHI
Chang Shun, the White Stripe in the Waves, Wrestling with Li K'uei, the Black Whirlwind in the Ching Yang River (Rorihakucho chojun kokusempu riki kochu ni tatakau no zu), 1887. Color woodcut diptych, 28 ⅛ x 9 ⅜ in. (71.5 x 23.7 cm)
FINE ARTS MUSEUMS OF SAN FRANCISCO, MUSEUM PURCHASE, ACHENBACH FOUNDATION FOR GRAPHIC ARTS ENDOWMENT FUND, 2002.16A–B

fashionable beauties, and rowdy legendary heroes made in the eighteenth and nineteenth centuries. His indifference is notable given the enormous impact of ukiyo-e on the tattoo world and on his own later work.[6] In the coming years, as Hardy's tattooing skills advanced, he would make bold use of ukiyo-e designs and develop a great respect for the richness of the tradition.[7]

A full backpiece tattoo that Hardy worked on from 1982 to 1983 is but one example, among hundreds over his career, of a design that quotes from an ukiyo-e master (fig. 15).[8] In 1887 Tsukioka Yoshitoshi created a dynamic woodblock print diptych of the righteous rebel Zhang Shun, shown with upper-body tattoos, fighting underwater with Li Kui (fig. 16).[9] The story, based upon the fourteenth-century Chinese novel *Shuihu zhuan* and popularized in nineteenth-century Japan as *Suikoden* (*The Water Margin*), follows the exploits of 108 legendary heroes.[10] In its inclusion of Zhang Shun's plunging tattooed body, Hardy's design references the medium of skin, giving the piece an ironic and self-aware twist. Hardy further embellished the pictorial surface by adding drama to the waves and the motif of the Dragon King's undersea palace. His reliance on a single source for the main part of a tattoo is rare. More characteristic is the approach he took to a preliminary drawing of a white fox for a large tattoo from 1981 (fig. 17). With it Hardy displays his masterful ability to adapt various sources into one image, integrating multiple ukiyo-e artists' depictions of a magical, shape-shifting nine-tailed fox from Japanese folklore into a work designed to fit the left chest, torso, and thigh of a client.[11] Hardy

has commented that trickster and transformer myths make logical subjects for tattoos, since being tattooed is another type of transformation.[12]

Among many tattoo artists, Japanese tattoos are regarded as the pinnacle of the art form. Even before Oakland tattoo artist Phil Sparrow (Samuel Steward) gave Hardy his first opportunity to try tattooing in 1966, Sparrow shared with him a book titled *Irezumi* (1966), by Ichirō Morita and Donald Richie. The title, the Japanese word for tattoo, literally means "to insert ink." Unassuming by today's publishing standards, with fuzzy black-and-white photographs lacking great detail, the book at the time was a precious, rare visual resource on traditional Japanese tattoos. Referred to as "suits," this type of tattoo covers the wearer's back, torso, upper arms, and upper legs and features large figures in dramatic poses surrounded by dynamic patterns, such as waves, that unify the entire composition. This marked contrast to the smaller, independent images seen at the time in most European and American tattoos made a monumental impression on Hardy.[13]

Once Hardy took the leap to becoming a serious tattoo artist, his quest expanded to include mastering the subject matter and techniques of Japanese tattoo work. Reflecting on the opening of his first shop in Vancouver, British Columbia, in 1968, he said, "All I wanted to do was tattoo and develop what I saw as potential in the medium."[14] In the twentieth century, the man who was most engaged with Japanese tattoos outside Japan was the world-renowned tattoo artist Sailor Jerry (Norman Collins). With the help of Zeke Owen, Hardy wrote to Sailor Jerry in Honolulu, and in 1969 they began an intensive relationship by mail, exchanging design concepts and thoughts on Japanese tattooing and the potential and future of the medium. As Sailor Jerry embraced the role of Hardy's mentor, he explained his passion about the quality and accuracy of tattoo design and his disdain of shoddy work. In a 1969 letter to Hardy, Sailor Jerry wrote, "To attempt to emulate the Japanese in their work style without extensive understanding of the oriental mind and culture is utterly ridiculous as evidenced by some of the so-called 'Japanese-style' work coming out."[15] In 1972 Sailor Jerry invited Hardy to Honolulu to meet the Japanese tattoo artist Horihide (Kazuo Oguri), with whom Sailor Jerry had been corresponding. The meeting with Horihide proved to be a life-changing event for Hardy, as it led to an opportunity to train under Horihide in Japan.

In June of 1973, Hardy became the first Western tattoo artist to learn directly from a master tattooer in Japan (figs. 5, 35). Shortly after he arrived and started working with Horihide in a small, nondescript apartment in Gifu, Hardy invited Francesca Passalacqua to join him; the two are still together today. At that time in Japan, tattooing was practiced only on the margins of society, and most of the clients were yakuza, or gangsters, who had little interest in the finer points of Japanese art or history. While Horihide had exceptional skill in classic tattoo images, such as carp, dragons, and flowers, Hardy soon realized that a fairly rigid repertoire of subjects existed and that "tattooing [in Japan] was as limited and codified as Western tattooing."[16] Not long afterward, Hardy reached the conclusion that

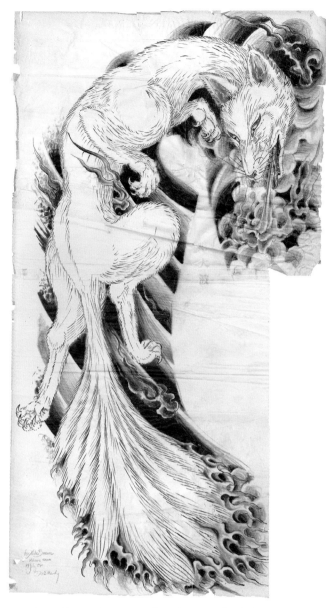

17
DON ED HARDY
Fox Spirit
(tattoo design for left
chest, torso, and thigh),
1981. Black ink and
colored pencil on
tracing paper, 30 ¾ x
17 in. (78.1 x 43.2 cm)
COLLECTION OF THE
ARTIST

spending time with gangsters while also struggling with basic communication was not an effective way to advance his goal of bringing more creativity and sophistication to the art of tattooing. After five months he returned to the States.

Hardy's success as a custom tattoo artist grew, and by the early 1980s, he was making regular trips to Japan to meet with the eminent master Japanese tattoo artists Horiyoshi II (Tamotsu Kuronuma)[17] and Horiyoshi III (Yoshihito Nakano).[18] Such trips also gave Hardy the opportunity to attend performances of Kabuki theater, visit museums to absorb as much Japanese art as possible, and tattoo young adults from Japan's growing rockabilly subculture. Other significant relationships he cultivated in Japan were with Dr. Katsunari Fukushi and his wife. In 1926 Fukushi's father, Dr. Masaichi Fukushi, had started a collection of tattooed human skins to aid in his study of moles. Skin donors, many of whom were honored to have their tattoos preserved, would receive a cash advance for their postmortem contributions.[19] In 1983 Hardy visited the Fukushis and had the opportunity to see—and touch—the wet skins stored at Tokyo University.[20] While awestruck by the experience of picking up the formaldehyde-soaked skins in his gloved hands, Hardy later wryly commented, "They felt like sweaters."

When considering Hardy's career, it is evident that his vast energy and creativity have continuously sought and found multiple outlets. In 1982, while Hardy was building up his custom tattoo work, he and Passalacqua launched the magazine *Tattootime* (fig. 38). Introducing thematic articles and showcasing the work of cutting-edge artists to readers hungry for information, the publication played a significant role in tattoo history. This effort morphed into Hardy Marks Publications, which has to date produced more than forty books on tattoo art and history. In 1985 Hardy and Passalacqua brought the legendary Horiyoshi II to San Francisco and Seattle for the National Tattoo Association Convention.[21] The soft-spoken tattoo artist, who had never been out of Japan, was moved by the enthusiasm for tattooing that greeted him, but he was mystified by the diversity of American tattoo designs. While in Seattle, he requested to go to a Shingon Buddhist temple to pray in atonement for all the pain his work had caused. He had no tattoos himself.

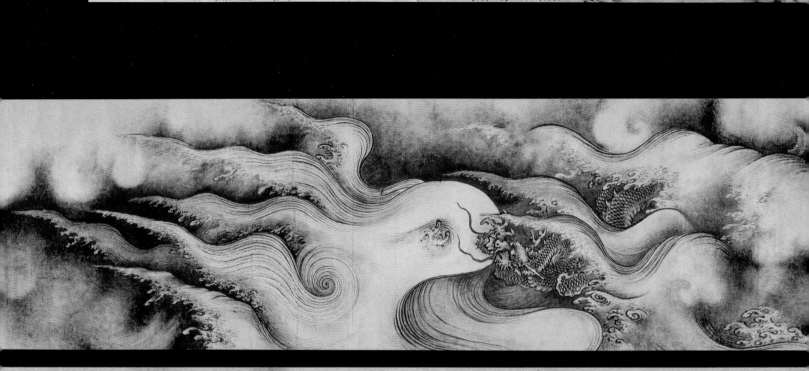

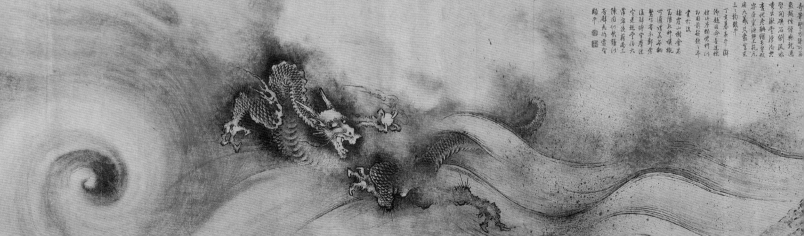

18
CHEN RONG
Nine Dragons, dated 1244. Ink and color on paper, image: 18 ¼ x 377 ⅜ in. (.5 x 9.6 m); overall: 18 ⅜ x 589 ⅛ in. (.5 x 15 m)
ABOVE: **Overall**
OPPOSITE: **Details**
MUSEUM OF FINE ARTS, BOSTON, FRANCIS GARDNER CURTIS FUND, 17.1697

In May of that year, Hardy and Passalacqua assembled a group of world-renowned tattoo artists, including Horiyoshi III, from Japan, and Pinky Yun (Bing Kuan), of Alameda, California, and formerly of Hong Kong, to travel to Rome for a groundbreaking exhibition on tattoos and tattooing.[22] By 1986 it was clear to Hardy that the pace at which he was tattooing clients, publishing, and pursuing other projects to advance tattoo art was untenable. Partly to deter himself from taking on too many commitments, he and Passalacqua relocated to Honolulu, where he was able to devote more time to his non-tattoo artwork. Returning to printmaking in the early 1990s, in 1995 he created *Frontier Justice* and *Sacred Tiger Ascending*, previously discussed.

In 2000 Hardy began an ambitious project that he had envisioned twenty-four years earlier. In 1976, a dragon year in the East Asian calendrical system, Hardy had the idea for an immense painted work that would feature a vast number of dragons, but he could not find a satisfactory solution for how to accomplish this feat. On January 1, 2000, in another dragon year, Hardy began painting *2000 Dragons* (pl. 151). In East Asia dragons are believed to be auspicious creatures with awesome strength that control rain but also have a voracious desire for treasure. Like a writhing dragon, the entire body of the five-hundred-foot-long painting is never visible at one time; rather it twists and turns in space as it adjusts to its environs (figs. 11, 49). Using a roll-through easel, Hardy could only paint one five-foot-long section of the two-thousand-foot-long surface at a time before rolling up the painting like a giant handscroll and moving on to the next portion.

The dragons in the scroll, each numbered with Asian characters, are rendered in various colors, sizes, and shapes, composing a diverse group that amazes at every turn. Some are depicted in a style faithful to East Asian ink-painting traditions, as with a group of dragons shown emerging from swirling clouds; others range across styles, time periods, and cultures. Clusters of tiny dragons appear, as does a dragon chair, a long red Mesoamerican feathered serpent, and others hidden among a sea of crashing waves. After all the drama, movement, and variation, the scroll ends with a surprise: a charmingly diminutive blue-and-white ceramic teapot with three small cups, each decorated with its own tiny dragon.

Hardy's key inspiration for *2000 Dragons* was a magnificent ink-on-paper handscroll in the collection of the Museum of Fine Arts, Boston, titled *Nine Dragons* (dated 1244; fig. 18), by the Chinese scholar-painter Chen Rong (ca. 1200–1250).[23] Hardy had long been fascinated with the painting's deftly depicted dragons, which writhe as they disappear and reappear among black clouds and waves. As in many cultures, certain numbers have special significance in East Asia. While Hardy concentrated on the number two thousand in response to the turn of the millennium, Chen Rong used the number nine because he had been impressed by earlier paintings he had seen of nine horses and nine deer. The number also held many positive cultural associations for him: it enjoyed an auspicious relationship with the emperor; the Dragon King has nine offspring that live in an undersea palace; and in Chinese the word for "nine" sounds the same as the word for "long-lasting."

Hardy finished his scroll on July 28, 2000, after seven months of working on it. He used the experience to free himself from some of the limitations his tattoo career had placed on his artwork by working larger, looser, and more spontaneously than his previous work had allowed.[24] In addition to being exhibited at the de Young, *2000 Dragons* has been unrolled and suspended for display at Track 16 Gallery, Santa Monica (2000–2001); Museum of Contemporary Art Denver (2001); VII Bienal de Cuenca, Ecuador (2001); Guayaquil and Quito, Ecuador (2001); Yerba Buena Center for the Arts, San Francisco (2002); Academy Art Center at Linekona, Honolulu (2004); and DiverseWorks, Houston (2012).[25] To experience the scroll, one must navigate its course by riding through the waves, storms, and sites of stillness, wrapping oneself in its energy.

Dragons are one of many themes related to Asian art that appear frequently in Hardy's work. As with many of his other favorite subjects, he has spent so much time drawing and redrawing the creatures on different surfaces that their forms have become embodied. This type of learning can be expressed in the Japanese phrase *"mi ni tsuite,"* which literally means "attached to the body," or what Hardy refers to as "muscle memory."[26] Natural phenomena, such as water, waves, and rocks, are also prominent as embodied motifs. These themes are particularly evident in Hardy's 2008 painting *Mi Fu's Vacation* (pl. 125), from his *Ghost Writers* series, a body of work inspired by photo negatives, X-rays, and stone rubbings.[27] Done in white outline on a surface of black-and-blue splashed and sprayed ink,

Mi Fu's Vacation depicts the specter of a clipper ship bursting with sharp-edged Chinese-style rocks. Its title references the Chinese painter Mi Fu (1051–1107), who is renowned for his misty and dotted ink landscapes and his obsession for collecting scholar's rocks. Like other works by Hardy, *Mi Fu's Vacation* combines his personal fascination with water, US naval culture, and the rocky shore of Corona del Mar, California, where he grew up, while demonstrating his vast knowledge of East Asian art history.

Religious themes are particularly pervasive in Hardy's work. Although some figures, like Zaō Gongen, appear throughout Hardy's oeuvre relatively intact, other members of "Hardy's gang" have undergone countless permutations. Some may criticize such reformatting and hybridizing of beloved icons and religious figures as disrespectful cultural appropriation; others may interpret it as homage. As Hardy unapologetically layers his art with his personal reworking of images from across the globe to project his vision, he fearlessly takes risks, defies expectations, and reminds us that good art is about questioning and provoking new ways of thinking. We celebrate Ed Hardy for making the journey into unfamiliar waters and investing great physical and mental energy into the study and application of Asian art. In doing so, he has broken down barriers and built up cross-cultural communication, all the while inspiring us with his boundless zest for art.

Notes

1 For scholarship on the plaque, see Heather Blair, "Zaō Gongen: From Mountain Icon to National Treasure," *Monumenta Nipponica* 66, no. 1 (2011): 3–5. For a good photograph, see Osaka Shiritsu Bijutsukan, ed., *En no Gyōja to Shugendō no sekai: Sangaku shinkō no hihō: En no Gyōja Shinpen Daibosatsu 1300-nen onki kinen* [The World of Enno-Gyoja and Shugendoh] (Osaka, Japan: Osaka Shiritsu Bijutsukan, 1999), figs. 79, 53, 215–216. Hardy attended this exhibition in the Tokyo venue at Tōbu Bijutsukan, which was likely the first time he saw the plaque, which measures 26 ³⁄₈ by 30 inches.

2 For more on *tengu*, see Haruko Wakabayashi, *The Seven Tengu Scrolls: Evil and the Rhetoric of Legitimacy in Medieval Japanese Buddhism* (Honolulu: University of Hawai'i Press, 2012).

3 Don Ed Hardy, *Tattooing the Invisible Man: Bodies of Work, 1955–1999* (Santa Monica, California: Smart Art Press, 1999), 13–16. Hardy's 1955 dragon drawing appears on page 15. See also Don Ed Hardy, *Drawings for Tattoos 3* (San Francisco: Hardy Marks Publications, 2018), 17, 19, 53, 88.

4 The print was published in Hardy, *Tattooing the Invisible Man*, 253.

5 "I am anxious to emphasize core qualities beyond apparent 'exotic' subject matter: at heart, the influence of Zeami's Jo Ha Kyu instructions, which Gordon Cook first referred me to in 1963—and set off my involvement with Eastern thought," Don Ed Hardy, email message to authors, October 12, 2018.

6 Hardy, *Tattooing the Invisible Man*, 41–43.

7 Ibid., 40–41; Don Ed Hardy, *Drawings for Tattoos 1* (San Francisco: Hardy Marks Publications, 2016), 7. Hardy's negotiation between printmaking and tattooing is discussed in Paul Mullowney, "Print Collaboration East/West," in *Wood Skin Ink: The Japanese Aesthetic in Modern Tattooing* (Makawao, Maui, Hawaii: Hui No'eau Visual Arts Center; San Francisco: Hardy Marks Publications, 2005), 5–10.

8 An image of this tattoo appears in "In Japanese Waters," *Tattootime* 3, no. 1 (1984): 58.

9 Regarding figure 16 in this essay, *Chang Shun, the White Stripe in the Waves, Wrestling with Li K'uei, the Black Whirlwind in the Ching Yang River* (*Rorihakucho chojun kokusempu riki kochu ni tatakau no zu*) (1887), by Tsukioka Yoshitoshi, the authors note that they prefer different systems for romanization of the Chinese and Japanese words than the Achenbach Foundation for Graphic Arts uses in its translation. Their preferred title is *Zhang Shun, the White Stripe in the Waves, Wrestling with Li Kui, the Black Whirlwind, in the River* (*Rōrihakuchō Chōjun Kokusenpū Riki Kōchū ni tatakau no zu*). The characters in the text allude to the location of the fight as the Xunyang River.

10 Roger Keyes, *The Bizarre Imagery of Yoshitoshi: The Herbert R. Cole Collection* (Los Angeles: Los Angeles County Museum of Art, 1980), 60–61; Chris Uhlenbeck, *Yoshitoshi: Masterpieces from the Ed Freis Collection* (Leiden, the Netherlands; Boston: Hotei, 2011), 125. For more on *Suikoden*, see Inge Klompmakers, *Of Brigands and Bravery: Kuniyoshi's Heroes of the* Suikoden (Leiden, the Netherlands: Hotei, 1998), 22–25. For an excellent source on tattoo images in ukiyo-e, see Sarah E. Thompson, *Tattoos in Japanese Prints* (Boston: MFA Publications, 2017).

11 Hardy signed this piece with his Japanese tattoo name, Hori Onami, with characters that mean "tattooer great wave."

12 Don Ed Hardy, conversation with the authors, December 29, 2018; Hardy, *Drawings for Tattoos* 1:10. He made the tattoo for Mike Brown, a good friend who was a baker.

13 Ichirō Morita and Donald Richie, *Irezumi* (Tokyo: Zufu Shinsha, 1966). Richie, who later became a close friend of Hardy's, supplied the English text for the book.

14 Joel Selvin and Don Ed Hardy, *Wear Your Dreams: My Life in Tattoos* (New York: Thomas Dunne Books/St. Martin's Press, 2013), 57–58.

15 Ibid., 79. See also Sailor Jerry and Don Ed Hardy, *Sailor Jerry Collins, American Tattoo Master: In His Own Words* (Honolulu: Hardy Marks Publications, 1994), 29.

16 Selvin and Hardy, *Wear Your Dreams*, 87–110, 134.

17 For more on Horiyoshi II, see Akimitsu Takagi et al., *Nihon shisei geijutsu Horiyoshi* [Japan's tattoo arts: Horiyoshi's world], expanded edition (Tokyo: Keibunsha, 2006).

18 The younger Horiyoshi III (Yoshihito Nakano) came from a different lineage than Horiyoshi II (Tamotsu Kuronuma), and different characters are used in their Horiyoshi names. The practice of naming used by Japanese tattoo artists generally reflects the lineage of their teachers. It is common to use the character "hori" followed by a second character that has personal associations. The word *hori*, in general, means carving. It is also used in verb form to describe the action of tattooing. A number is added after the name to indicate generations.

19 "Speaking of Pictures . . . Japanese Skin Specialist Collects Human Tattoos for Museum," *Life Magazine* 28, no. 14 (April 3, 1950): 11–14; Don Ed Hardy, "Remains to be Seen," *Tattootime* 4, no. 1 (1987): 74–78. For a medical essay on tattooing by Dr. Katsunari Fukushi, see Takagi et al., *Nihon shisei geijutsu Horiyoshi* 1:163–173.

20 Selvin and Hardy, *Wear Your Dreams*, 197–198, 200–202.

21 On the 1985 Seattle Convention, see Takagi et al., *Nihon shisei geijutsu Horiyoshi* 2:58–59, 93–94, 122.

22 Hardy, *Tattooing the Invisible Man*, 117; Don Ed Hardy, Simona Carlucci and Giorgio Ursini Ursic, *L'Asino e la zebra: Origini e tendenze del tatuaggio contemporaneo* (Rome: De Luca, 1985).

23 Wu Tung, *Tales from the Land of Dragons: 1,000 Years of Chinese Painting* (Boston: Museum of Fine Arts, 1997), 197–201. For still images, see https://www.mfa.org/collections/object/nine-dragons-28526; for a digital version of the entire scroll, see https://scrolls.uchicago.edu/view-scroll/49 (both accessed December 26, 2018).

24 Hardy commented, "This painting changed me in a fundamental way, opened possibilities I didn't know I could explore." Selvin and Hardy, *Wear Your Dreams*, 257.

25 See Don Ed Hardy and Laurie Steelink, *2000 Dragons* (Santa Monica, California: Smart Art Press, 2000); Don Ed Hardy and Renny Pritikin, *2000 Dragons/Dragones: Don Ed Hardy* (San Francisco: Yerba Buena Center for the Arts, 2001). For videos of the scroll, see http://www.archive.track16.com/exhibitions/dragon/2000dragons_hardy.html and https://www.youtube.com/watch?v=1dnwIaHxisU (both accessed December 26, 2018).

26 Selvin and Hardy, *Wear Your Dreams*, 230.

27 Don Ed Hardy, *Don Ed Hardy Paintings: 798 Art District, Beijing, September 7–9, 2013* (San Francisco: Hardy Marks Publications, 2013), 5, 62–63.

The Art Education of Ed Hardy

Jeff Gunderson

Hardy spent his formative years immersed in a mid-century California rife with new philosophies, innovative vernacular art, tidal waves of societal change, and a glut of visual stimuli. He wholeheartedly participated in these cultural revelations, and their kaleidoscopic range would shape his views and his art for the next six decades.

Hardy's enthusiasm for this new world was likely a reaction to the homogenous, narrow-minded environment of 1950s Orange County. Raised by his mother in Corona del Mar, Hardy grew up in a version of the region that no longer exists, with the beach down the street and nearby cowboys behind "barbed wire around the Irvine Ranch."[1] His first major inspiration was the work of Disney cartoonist Carl Barks, the inventor of Scrooge McDuck, uncle to Donald, whose strong graphics "tapped into all kinds of exotic scenarios," recalls Hardy.[2] He was also inspired by post-war Japanese iconography. His father, who had relocated to Japan to work with General Douglas MacArthur's US Occupation Forces, both contributed child support and sent his son "all kinds of souvenirs, from teacups

to satin boxing shorts" and "reversible jackets embroidered with Japanese power symbols, Mount Fuji, dragons, tigers" (fig. 27).[3] Added to this mix were the tattoos that Hardy saw on World War II and Korean War vets on the beach and in Wanted posters in his hometown post office.

At ten Hardy's truly formative years began at the Long Beach Pike, "a big, scary, pre-Disneyland amusement park built on a pier on the beach," twenty-five miles north of Corona del Mar.[4] His typical day involved smoking a pack of cigarettes, going on the Cyclone Racer roller coaster, and visiting the half dozen tattoo shops at the Nu-Pike arcade. Being there, Hardy remembers, "was like going off the high board."[5] You had to be eighteen to get into the shops, so he would get kicked out of every shop except the one owned by Bert Grimm, whom Hardy considered "the quintessential tattoo flimflam man—great storyteller, great bullshitter, great self-promoter . . . and [he] could also really tattoo."[6]

Hardy's fascination with all things tattoo led him to write a grade-school research paper on the history of the practice, a project that took him to the Los Angeles Public Library, where he spent the day absorbed in *Memoirs of a Tattooist* (1958), by British tattooer George Burchett.[7] This scholarly investigation initiated Hardy into a lifetime of research in libraries, special collections, and his own extensive library. He asserts, "This is the ultimate luxury: to just read, pursue some kind of scholarship, with no end in mind; just absorbing the material and somehow know it's enriching you."[8]

Hardy observed the advent of car shows on the beach next to the Long Beach Pier,

remembering the vehicles as "moving pieces of art," whose custom paint jobs, pinstriping, and flames proved mesmerizing.[9] Although he wasn't interested in the cars as functional objects, he appreciated their value as sculptural forms.[10] He saw firsthand the flying eyeball of Von Dutch (Kenneth Howard), the work of Dean "The Kid" Jeffries, and that of Ed Roth, who airbrushed shirts before becoming known as "Big Daddy" Roth. Such imagery would later become known as "monster art" and "weirdo painting."[11] Hardy even sold his own airbrushed versions of monster art sweatshirts with cut-off sleeves to teenagers at the beach (fig. 29), early evidence of his entrepreneurial spirit. His later research connected this art to its "roots in ancient Japanese paintings of 'hell scenes,' shown in scrolls full of wild flames and grotesque, emaciated figures symbolizing damned souls."[12] Southern California beach culture inevitably drew Hardy to surfing, which, he says, took over his life. "All I wanted to do was draw surf art," he says.[13]

Hardy was a young waterman by fourteen, and his search for good waves exposed him to Southern California's next cultural awakening: Laguna Beach's Beat scene, which consisted of "bongos and beards, and poetry readings." He read Allen Ginsberg's "Howl" and Gregory Corso's "Bomb" and "got hip to [William S.] Burroughs and his attitude of being an anonymous outsider."[14] Hardy listened to West Coast jazz and frequented Café Frankenstein, in Laguna Beach, and the Prison of Socrates Coffee House, in Newport Beach.

Away from the beach, Hardy "lucked across a great high school art teacher," who was

"well-read, hip, and socially conscious." Hardy's first true mentor, Shirley Rice was a liberal beacon in ultraconservative Orange County.[15] She taught him about Pablo Picasso, Hieronymus Bosch, Francisco Goya, James Ensor, and Ben Shahn's *The Passion of Sacco and Vanzetti* series (1931–1932), helping spark his lifelong interest in art history.[16] He became excited "about the humanist potential of art . . . art that is going to save the world."[17] Rice encouraged his budding art career, for which he had been rewarded "with gold keys, blue ribbons, and a tiny bit of money" at the LA Scholastic Art Awards in 1962 (fig. 30).[18] Hardy remembers himself as prone to melodrama and identifying with the morose work of Norwegian painter Edvard Munch, whose drawings and pastels "strove to exude a murky sweat" beyond his youthful experience.[19] After high school Hardy put his surfboard in the garage and focused on making art,[20] and that summer he qualified for a booth at the Laguna Beach Art Festival, where he wore his Ray Charles wraparound sunglasses and displayed his "tormented drawings. . . no seascapes . . . only serious art" (fig. 19).[21]

That summer Hardy also fell in with two like-minded young artists, Doug Hall and Ken Conner, fellow wanderers eager to investigate the new art energy in Los Angeles—the epicenter of which was a cluster of galleries along the 500–900 blocks of North La Cienega Boulevard. Visiting these galleries was a revelation for Hardy, who remembers being at a loss, thinking, "Is this a joke? . . . It was fantastic!"[22] Hardy, Hall, and Conner participated in the Monday Night Art Walks along La Cienega, a destination for hipster art aficionados. The most dynamic and chaotic

gallery was the Ferus Gallery.[23] Ferus was the brainchild of Walter Hopps and the trailblazing sculptor Edward Kienholz, and its founding marked the beginning of Hopps's massive influence on the world of art. Hopps would soon move on to the Pasadena Art Museum, where he curated the first retrospectives of Kurt Schwitters, in 1962; Marcel Duchamp, in 1963; and Joseph Cornell, in 1967.[24] Hardy thought of Hopps as "a complete art hero,"[25] while actor and artist Dennis Hopper considered him "the intellectual godfather of the underworld. . . . He knew the difference between a real artist and one who was posing."[26] Many of the early Ferus artists were from Northern California. Added to this mix were LA Cool School artists, a group that included John Altoon, Larry Bell, Billy Al Bengston, Robert Irwin, Kienholz, Ken Price, and Ed Ruscha. These artists took surf, car, and beach culture and meshed it with personal art that had a sense of place, a spirit of the times, and a delinquent disregard for conventions. This unique collection of artists and exhibitions proved to be significant ingredients in Ed Hardy's art education.

In 1962 Hardy saw Kienholz's *Roxy's* installation at Ferus. He thought the immersive rendering of a 1940s brothel was "incredible, crazed, high gutsy stuff."[27] After seeing a Bruce Conner exhibition at Ferus, Hardy collaged a kind of homage to Conner titled *Life of a Tattooer* (1962; pl. 20), complete with torn pages from tattoo catalogues and pictures of flash against a background of black oil paint.[28] Ferus also exhibited Andy Warhol's *Campbell's Soup Cans* (1962), which consists of thirty-two paintings of the title subject, prior to its being

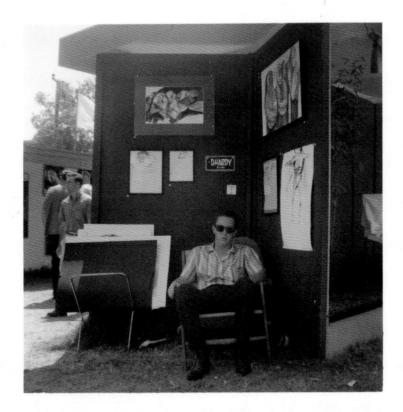

19
Ed Hardy in his booth
at the Laguna Beach
Art Festival, 1962
COLLECTION OF DON ED
HARDY

shown in any New York gallery.[29] When Hall
and Hardy saw the work, Hardy reports that they
"burst out laughing; we couldn't believe what we
were seeing."[30] They trekked to the Pasadena
Art Museum to see the pioneering Schwitters
retrospective, which had strongly influenced the
generation of Pop artists. Hardy then saw two
other exhibitions at the museum—*Llyn Foulkes:
Paintings and Constructions*, which he thought was
"really astounding . . . confrontational, creepy
paintings that are built up layer by layer,"[31] and
New Paintings of Common Objects, the first
museum survey of Pop artists, which included Jim
Dine, Joe Goode, Phillip Hefferton, Roy Lichten-
stein, Robert O'Dowd, Ruscha, Wayne Thiebaud,
and Warhol.[32] Taken with O'Dowd's and Heffer-
ton's paintings on currency, Hardy quickly did his
own variations of art on banknotes.

An array of artists captured Hardy's
attention, including the "ceramic revolution"
sculptors, particularly Peter Voulkos and Ken
Price, who would go on to "transform clay from a
crafts material to . . . [one with] the avant-garde
potential of paint."[33] Selden Rodman's book *The
Insiders* (1960) introduced Hardy to artists like
José Luis Cuevas, whose caricatures celebrated the
human condition and whose work Hardy tracked
down at the Silvan Simone Gallery, in Los
Angeles.[34] After Hardy met Rex Evans, a retired
movie star with a high-end gallery on La Cienega,
Evans and his partner took an interest in Hardy's
work and included some of it in the gallery.
Several of his drawings sold there, which Hardy
counted as his first commercial gallery success.

In the fall of 1962, Hardy relocated
to San Diego County to live with Conner and
help tend to Conner's parents' avocado ranch
while attending the La Jolla School of Arts.
Hardy hoped to study with Ferus artist John
Altoon, who had taught at La Jolla the previous
semester and whose work Hardy admired. The
artist Ed Moses once described Altoon as "the
model of the way an artist should be, wild, unpre-
dictable, irascible."[35] Although Altoon ended up

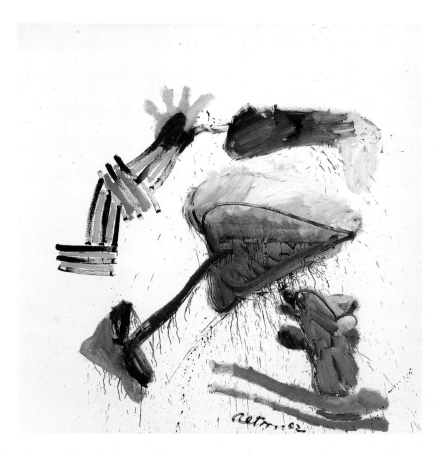

not teaching that semester, Hardy saw Altoon's *Ocean Park* series (1962; fig. 20) that fall at Ferus. He writes that seeing the paintings was "one of the most revelatory experiences of my young life . . . these works still resonate with me."[36] At the same time, Hardy saw paintings by San Francisco artist Joan Brown at the Primus-Stuart Gallery. Brown, whose art would soon be on the cover of *Artforum*, was then teaching at the San Francisco Art Institute (SFAI)—giving Hardy another reason to investigate art school in Northern California.

Eighteen and facing the possibility of being drafted, Hardy enrolled in Orange Coast College, an accredited community college in Costa Mesa, for the spring 1963 semester. He completed his *Self-Portrait with Bonnie* (1963; pl. 18) while studying there. A fellow student, Bonnie Russell was part of a growing group of Hardy's friends who would eventually make their way north.[37] On a visit to scout out San Francisco, Hardy was driven straight to North Beach. He remembers deciding, "Well, this is it! I couldn't believe I was

still in California, because California to me was John Wayne [and] John Birch Society repressive stuff."[38] Hardy's acceptance to SFAI seemed like "a passport to freedom."[39] With his mother's financial support, he enrolled and, once there, worked on the maintenance crew. Soon, however, he found a student job in the library with head librarian Herberta Faithorn.[40] Hardy's first classes included sculpture with Manuel Neri, whose work served as a sculptural complement to Bay Area Figurative painting.[41] Philip Leider, founding editor of *Artforum*, thought Neri, along with Brown, Bruce Conner, Jay DeFeo, and Wally Hedrick, were "the nucleus of whatever was happening in San Francisco," where "there was a sense of community . . . a besieged community" (fig. 21).[42] They put an "emphasis on art as a rigorously ethical, almost religious activity and on the passionate, committed identification of the artist with their work."[43] Although this art had distinct regional character-istics, it remained in step with the contemporary art world.[44] Hardy admired the self-confidence of the Bay Area Figurative painters, who had

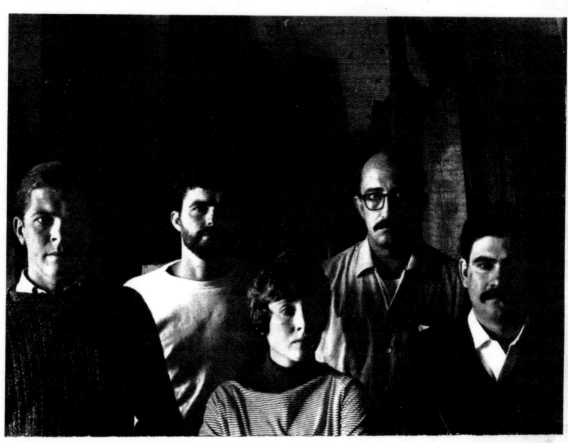

PHOTOGRAPH BY PHILIP GREENE

The Nude:
Graphics by 5 Artists

WM H. BROWN ALVIN LIGHT JOAN BROWN GORDON COOK MANUEL NERI

Achenbach Foundation for Graphic Arts California Palace of the Legion of Honor

August 18 through September 16, 1962

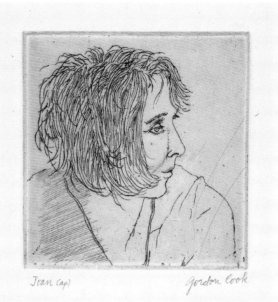

re-embraced landscapes and figures but painted them in a loose and expressive style. "It wasn't tight, representational work, but beautiful killer paintings. . . . the Art Institute may have been a long way from Park Avenue galleries, but it was a hive of intellectual activity and creative expression," he recalled.[45]

Taking introductory lithography with Richard Graf, Hardy came to appreciate how learning printmaking, like tattooing, felt like an apprenticeship with an instructor who had "strongly held opinions of correct procedures and closely guarded trade secrets."[46] Hardy's first non-studio classes were with Ken Lash and Richard Miller. Lash, a poet who lived in the coastal town of Bolinas, in Marin County, assigned students Joseph Campbell's *The Hero with a Thousand Faces,* his work of comparative mythology from 1949. Miller, a World War II veteran, pacifist, and radical with a PhD in history, would occasionally conduct class at Vesuvio Cafe, in North Beach, and once fired a Civil War musket in the classroom to demonstrate the horrors of war.[47]

Hardy's studio faculty included painters Bill Brown, Joan Brown, Gordon Cook, James Budd Dixon, Julius Hatofsky, Joe Oddo, and Don Weygandt. Cook taught etching and engraving, mediums that captivated Hardy: "It was like throwing knives at a target behind your back, looking at a mirror."[48] Cook insisted that students develop a thorough knowledge of printmaking history and introduced Hardy to Eastern as well as Western aesthetics.[49] Cook believed "that a subtle practice of art should be integrated with everyday existence, avoiding preciousness and elitist conceits."[50] Cook's

heroes were diverse: Rembrandt and the comics character Krazy Kat, country singer Hank Snow and Italian painter Giorgio Morandi, and one-man band Jesse Fuller and Italian Renaissance artist Piero della Francesca.[51] Cook proved to be a supportive teacher, sending students to print shows featuring works of the old masters and assigning readings of Erwin Panofsky to "shape their understanding of the artist's role in society."[52] Hardy described Cook as a "proud blue collar guy . . . a journeyman hand typesetter," who kept his day job and taught part-time. He loved country music and the Beat poets and was close with the poet Kenneth Patchen.[53] Hardy described Cook's meticulous art—still lifes, nudes, and landscapes, drawn from life—as "incredibly nuanced" and "super masterly" (fig. 22; pl. 23).[54] Cook "disdained the arrogance and chic of the art literati, pursuing instead the company of salt-of-the-earth men at local bars, the Dolphin Swimming and Boating Club, and North Beach coffeehouses."[55] Cook was extremely wary of academia and artists and warned Hardy to avoid both.

Cook expected a lot from his best students, two of whom were Hardy and Martha Hall. For one assignment, the two went to the city's highest point, from which Hardy did an intricate etching of the landscape below, *San Francisco*

23
JOAN BROWN
Noel and Bob, 1964.
Oil on canvas, 72 x
60 ¼ in. (182.9 x 153 cm)
FINE ARTS MUSEUMS OF
SAN FRANCISCO, MUSEUM
PURCHASE, AMERICAN ART
TRUST FUND, MR. AND MRS.
J. ALEC MERRIAM FUND,
AND MORGAN AND BETTY
FLAGG FUND, 2003.67

from Twin Peaks (1964/1998; fig. 4). During his four years at SFAI, Hardy apprenticed with Cook—learning his trade secrets and laboriously becoming a master etcher and engraver.

Hardy's other primary influence at SFAI was Joan Brown. He loved Brown's use of thick paint, her unpredictable brushwork and choice of everyday subjects (fig. 23), and the fact that she was "full of piss and vinegar . . . swore like a trooper, could drink anybody under the table . . . we were all in love with her."[56] Brown shared Cook's refreshing honesty and disdain for hypocrisy.[57] Brown and Cook "had a completely no-bullshit, tough outlook on art . . . they were extremely intelligent, deeply read, and deep thinkers . . . they appreciated the stuff that was just everyday."[58] They both loved the water, the ocean, and particularly San Francisco Bay. Cook's embrace of the ocean was "mystical," says Hardy. "An avid swimmer in the Bay . . . he really had a feeling about some kind of preternatural energy that comes from . . . the ocean . . . the weather changing, the fog."[59] Brown also swam in the San

Francisco Bay and in the 1970s did an extensive series of large paintings inspired by her swims from Alcatraz to San Francisco and across the Golden Gate. Brown confidently followed her own path, never caring what galleries or collectors thought of her art. After experiencing tremendous success with her early paintings, she simply withdrew from exhibiting in galleries in 1965.[60] Hardy witnessed Brown's retreat firsthand. Combined with Cook's counsel, it further solidified his own suspicions of the art world.

Hardy focused on etching with Cook, continued to take drawing from Brown, and enrolled in a class with Richard Shaw, who had started teaching ceramics. Shaw and Hardy visited Oakland to get tattoos from Phil Sparrow, also known as Samuel Steward. Hardy knew of Sparrow's reputation as a tattooer but soon learned of his previous identity as a PhD-holding English professor at Loyola University, in Chicago; as a confidant of Alfred Kinsey; and as a friend of Gertrude Stein. Hardy describes Sparrow as a "renegade intellectual" who went into tattooing "to distance himself from academia."[61] Around this time, in 1967, Hardy received a graduate fellowship to the Yale University School of Art. But Brown's and Sparrow's examples, along with Cook's advice, steered Hardy away from an academic path. In Hardy's self-portrait *Future Plans* (1967; pl. 29), his final etching for his BFA exhibition, he depicts himself sitting on a stool, shirtless and heavily tattooed. Reactions to Hardy's career choice were mixed. Some were dismayed by his decision to abandon "high art" for a "bastardized sailortown craft," but others "applauded the weirdness of it."[62]

43

24
DON ED HARDY
*Future Plans
(Leaving Art School)*,
2008. Oil, enamel, and
digital print on panel,
42 x 32 x 3 in. (106.7 x
81.3 x 7.6 cm)
COLLECTION OF THE
ARTIST

Sparrow tried to warn Hardy about the pitfalls of the intensely competitive tattoo world, seeing him as a fresh-faced kid who was no match for the "tattoo jungle."[63] Hardy did struggle in his initial effort to establish his own shop in Vancouver, British Columbia, and he soon left for a more apprentice-like situation, first in Seattle and then in San Diego. A quick learner, he turned his aesthetic eye to the very best tattooers, seeking out training from some of the finest in the world, including Honolulu's Sailor Jerry (Norman Collins) and Japan's legendary Horihide (Kazuo Oguri). After working with Horihide in Japan, Hardy set up Realistic Tattoo Studio, in San Francisco, in 1974. His links with SFAI and the California art world, including Brown, Cook, and Shaw, persisted. Shaw even had Hardy deliver a lecture on the history of tattooing to his graduate seminar. Following the lecture, he tattooed Shaw and some of the students. "It blew the class away," Shaw remembers.[64] Hardy's affection for his alma mater and his engagement with its students remains strong to this day, evidenced by his receipt of an honorary doctorate from the school in 2000 and his guest lectures in classes there.

As Hardy's tattooing career flourished, he continued to engage with the broader art world. In the 1990s he reconnected with printmaking at a small fine arts press in Chicago and also curated exhibitions of tattoo art for younger audiences, whose ideas about the form proved more open-minded than previous generations'. In 1995 Hardy organized the influential exhibition *Pierced Hearts and True Love: A Century of Drawing for Tattoos*, at the Drawing Center, in New York. These undertakings, along with

publisher, writer, and musician V. Vale's RE/Search publication *Modern Primitives* (1989), which featured Hardy's work, helped introduce the art of tattooing to the hipster and later the mainstream art scene. Through Manuel Ocampo, one of his favorite artists, Hardy was introduced to Laurie Steelink at Santa Monica's Track 16 Gallery and reconnected to the LA gallery scene. By this time Hardy had returned to the studio and was wrestling with how to assimilate his "wide range of . . . iconic, amuletic, and decorative forms developed through years of tattooing" with the visual incitements, art-school training, and historical influences gleaned in his youth.[65] Hardy has described his artistic development as akin to a tornado, an attempt to "integrate, collapse all these cultures, all these time periods, all these art styles, into some kind of new stew that nobody's seen."[66]

Hardy's reverence for his early mentors is evident in two artworks that he recently revisited. Returning to *Future Plans*, he added to the title *Leaving Art School* (2008; fig. 24). Instead of showing himself sitting on a stool, Hardy has depicted himself on top of a stack of books honoring Gordon Cook, Joan Brown, Samuel M. Steward, and Shirley Rice. After the deaths of both Cook and Brown, in 1985 and 1990, respectively, Hardy returned to his early *San Francisco from Twin Peaks*, adding an elaborate sky through which Gordon Cook rows a wooden boat, guiding Joan Brown as she swims out through the Golden Gate (fig. 25).

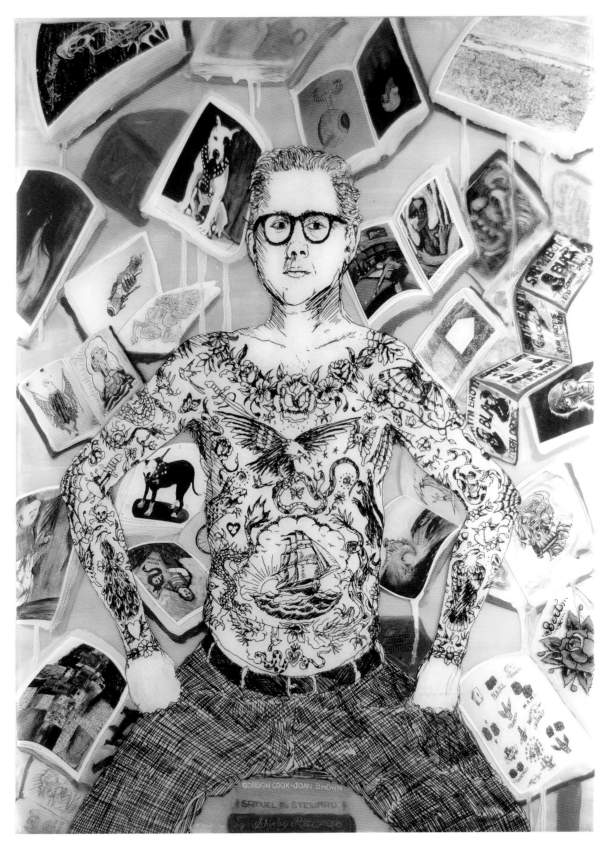

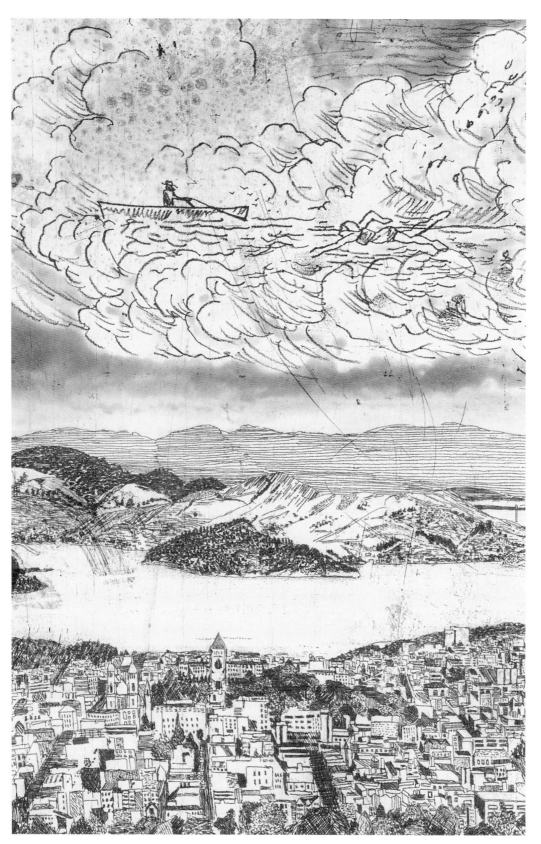

25
DON ED HARDY
Gordon and Joan
Escape the '90s
(detail), 1964/1998.
Etching, 28 x 33 ⅞ in.
(7.1 x 8.6 cm). Printed by
Paul Mullowney
FINE ARTS MUSEUMS OF
SAN FRANCISCO, GIFT OF
THE ARTIST, 2017.46.30

Notes

1 Joel Selvin and Don Ed Hardy, *Wear Your Dreams: My Life in Tattoos* (New York: Thomas Dunne Books/St. Martin's Press, 2013), 11.

2 Don Ed Hardy, in-class lecture, San Francisco Art Institute, in Marian Wallace, *Studio 18* (San Francisco: RE/Search Publications, 2014), DVD.

3 Don Ed Hardy and Alan B. Govenar, *Ed Hardy: Beyond Skin* (Kempen, Germany: TeNeues, 2009), 22, 42.

4 Selvin and Hardy, *Wear Your Dreams*, 13.

5 Don Ed Hardy, in *Ed Hardy: Tattoo the World*, directed by Emiko Omori (Germany: Eye See Movies, 2010), DVD.

6 Selvin and Hardy, *Wear Your Dreams*, 13.

7 Ibid., 15.

8 V. Vale and Marian Wallace, *Ed Hardy: Interviews by V. Vale* (San Francisco: RE/Search Publications, 2013), 29.

9 Hardy, in *Ed Hardy: Tattoo the World*, DVD.

10 Selvin and Hardy, *Wear Your Dreams*, 16.

11 Ibid., 16.

12 Don Ed Hardy, *Tattooing the Invisible Man: Bodies of Work, 1955–1999* (Santa Monica, California: Smart Art Press, 1999), 17.

13 Hardy, in *Ed Hardy: Tattoo the World*, DVD.

14 Hardy and Govenar, *Ed Hardy: Beyond Skin*, 8; Hardy, in *Ed Hardy: Tattoo the World*, DVD.

15 Hardy, in *Ed Hardy: Tattoo the World*, DVD.

16 Selvin and Hardy, *Wear Your Dreams*, 19.

17 Hardy, in *Ed Hardy: Tattoo the World*, DVD.

18 Selvin and Hardy, *Wear Your Dreams*, 22.

19 Hardy, *Tattooing the Invisible Man*, 36.

20 Ibid.

21 Selvin and Hardy, *Wear Your Dreams*, 23.

22 Don Ed Hardy, in discussion with the author, December 2018, Artist's File: Hardy, Don Ed, San Francisco Art Institute Archives.

23 Morgan Neville and Kristine McKenna, *The Cool School: How LA Learned to Love Modern Art* (New York: Arts Alliance America, 2008), DVD.

24 Calvin Tomkins, "A Touch for the Now," *The New Yorker*, July 29, 1991; Walter Hopps, Deborah Treisman, Anne Doran, and Edward Ruscha, *The Dream Colony: A Life in Art* (New York: Bloomsbury, 2017), 151.

25 Hardy, in discussion with the author, December 2018.

26 Tomkins, "A Touch for the Now," 40.

27 Kristine McKenna, *The Ferus Gallery: A Place to Begin* (Gottingen, Germany: Steidl, 2009), 231; Hardy, in *Ed Hardy: Tattoo the World*, DVD.

28 Selvin and Hardy, *Wear Your Dreams*, 22.

29 McKenna, *The Ferus Gallery*, 92.

30 Selvin and Hardy, *Wear Your Dreams*, 20.

31 Vale and Wallace, *Ed Hardy: Interviews by V. Vale*, 104.

32 McKenna, *The Ferus Gallery*, 248.

33 Neville and McKenna, *The Cool School*, DVD.

34 Selvin and Hardy, *Wear Your Dreams*, 27.

35 Neville and McKenna, *The Cool School*, DVD.

36 Hardy, in discussion with the author, December 2018.

37 Martha Hall, Richard Shaw, David MacKenzie, Bonnie Russell, John Duff, and Reggie Daniger all attended the San Francisco Art Institute during this period.

38 Vale and Wallace, *Ed Hardy: Interviews by V. Vale*, 64.

39 Hardy, *Tattooing the Invisible Man*, 37.

40 Selvin and Hardy, *Wear Your Dreams*, 30.

41 Thomas Albright, *Art in the San Francisco Bay Area: 1945–1980: An Illustrated History* (Berkeley, California: University of California Press, 1985), 72.

42 Amy Newman, *Challenging Art: Artforum, 1962–1974* (New York: Soho Press, 2000), 29.

43 Albright, *Art in the San Francisco Bay Area*, 111.

44 Terry St. John, *The Dilexi Years* (Oakland, California: Oakland Museum, 1984), 18.

45 Selvin and Hardy, *Wear Your Dreams*, 31.

46 Don Ed Hardy, "Marks for Life," in *Indelibly Yours: Smith Anderson Editions and the Tattoo Project* (Palo Alto, California: Smith Anderson Editions, 2011), 3.

47 Marsha Ginsburg, "Richard Miller: Renaissance Man," *San Francisco Chronicle*, June 17, 2006.

48 David Bransten, *Ron and Don: Ron Nagle and Don Ed Hardy* (San Francisco: Bay Package Productions and Rena Bransten Gallery, 2015), DVD.

49 Hardy, *Indelibly Yours*, 2.

50 Ibid.

51 Christina Orr-Cahall, Gordon Cook, Kenneth Baker, and Wayne Thiebaud, *Gordon Cook: A Retrospective* (Oakland, California: Oakland Museum, 1987), vii.

52 Ibid., 2.

53 Hardy, in *Ed Hardy: Tattoo the World*, DVD.

54 Selvin and Hardy, *Wear Your Dreams*, 33.

55 Orr-Cahall et al., *Gordon Cook: A Retrospective*, 1.

56 Selvin and Hardy, *Wear Your Dreams*, 32.

57 Hardy, *Tattooing the Invisible Man*, 38.

58 Vale and Wallace, *Ed Hardy: Interviews by V. Vale*, 87.

59 Ibid., 81–82.

60 Karen Tsujimoto and Jacquelynn Baas, *The Art of Joan Brown* (Berkeley, California: University of California Press, 1998), 235.

61 Vale and Wallace, *Ed Hardy: Interviews by V. Vale*, 24.

62 Hardy, *Tattooing the Invisible Man*, 41.

63 Hardy, in *Ed Hardy: Tattoo the World*, DVD.

64 Richard Shaw, in discussion with the author, November 2017, Artist's File: Shaw, Richard, San Francisco Art Institute Archives.

65 Alice Wong, *Post-Tattoo: Works by Kandi Everett, Don Ed Hardy, and Michael Malone* (Honolulu: Contemporary Museum, 2004), 3.

66 *Spark: Don Ed Hardy and the Art of Tattoo*, produced by Pam Rourke Levy (San Francisco: KQED and Bay Area Video Coalition, 2004), DVD; Hardy, in Wallace, *Studio 18*, DVD.

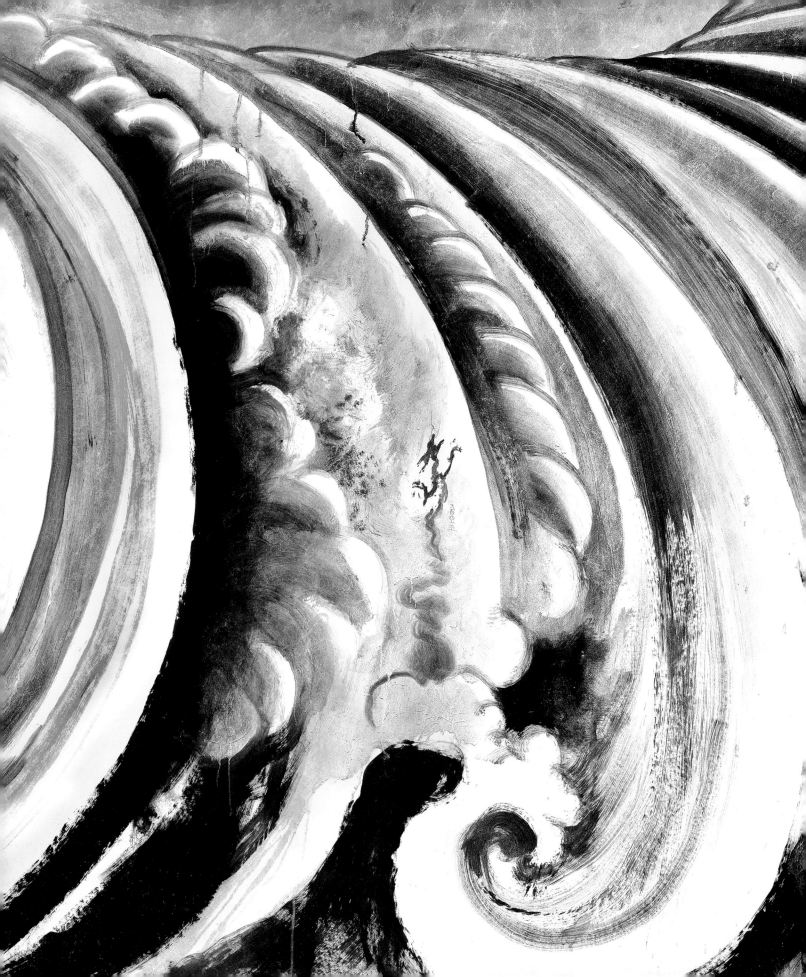

Catalogue

Karin Breuer

*Unless otherwise noted,
all works are by Don Ed Hardy
and from the collection
of the artist.*

"At age ten
when I looked at
Len's dad's tattoos,
it was a gosh-darn
bolt from the blue.
I knew I wanted to
do this.
And I went for it.
Everything I
ever did was
another step
on that path."

Kiddie Flash and Toy Tattoos

A trove

OF CHILDHOOD DRAWINGS, many of them
inscribed and dated by his mother, reveal that
Don Ed Hardy was serious about art from the
age of four. He loved to draw and in 1955, at
the age of ten, channeled his creative energy
into making tattoo art. He was fascinated
by the tattoos on neighborhood friends'
fathers who had served in World War II. His
admiration of those traditional designs led
Hardy to investigate the tattoo parlors of the
Long Beach Pike, an amusement zone not far
from his home in Corona del Mar, California.
Filled with lowbrow and seedy enterprises, the
Pike was near naval shipyards and attracted
scores of sailors on extended shore leave.
To the young Hardy, it was exotic territory.
Among the many tattoo shops was that of Bert
Grimm, a veteran tattoo artist who allowed
the underage boy to watch him tattoo, copy
tattoo flash (sample drawings for tattoos),

and take photographs of the shop windows
filled with tattoo imagery (figs. 2, 3). The
tattoo parlor's colorful ambiance motivated
Hardy to set up a tattoo shop in the den
of his family home, where he decorated the
walls with sheets of his tattoo designs copied
from those he'd seen in Grimm's shop and
brochures he'd ordered from catalogues and
magazines (fig. 28; pls. 1, 2, 5). He drew
tattoos on the backs, chests, and arms of his
friends for a few cents each, using watercolor
pencils and Maybelline eyeliner (fig. 1; pls. 4,
6). Hand-lettered signs warned prospective
customers that they were required to be nine
years old and have parental permission to get
a tattoo. The enterprise captured the atten-
tion of a local newspaper reporter, and in
1956 a small article appeared in the *Newport
Harbor Ensign*, accompanied by a photo
of Hardy and partner Len Jones with their
customers (pl. 3). Hardy remembers it as his
"first publicity."

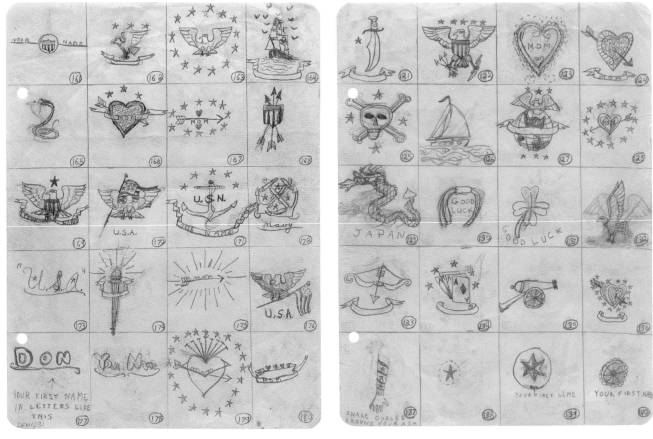

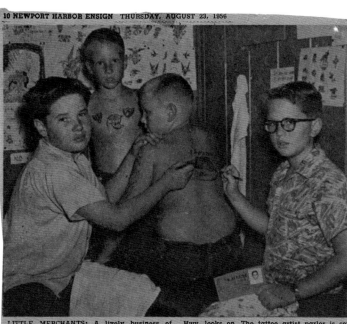

1 ABOVE LEFT
Untitled tattoo designs,
161–180, ca. 1955.
Graphite on paper,
10 ½ x 8 in. (26.7 x
20.3 cm)

2 ABOVE RIGHT
Untitled tattoo designs,
121–140, ca. 1955.
Graphite on paper,
10 ½ x 8 ¼ in. (26.7 x
21 cm)

3 RIGHT
Newspaper clipping
from the *Newport
Harbor Ensign*, 1956
COLLECTION OF DON ED
HARDY

LITTLE MERCHANTS: A lively business of tattooing is the strictly private enterprise of Lenny Jones (left) age 11, of 618 Heliotrope Ave., Corona del Mar, and Don Hardy (right), also 11, of 703 Goldenrod Ave. Here they are working on one of their customers, Roger Johnson, 11, of 612 Goldenrod Ave., while another satisfied victim, Greg Tracer, 9, of 2743 E. Coast Hwy. looks on. The tattoo artist parlor is set up in Don Hardy's den, and both of the little entrepreneurs have mighty official looking though home-made business licenses. They use colored pencils for their tattooing. Some of their business regulations are: "You must have permission of your parents" . . . "Ages 9 to 12" "If under 9, stay out" . . . "NO CREDIT."

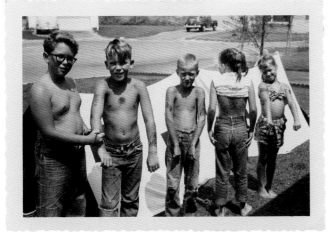

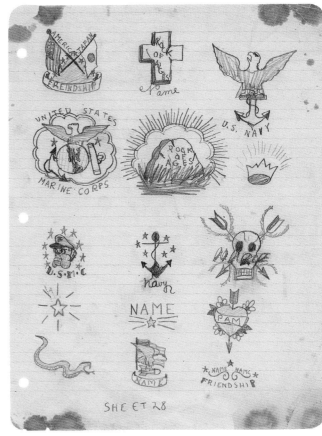

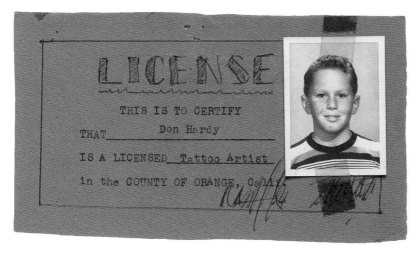

4 ABOVE LEFT
Satisfied Customers, 1956. Gelatin silver print, image: 3 ½ x 5 in. (8.9 x 12.7 cm)
COLLECTION OF DON ED HARDY

5 ABOVE RIGHT
Untitled tattoo designs, *Sheet 28*, ca. 1955. Graphite on ruled paper, 11 x 8 ½ in. (27.9 x 21.6 cm)

6 LEFT
Tattoo license, 1955. Blue ink, typewritten text, and gelatin silver print on blue paper, 3 ¼ x 5 ⅞ in. (8.3 x 14.9 cm)

53

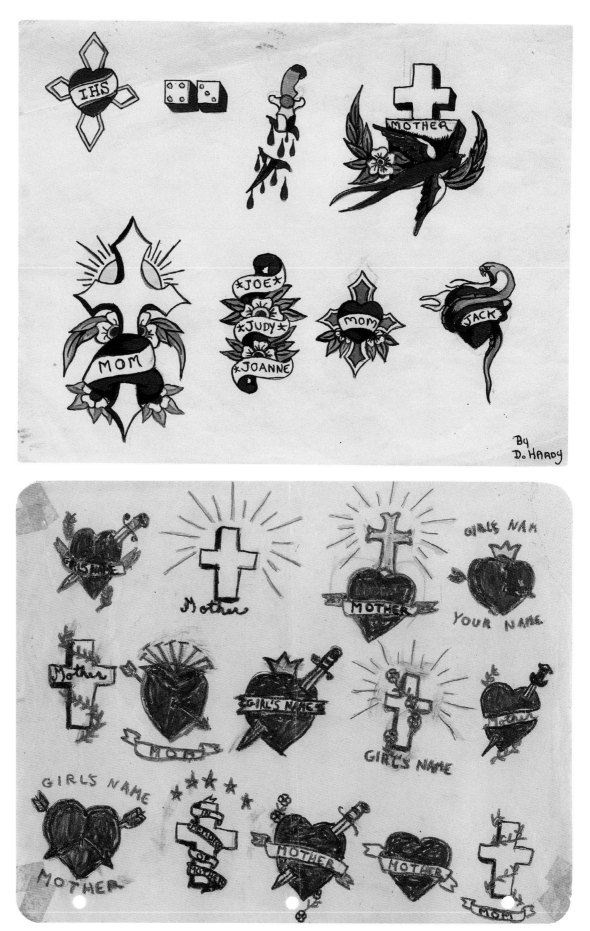

7 ABOVE
Untitled tattoo designs, 1958. Black ink and opaque watercolor over graphite on paper, 8 ½ x 11 in. (21.6 x 27.9 cm)

8 BELOW
Untitled tattoo designs, 1956. Wax crayon over graphite on paper, 8 ½ x 11 in. (21.6 x 27.9 cm)

54

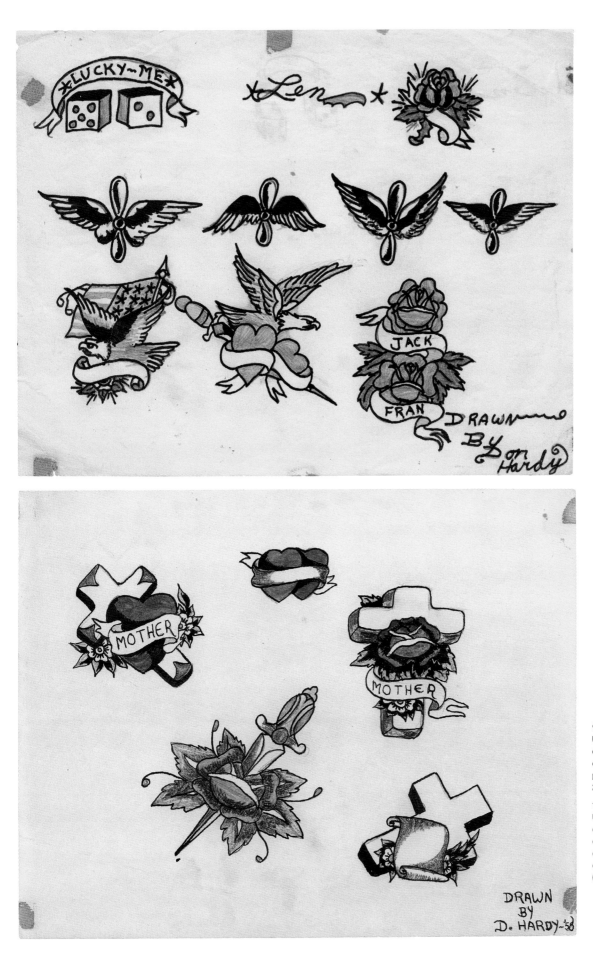

9 ABOVE
Untitled tattoo designs,
ca. 1958. Black ink and
colored pencil on
paper, 8 ½ x 11 in. (21.6 x
27.9 cm)

10 BELOW
Untitled tattoo designs,
ca. 1958. Black ink,
colored pencil, wax
crayon, and graphite
on paper, 8 ½ x 11 in.
(21.6 x 27.9 cm)

11 LEFT
*Black and White by
D. H.*, 1955. Graphite
on paper, 11 x 8 in.
(27.9 x 20.3 cm)

12 RIGHT
*Black and White by
D. Hardy and L.
Jones*, 1955. Black ink
and graphite on paper,
11 x 8 in. (27.9 x 20.3 cm)

56

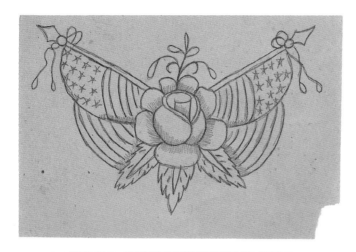

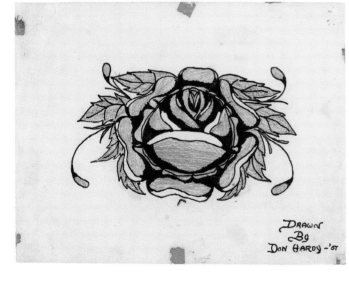

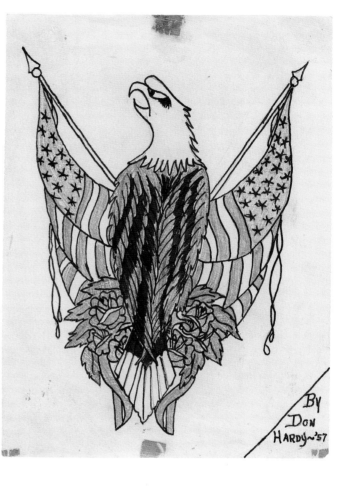

13 ABOVE LEFT
BERT GRIMM
Untitled tattoo design,
1955. Graphite on
paper, 6 x 9 in. (15.2 x
22.9 cm)
COLLECTION OF DON ED
HARDY

14 BELOW LEFT
Untitled tattoo design,
1957. Black ink and wax
crayon over graphite
on paper, 8 ½ x 11 in.
(21.6 x 27.9 cm)

15 ABOVE RIGHT
Untitled tattoo design,
1957. Black ink, wax
crayon, and graphite
on paper, 11 x 8 ½ in.
(27.9 x 21.6 cm)

"I couldn't think of anything but finishing my undergraduate degree and opening the tattoo shop."

Getting Serious about Art

2

Hardy's interest

IN TATTOOING WANED when he was a teenager, but he continued to be attracted to alternative art forms. He was briefly captivated by the imagery of custom car and hot-rod culture and at sixteen took up surfing, producing a series of drawings that depicted his fellow surfers tackling the waves. He also became interested in Beat culture, reading Allen Ginsberg's poetry and listening to cool West Coast jazz. An influential high school art teacher, Shirley Rice, encouraged him to delve into art history and learn about the humanist tradition in art, beginning with Rembrandt and including the work of Francisco Goya, Edvard Munch, and the American social realist Ben Shahn. He began visiting LA galleries on La Cienega Boulevard and came under the spell of Pop art after seeing the work of Andy Warhol and Larry Rivers exhibited there. Hardy's art of this period reflects their profound impact.

Accepted into the San Francisco Art Institute in 1963, he reveled in the radical diversity of the city, home to both a beatnik ethos and a burgeoning hippie culture. Hardy was drawn to intaglio printmaking because of the technical challenges of the craft, its traditions, and emphasis on line, which he likened to the art of tattooing. His instructor, Gordon Cook, encouraged Hardy to visit the Achenbach Foundation for Graphic Arts, at the Legion of Honor, to see the prints of the old masters. There he carefully inspected the engravings and etchings of Albrecht Dürer, Giorgio Morandi, Rodolphe Bresdin, and Rembrandt, among others (pls. 21, 25, 27). He was attracted to their work and that of printmakers who were considered outsiders for their unusual artistic visions. Connecting this experience with his early appreciation of tattoo culture, he gave a school presentation in 1966 claiming that tattooing was a forgotten American folk art warranting recognition beyond its marginalized status. Soon after, he visited the Oakland shop of tattooer Phil Sparrow (Samuel Steward), which resulted in one of Hardy's first tattoos and the conviction that he could make a career out of tattooing and bring new ideas to the form. In 1967 he completed *Future Plans*, one of his last etchings as a student—a smiling self-portrait of the young, bare-chested artist covered in tattoos (pl. 29).

⊚⊚⊚

16
Boy with Kite, 1962.
Tempera on prepared
paper board, 30 x
20 in. (76.2 x 50.8 cm)

60

17 ABOVE
Smith Brothers Patriotic, 1962. Oil on paper board, 25 ½ x 30 ½ in. (64.8 x 77.5 cm)

18 BELOW
Self-Portrait with Bonnie, 1963. Etching, plate: 8 ¾ x 6 ¾ in. (22.2 x 17.1 cm)
FINE ARTS MUSEUMS OF SAN FRANCISCO, GIFT OF THE ARTIST, 2017.46.14

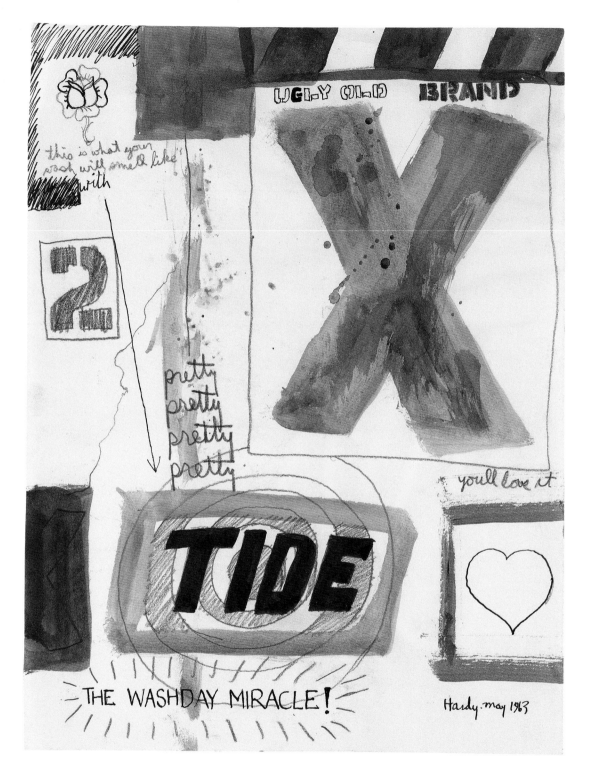

19
The Washday Miracle, 1963. Black ink, ink wash, and graphite on paper, 13 ⅞ x 10 ½ in. (35.2 x 26.7 cm)

20 OPPOSITE
Life of a Tattooer, 1962. Oil paint, black ink, gesso, and paper collage on paper board, 24 ⅛ x 18 in. (61.3 x 45.7 cm)

62

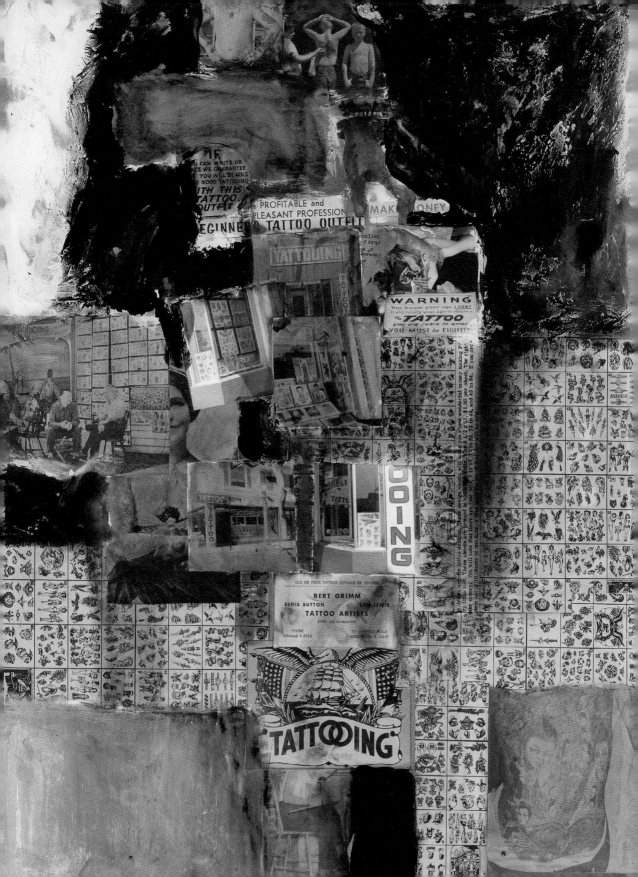

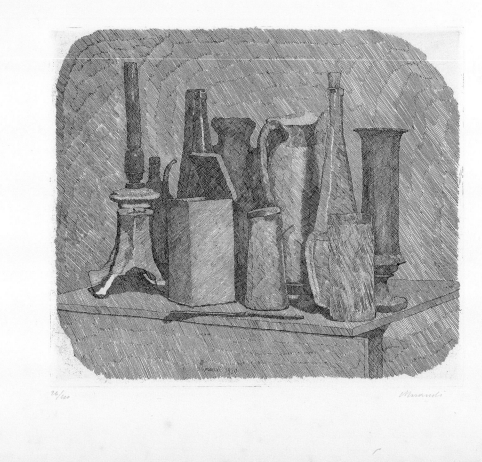

21
GIORGIO MORANDI
Grande natura morta
con la lampada a
petrolio (Large Still
Life with Oil Lamp),
1930. Etching, plate:
12 ⅝ x 14 ¼ in. (32.1 x
36.2 cm)

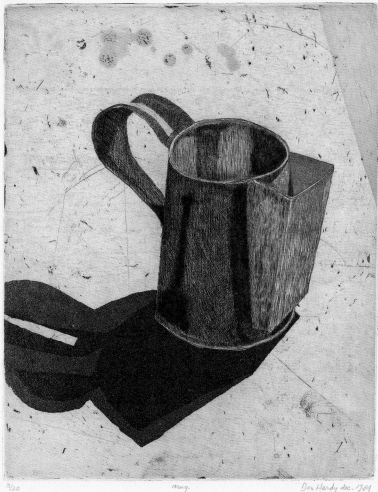

3/20 mug. Don Hardy dec. 1969

Pool with Boards (ap)

Gordon Cook

23
GORDON COOK
Pool with Boards
(Golden Gate Park,
San Francisco), 1957.
Etching, plate: 8 ¼ x
4 ⅜ in. (21 x 11.1 cm)
FINE ARTS MUSEUMS OF

Third state. 8 December 1969. Back yard III Don Hardy.
plate accidentally destroyed on 11 dec.

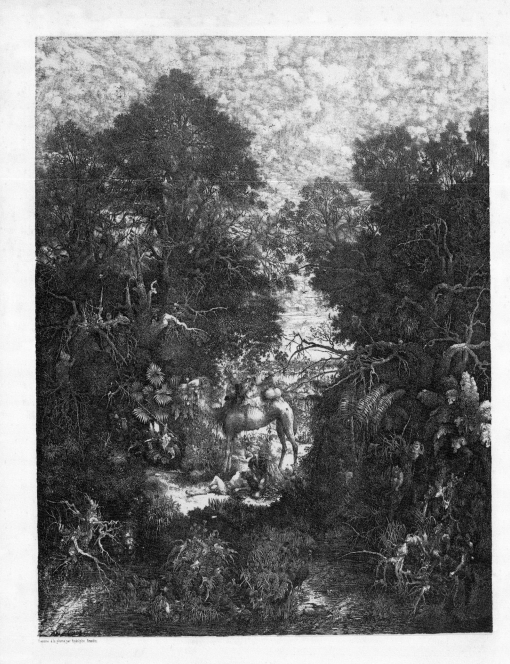

Tirage à la plume par Rodolphe Bresdin.

25
RODOLPHE BRESDIN
The Good Samaritan,
1861. Lithograph, image:
22 ⅜ x 17 ¾ in. (56.8 x
45.1 cm)
FINE ARTS MUSEUMS OF
SAN FRANCISCO, GIFT OF
MRS. EDGAR SINTON,
1958.136.1

26 OPPOSITE

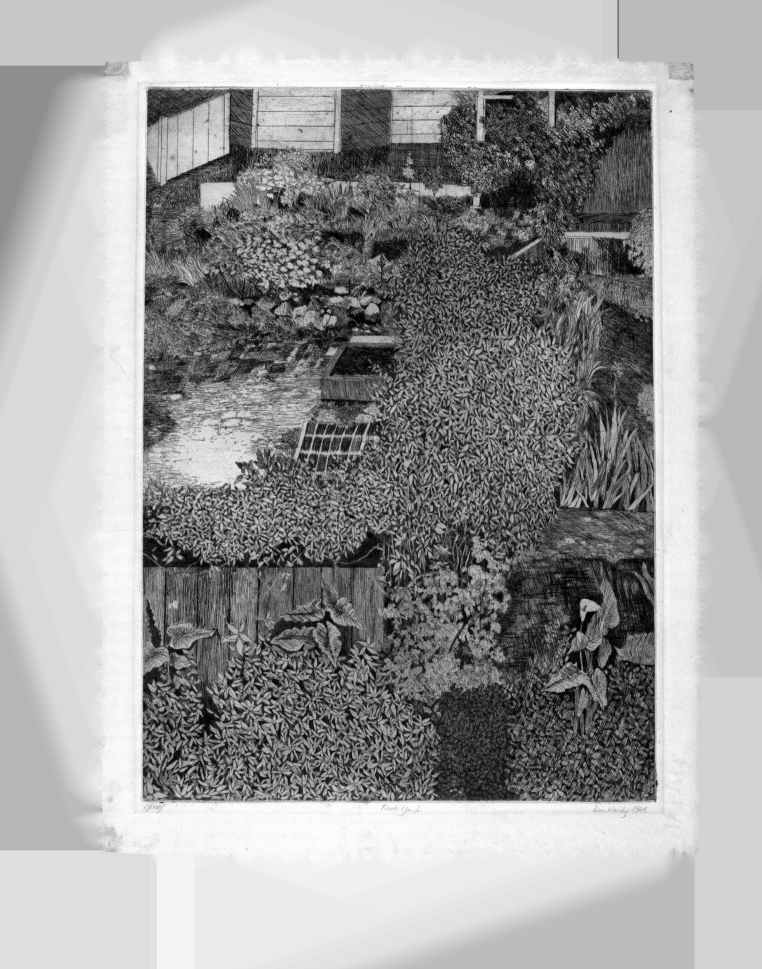

Back Yard. Don Hardy 1969

27 LEFT
**REMBRANDT
HARMENSZ. VAN RIJN**
*Self-Portrait Open
Mouthed, as if
Shouting: Bust,* 1630.
Etching, plate: 2 ⅝ x
2 ⅜ in. (6.7 x 6 cm)

28 RIGHT
Self-Portrait Gagging,
1964. Etching, plate: 4 x
2 ⅜ in. (10.2 x 6 cm)

29 OPPOSITE
Future Plans, 1967.
Etching, plate: 7 ⅛ x
7 ¾ in. (20 x 19.7 cm)

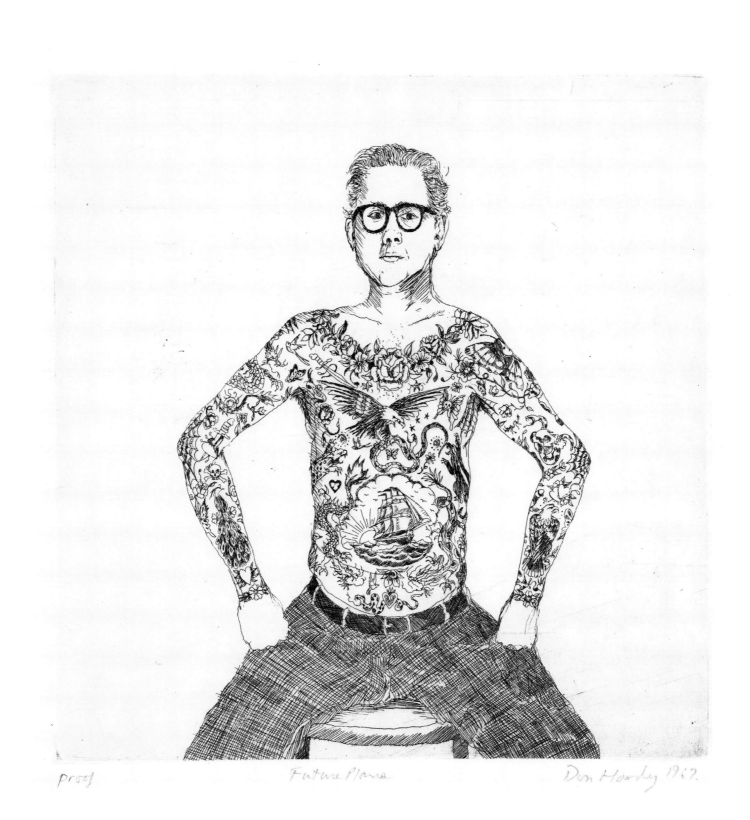

proof Future Plans Don Howdy 1957.

"I graduated art school with my lofty ideals and told everybody I was going to be a tattooer and turn this into an art, but found myself in relatively short order stamping Hot Stuff on sailors in San Diego."

Needle Work

After learning

THE BASICS OF TATTOOING from Phil Sparrow (Samuel Steward), who also introduced him to the art of Japanese full-body tattooing, Hardy experienced a long learning curve working at tattoo studios in Vancouver, British Columbia; Seattle; and San Diego, from 1968 to 1973. Combining his two middle names to create the needle name Ed Talbott and later Ed Hardy, he soon realized that he had grossly underestimated tattooing's difficulty. He dedicated himself to mastering the craft's technical aspects and resolved to comprehend the depth of design in Western-style tattooing. However, he eventually tired of reproducing its repertoire on the stream of Sailortown customers who visited the shops where he worked. Hardy's real quest was to digest the roots of the Japanese tattoo imagery he had first seen at Sparrow's shop. In the late 1960s, he was introduced to the work of Sailor Jerry (Norman Collins), a Honolulu-based tattooer who had developed an American style of tattoo that incorporated elements of the Japanese tradition. A long correspondence and eventual meeting with Sailor Jerry in 1969 convinced Hardy that he could expand the art form. He went on to develop a style that more fully integrated the epic American style with the Japanese tradition in larger, more elaborate tattoo compositions that interrelated with body contours.

Through Sailor Jerry's introduction to Japanese tattoo master Horihide (Kazuo Oguri), Hardy was invited to work in Gifu, a small town in central Japan. For five months in 1973, he worked alongside Horihide, becoming the first Westerner to tattoo in a traditional Japanese environment, absorbing the Japanese repertoire and tattooing a range of clients that consisted primarily of yakuza, or gangsters (figs. 5, 35).

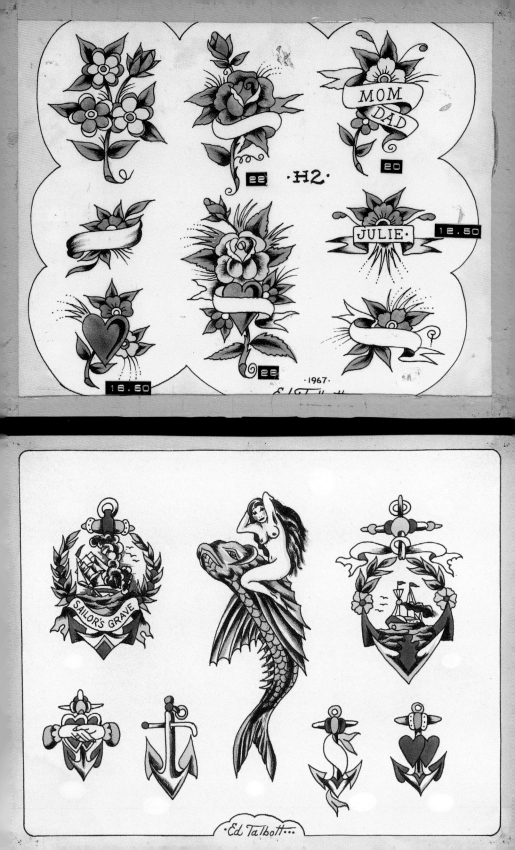

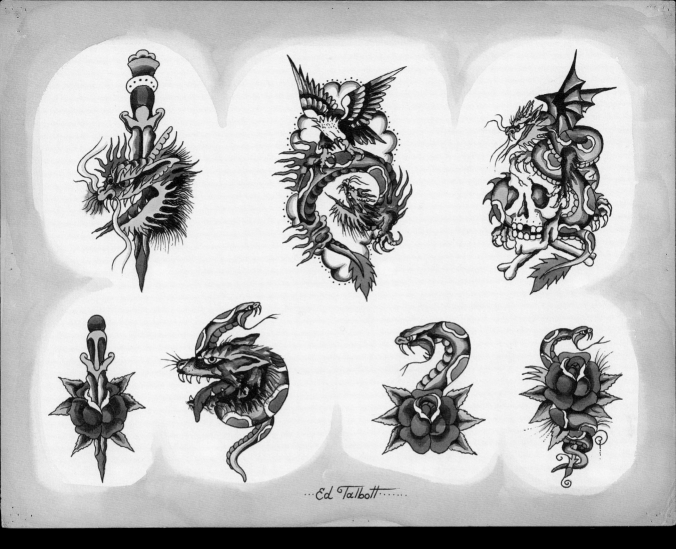

Ed Talbott

30 OPPOSITE ABOVE
Untitled tattoo designs,
H2, 1967. Black ink and
watercolor on paper
board, 11 ⅛ x 14 ⅛ in.
(28.3 x 35.9 cm)

31 OPPOSITE BELOW
Untitled tattoo designs,
1967. Black ink and
opaque watercolor on
paper board, 11 x 13 ⅞
in. (27.9 x 35.2 cm)

32
Untitled tattoo designs,
1967. Black ink and
watercolor on paper
board, 15 x 20 in. (38.1 x

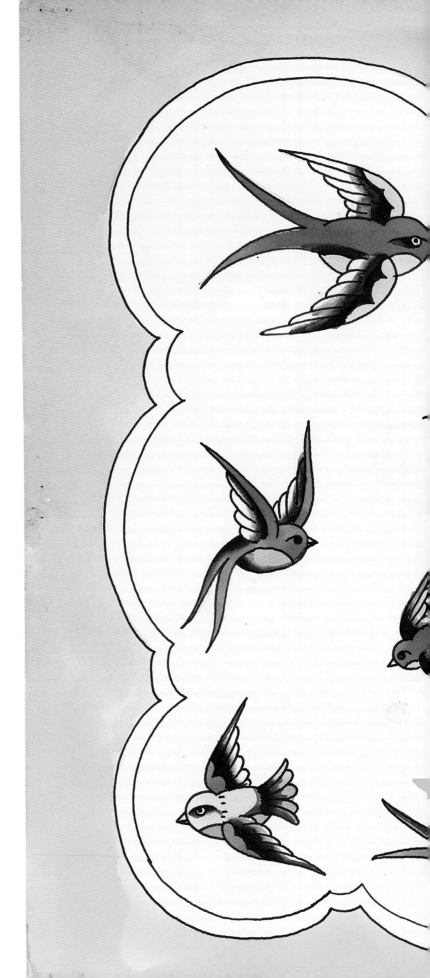

33
Untitled tattoo designs, 1968. Black ink and watercolor on paper board, 15 x 20 in. (38.1 x 50.8 cm)

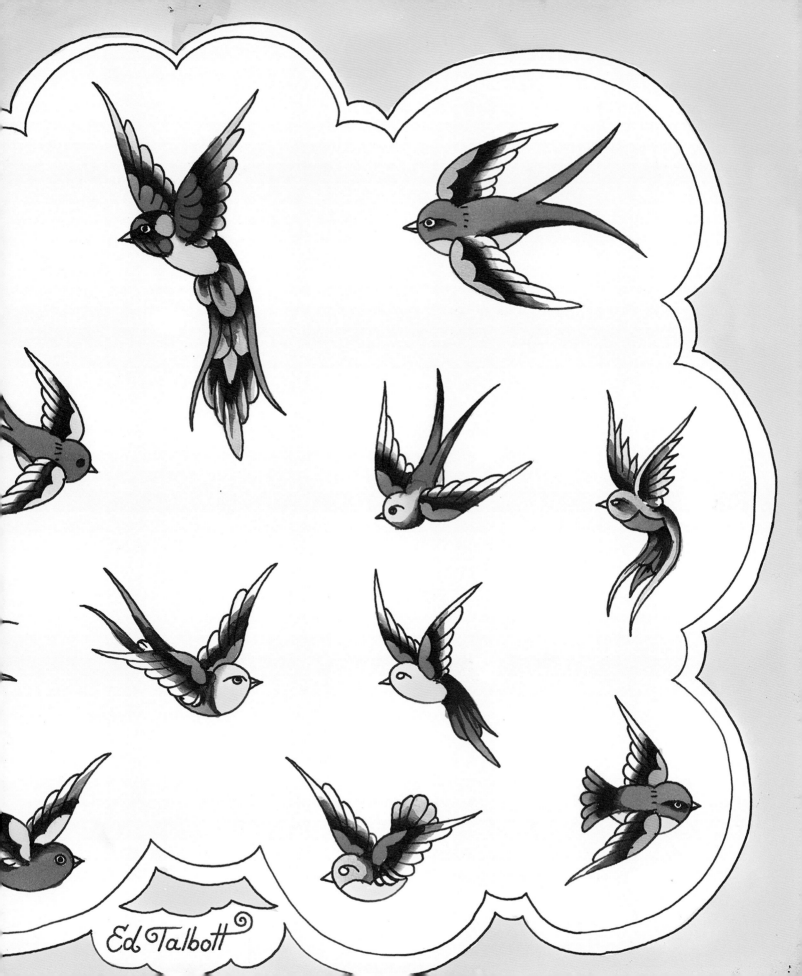

Ed Talbott

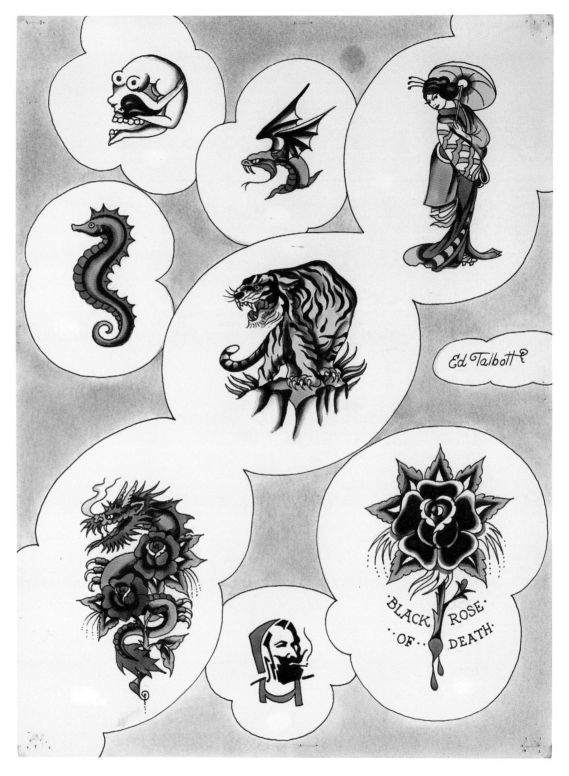

34
Untitled tattoo designs,
1968. Black ink and
watercolor on paper
board, 20 x 15 in.
(50.8 x 38.1 cm)

35 OPPOSITE
Untitled tattoo designs,
ca. 1968. Black ink and
transparent and
opaque watercolor on
paper board, 20 x 15 in.
(50.8 x 38.1 cm)

36
Untitled tattoo designs,
125, ca. 1968. Black ink
and watercolor on
paper board, 15 x 20 in.
(38.1 x 50.8 cm)

37 OPPOSITE
Untitled tattoo designs,
1968. Black ink and
transparent and
opaque watercolor on
paper board, 15 x 20 in.
(38.1 x 50.8 cm)

38 ABOVE
Untitled tattoo designs, *K1*, 1968. Black ink and transparent and opaque watercolor on paper board, 15 ¼ x 20 in. (38.7 x 50.8 cm)

39 BELOW
Untitled tattoo designs, *B2, 125*, 1968. Black ink and watercolor on paper board, 15 x 20 in. (38.1 x 50.8 cm)

40 OPPOSITE ABOVE
Untitled tattoo designs, *96, Designs from Sailor Jerry*, n.d. Black ink and transparent and opaque watercolor on paper board, 15 x 20 in. (38.1 x 50.8 cm)

41 OPPOSITE BELOW
Untitled tattoo designs, *I20*, 1970. Black ink and transparent and opaque watercolor over graphite on paper board, 12 x 15 in. (30.5 x 38.1 cm)

82

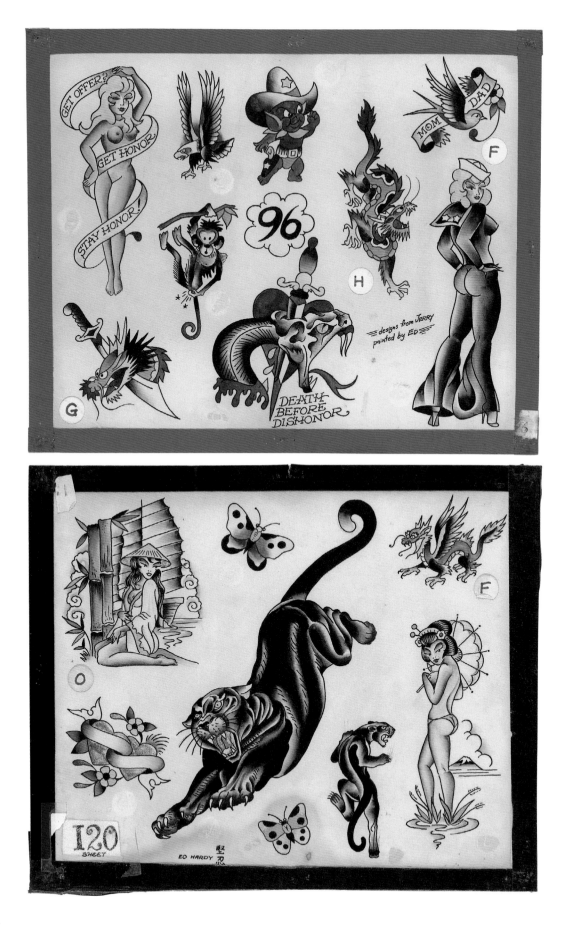

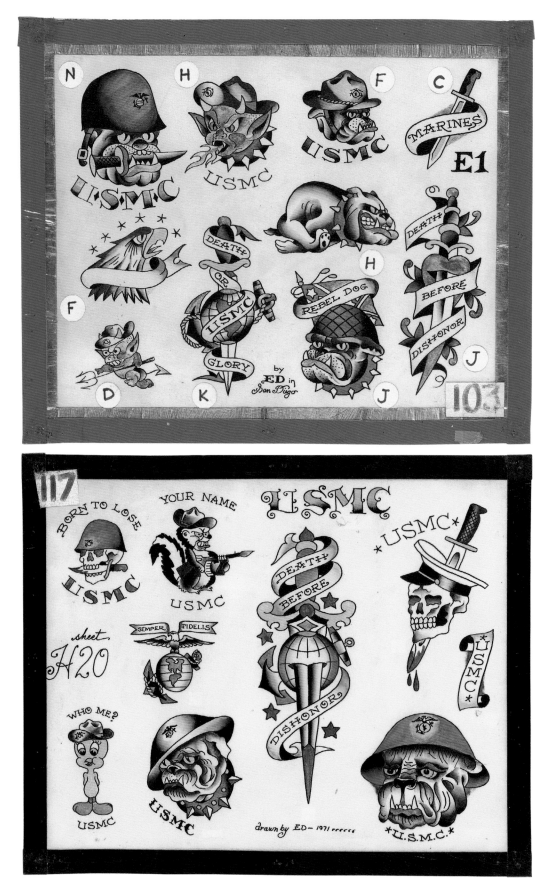

42 ABOVE
Untitled tattoo designs,
E1, 103, 1970. Black ink
and transparent and
opaque watercolor on
paper board, 12 x 15 in.
(30.5 x 38.1 cm)

43 BELOW
Untitled tattoo designs,
Sheet H20, 117, 1971.
Black ink and
watercolor on paper
board, 12 x 15 in. (30.5 x
38.1 cm)

44 OPPOSITE ABOVE
Untitled tattoo designs,
F20, 46, 1971. Black ink
and watercolor on
paper board, 12 x 15 in.
(30.5 x 38.1 cm)

45 OPPOSITE BELOW
Untitled tattoo designs,
N1, 107, ca. 1970.
Black ink and
watercolor on paper
board, 12 x 15 in. (30.5 x
38.1 cm)

84

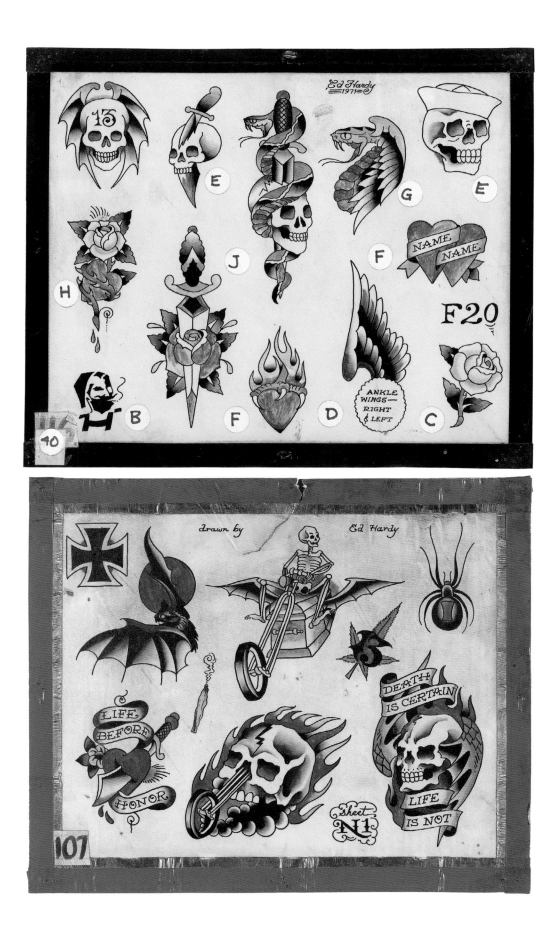

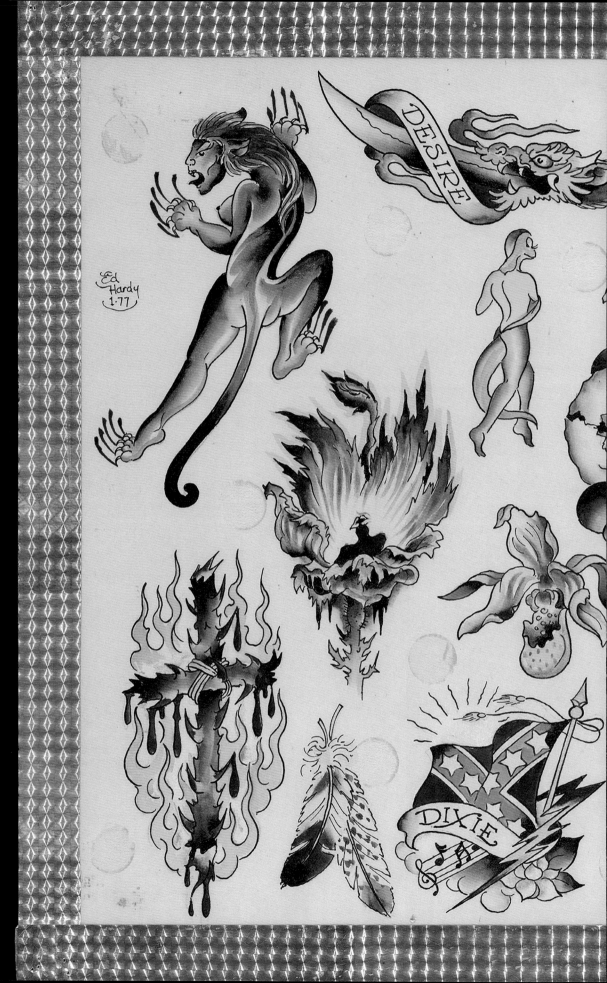

46
Untitled tattoo designs,
27, 1977. Black ink and
transparent and
opaque watercolor on
paper board, 15 x 20 in.
(38.1 x 50.8 cm)

86

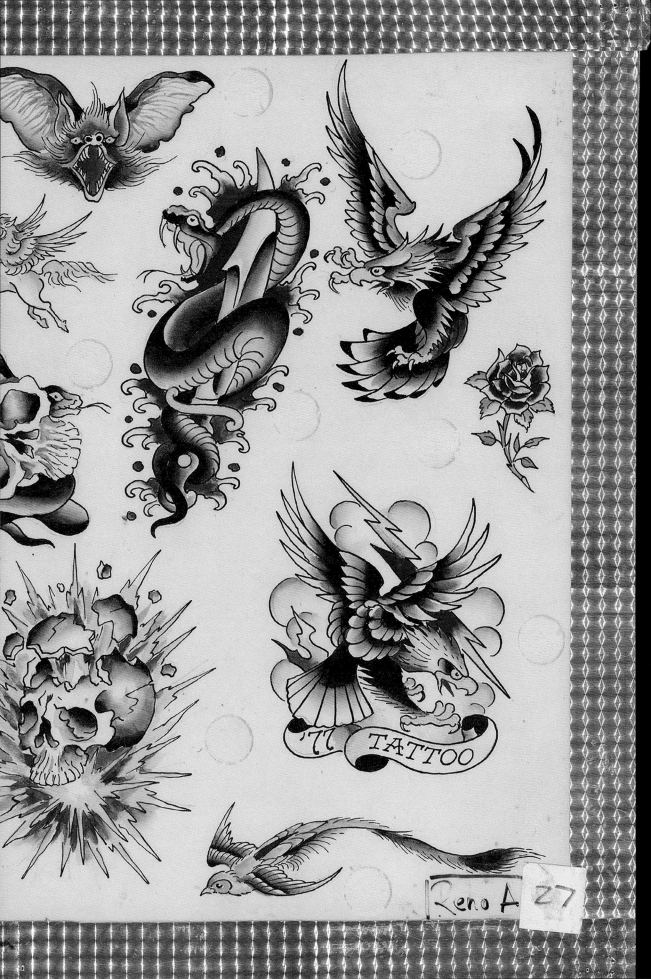

'77 TATTOO

Reno A 27

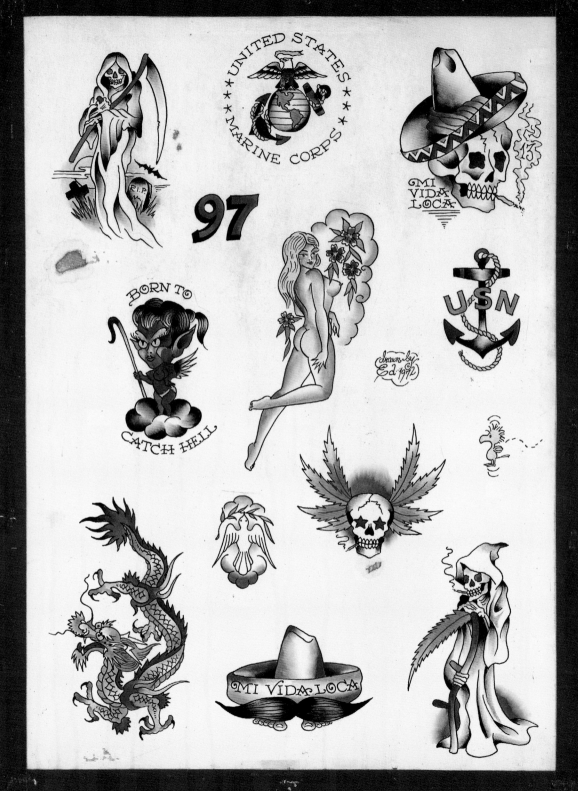

47
Untitled tattoo designs,
97, 1972. Black ink and
watercolor on paper
board, 20 x 15 in.
(50.8 x 38.1 cm)

48 OPPOSITE
Untitled tattoo designs,
75, 1973. Black ink and
opaque watercolor on
paper board, 20 x 15 in.

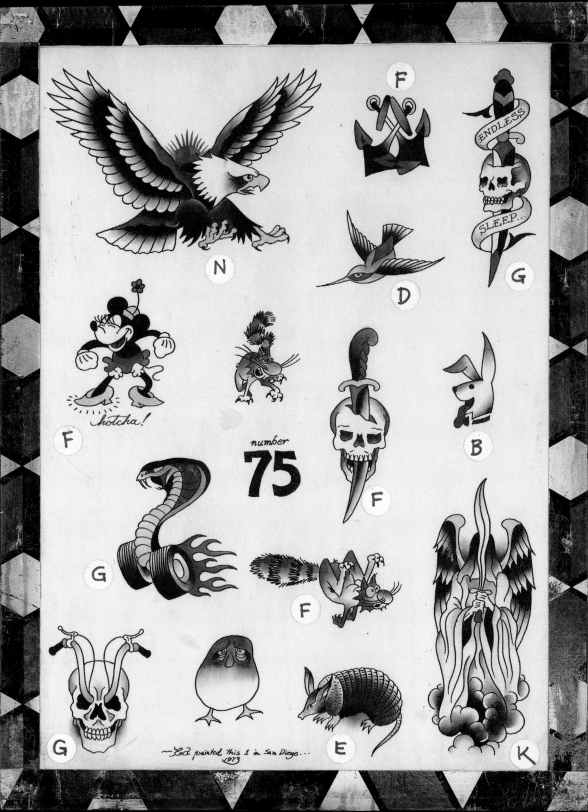

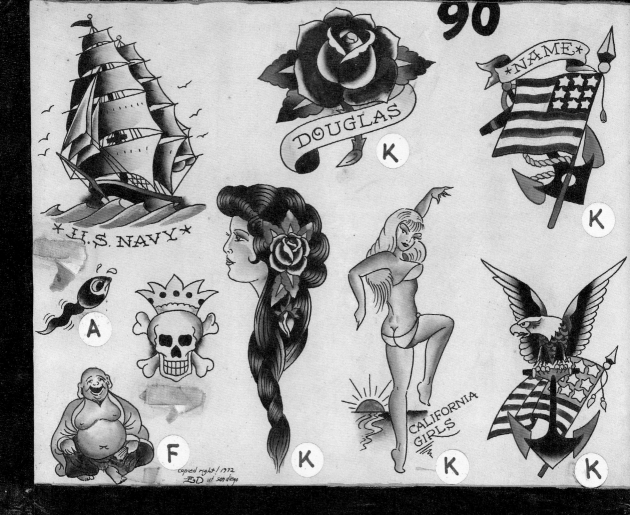

49
Untitled tattoo designs,
90, 1972. Black ink and
watercolor on paper
board, 12 x 15 in. (30.5 x
38.1 cm)

50 OPPOSITE
Untitled tattoo designs,
91, 1972. Black ink and
watercolor on paper
board, 15 x 20 in. (38.1 x

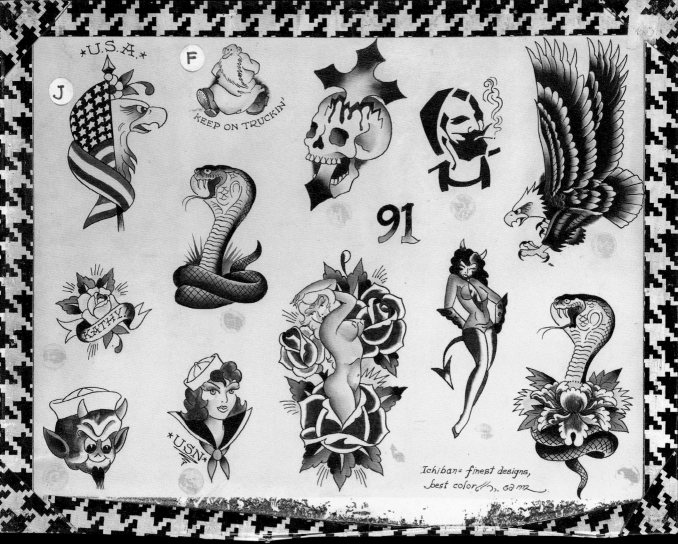

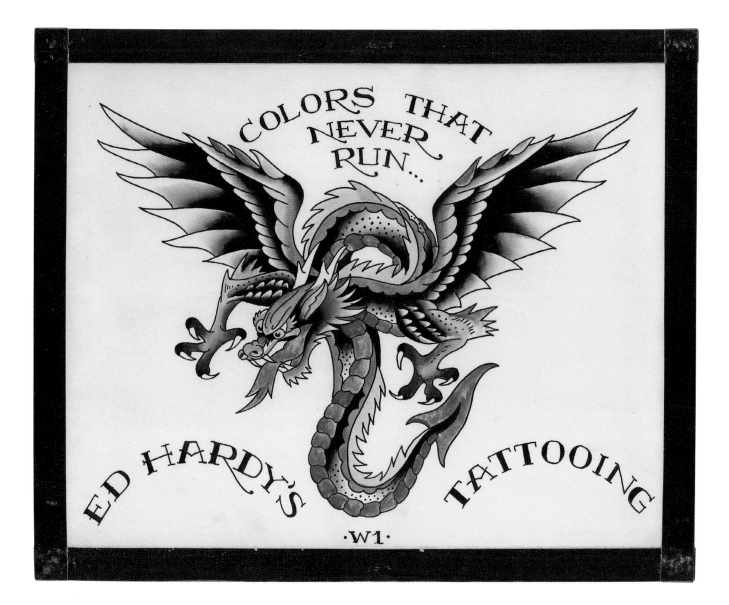

51
*Colors that Never
Run, W1*, n.d. Black ink
and watercolor on
paper board, 12 x 15 in.
(30.5 x 38.1 cm)

52 OPPOSITE
Making It, 1969. Black
ink and watercolor on
illustration board, 20 x
15 in. (50.8 x 38.1 cm)

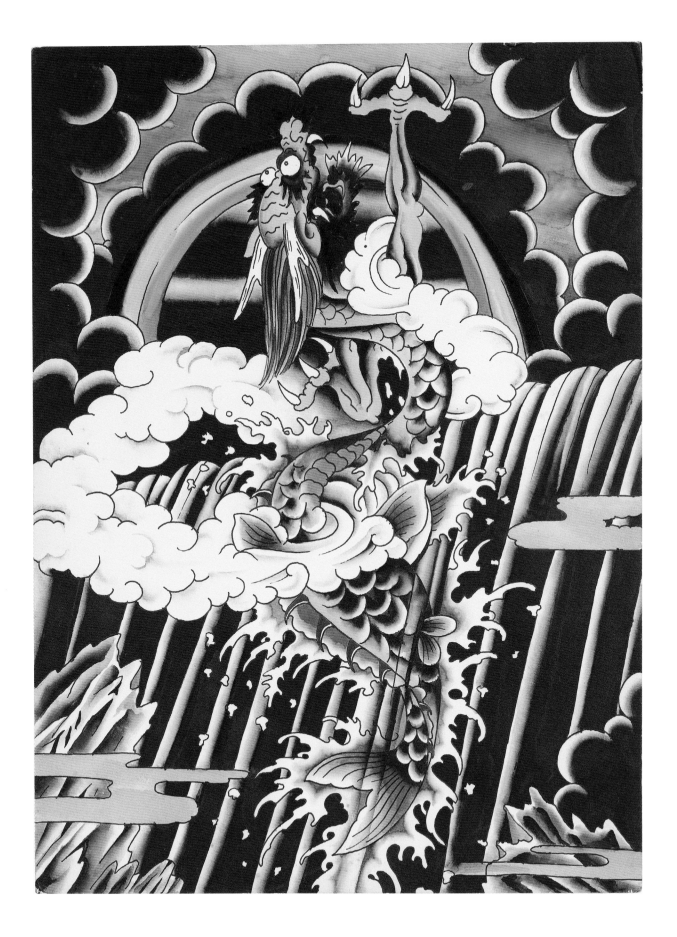

53
Untitled
(Japanese-style tattoo
design for right
pectoral to elbow),
1973. Black ink and
watercolor on paper,
14 ¾ x 11 ½ in. (37.5 x
29.2 cm)

54 OPPOSITE
Cold Sunlight
(Japanese-style tattoo
design for left pectoral
to elbow), 1973. Black

"My clients at Realistic [Tattoo Studio] came from the peripheries of society— Hells Angels, hippie visionaries— and the whole practice of tattoos oozed from there into the mainstream culture over the next twenty years."

Wear Your Dreams

4

Hardy's decision

TO OPEN REALISTIC TATTOO STUDIO, a private San Francisco studio, in 1974, was based on his experience in Japan, where appointment-only tattooing was the norm. However, unlike his Japanese counterparts, Hardy was interested in working with clients to produce one-of-a-kind tattoos. The business's slogan was "Wear your dreams." Hardy's concept was slow to catch on with customers, and his early commissions were predominantly from fellow professional tattooers who wanted unique work or new concepts to take back to their shops in other parts of the world. Much of his work consisted of large, ambitious body pieces that involved a considerable amount of consultation and drawing. Over time Hardy developed a varied clientele that included members of rock bands, Hells Angels (although he refused to do gang-related tattoos), actors and filmmakers, doctors and businessmen, and a number of women (who received tattoos less frequently than men at that time). While many of his clients preferred designs featuring Asian-style dragons and deities, others wanted tattoos that referenced their aspirations, occupations, or home locales. His designs from this time included a toreador and bull for a female bullfighter (pls. 65–67); a typewriter for a writer; and Joan of Arc, the Maid of Orleans, for a New Orleans resident (pl. 80).

The drawings that Hardy prepared on tracing paper for clients are tour de force tattoo designs, highly finished and colorful drawings that interestingly utilize the same media (black ink and colored pencils) that he used to create his childhood tattoo flash (fig. 17; pls. 55, 58, 59, 61, 64–66, 68, 70–83). Although he does not consider these pieces finished artworks, he replicated some particularly striking designs as finished drawings on sturdy illustration board and used them for shop decoration.

55
Snake Shaman
(tattoo design for
man's back and
buttocks), 1991. Black
ink, porous-point pen,
colored pencil, and
watercolor, with
corrections by artist in
white correction fluid
on tracing paper, 30 x
19 in. (76.2 x 48.3 cm)

56 OPPOSITE
Tattoo on man's back
and buttocks, 1992

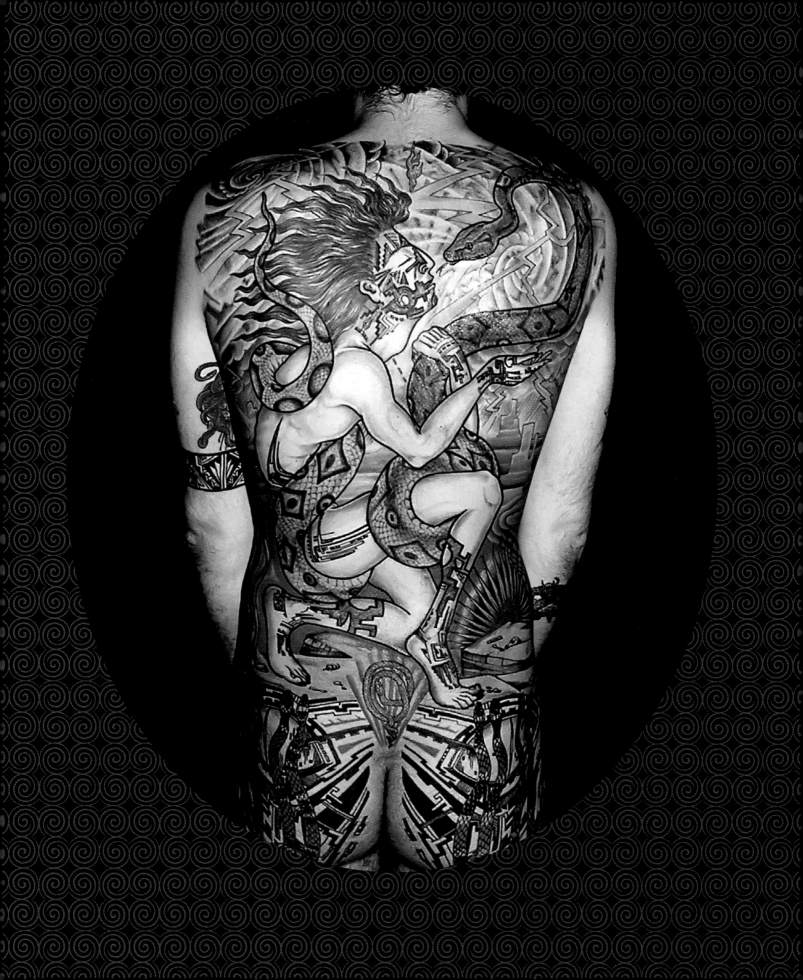

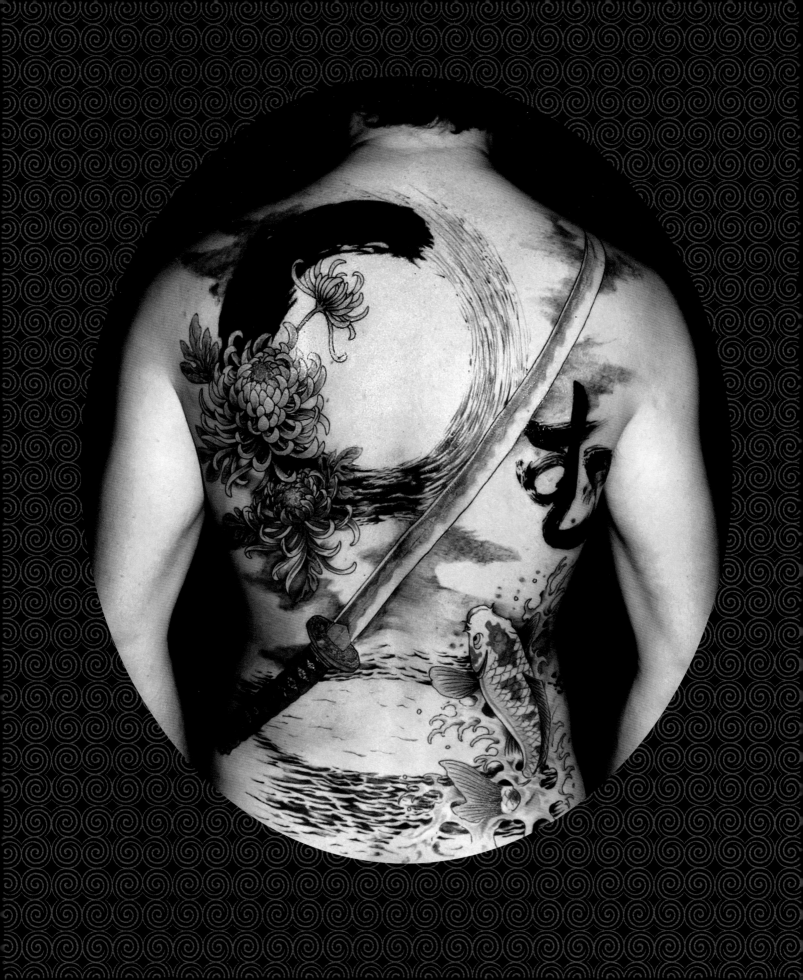

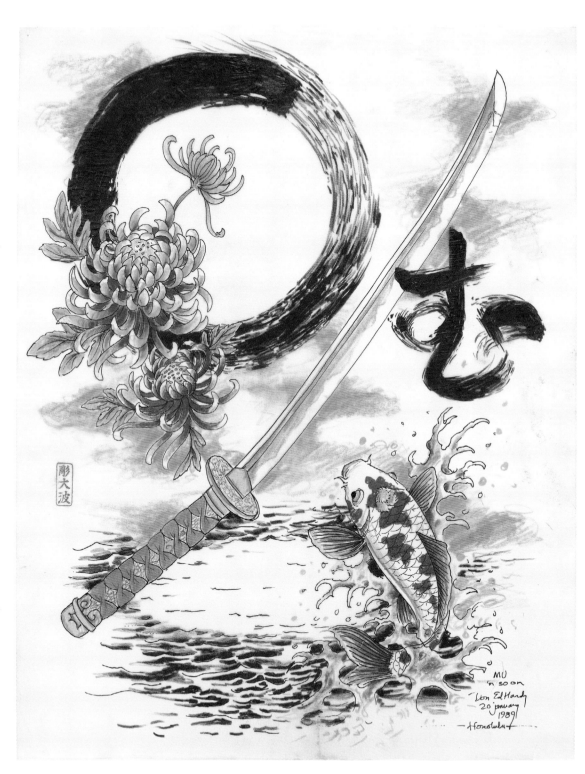

彫大波

MU
'n so on
Don Ed Hardy
20 january
1989
Honolulu

57 OPPOSITE
Tattoo on man's back,
1991

58
Zen Back (tattoo
design for man's back),
1989. Black ink, colored
pencil, and graphite on
tracing paper, 24 x 19 in.
(61 x 48.3 cm)

101

*rough draft — Kraken
for John Lemes
august 1974.*

59
*Rough Draft—
Kraken for John
Lemes (Giant squid)*,
1974. Black ink and
watercolor on paper
board, 11 x 14 in. (27.9 x
35.6 cm)

60 OPPOSITE
Tattoo on man's back,
buttocks, and legs,
1974–1976

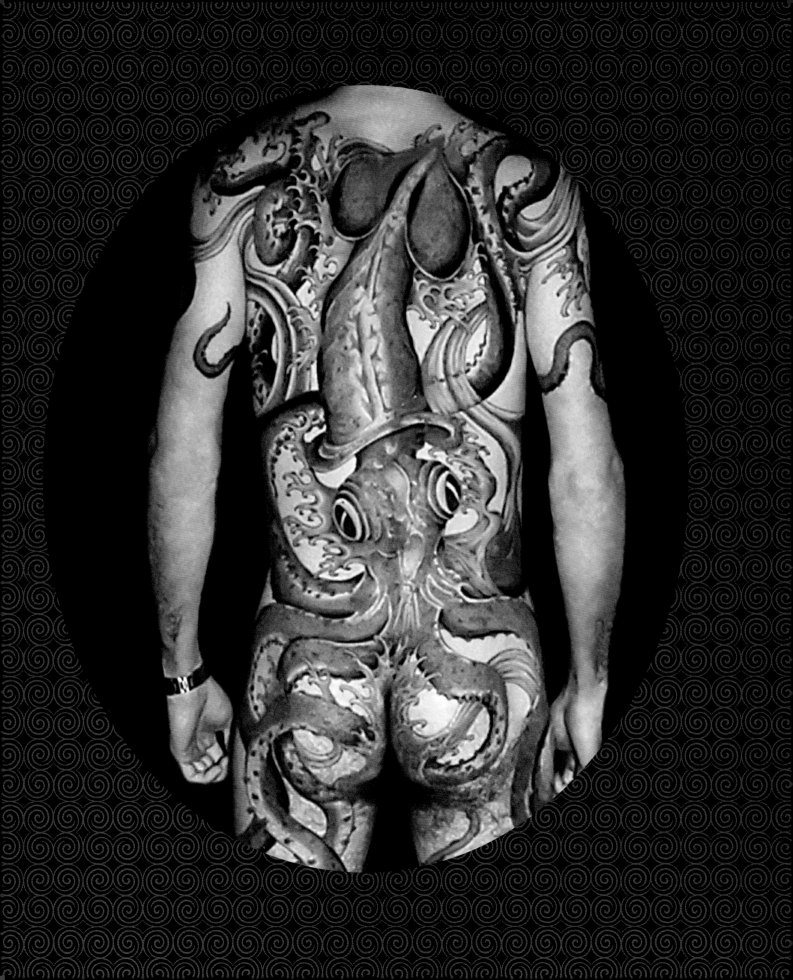

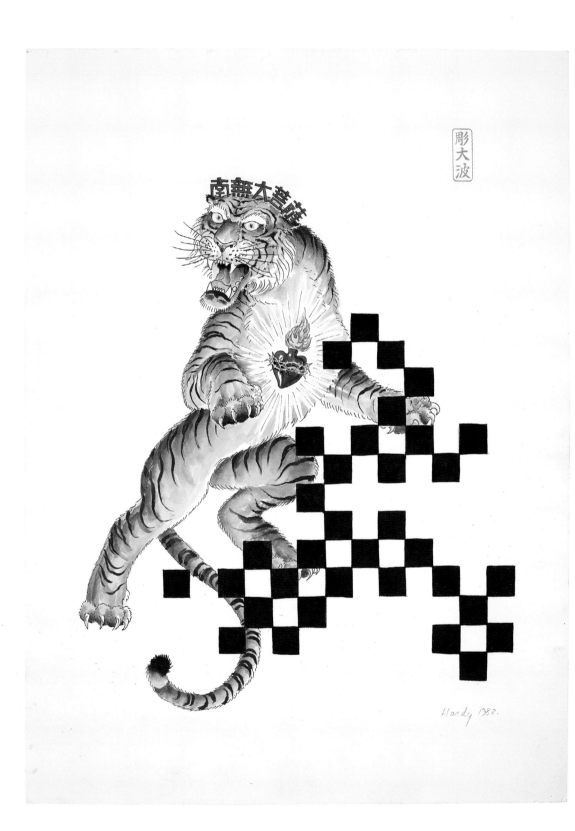

61
Untitled (Tiger with sacred heart), 1983.
Black ink and transparent and opaque watercolor on paper board, 20 ⅛ x 15 in. (51.1 x 38.1 cm)

62 OPPOSITE
Tattoo on woman's back, 1983

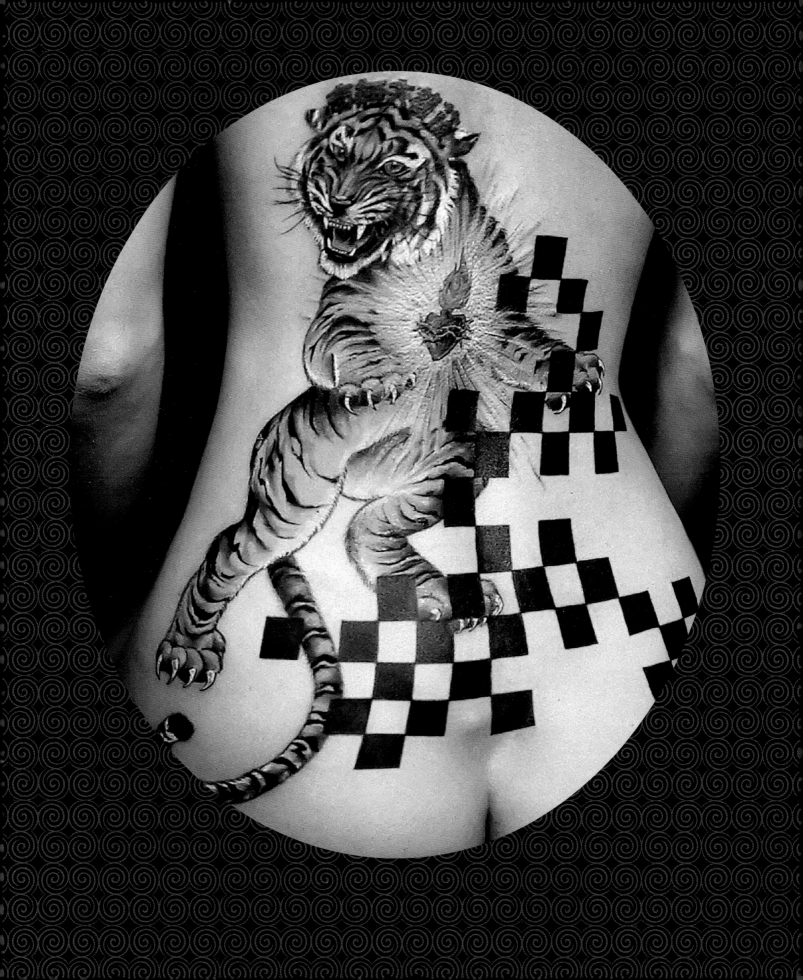

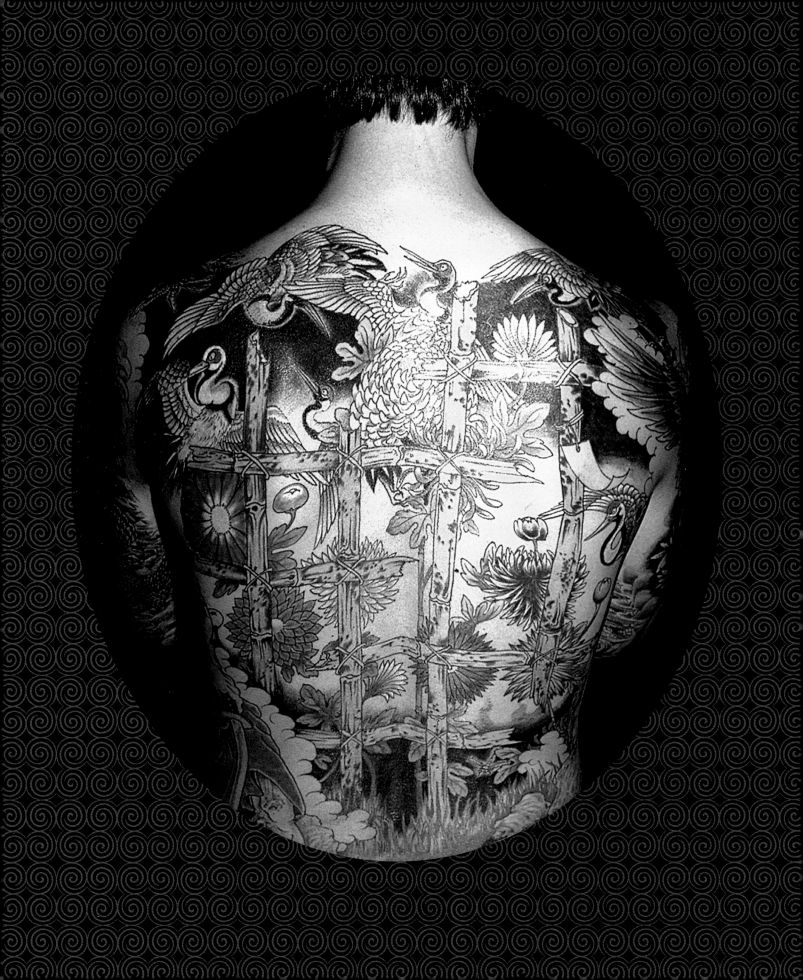

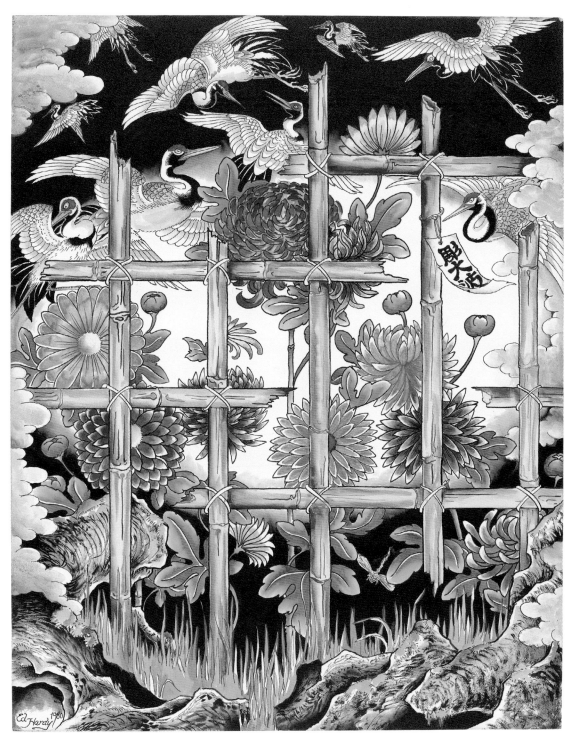

63 OPPOSITE
Tattoo on man's back,
1980

64
*Untitled (Bamboo
lattice with cranes and
chrysanthemums)*,
1980. Black ink and
transparent and opaque
watercolor on paper
board, 20 ⅛ x 16 in. (51.1 x
40.6 cm)

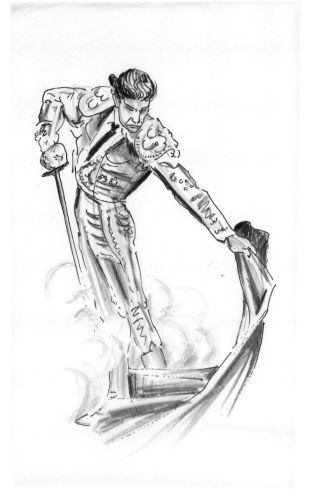

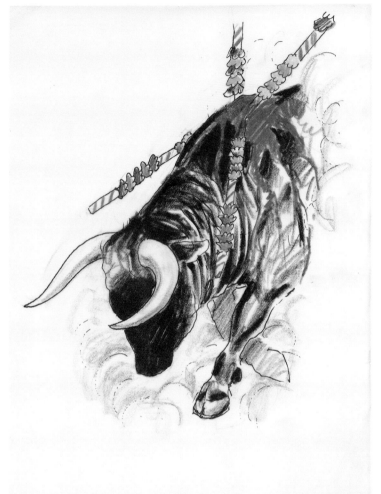

65 LEFT
***Bullfighter (for
Bella's rib)***, ca. 1980.
Black ink and colored
pencil on tracing paper,
14 x 8 ½ in. (35.6 x
21.6 cm)

66 RIGHT
Bull (for Bella's rib),
ca. 1980. Black ink and
colored pencil on
tracing paper, 12 x 9 in.
(30.5 x 22.9 cm)

67 OPPOSITE
Tattoo on woman's
right and left ribs, 1987

108

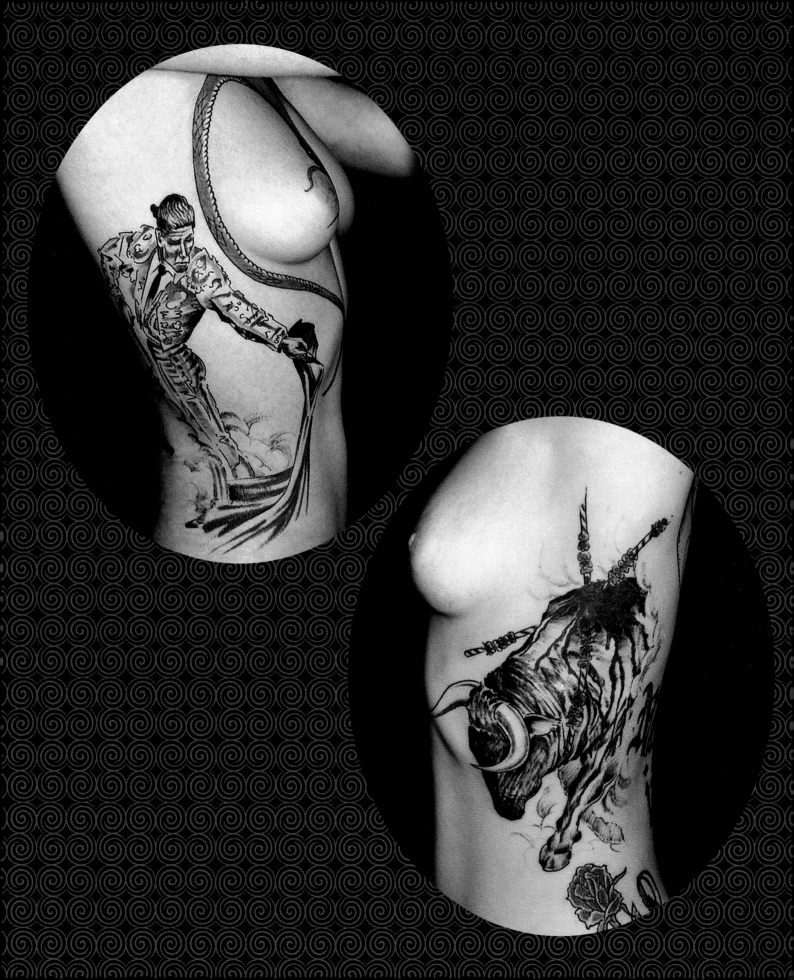

Hardy 10/88

70
Film Crazy (tattoo design), 1996. Black ink and colored pencil on tracing paper, 22 ⅝ x 14 in. (57.5 x 35.6 cm)

71 OPPOSITE
Untitled (Phoenix) (tattoo design for chest, front rib, and upper leg), 1985. Black ink, colored pencil, and graphite on tracing paper, 35 ⅛ x 19 in. (89.2 x 48.3 cm)

72
Untitled (Dragon)
(tattoo design for back
and buttocks), 1971.
Colored pencil,
porous-point pen, and
acrylic on tracing
paper, 42 ½ x 23 ½ in.
(108 x 59.7 cm)

73 OPPOSITE
*Tamatori-hime
(Princess Tamatori)*
(tattoo design for arm
or leg wrap), 1986.
Black ink, colored
pencil, and graphite on
tracing paper, 17 x 14 in.
(43.2 x 35.6 cm)

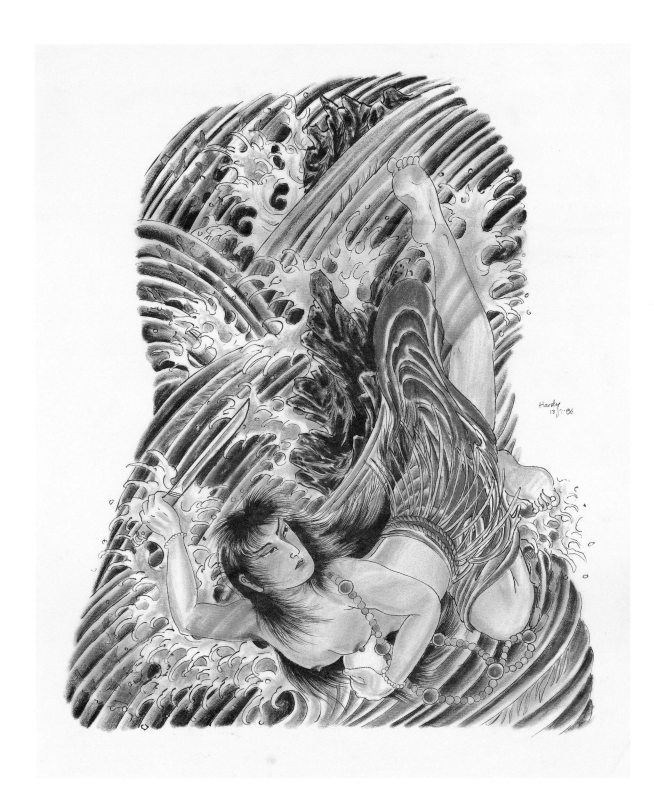

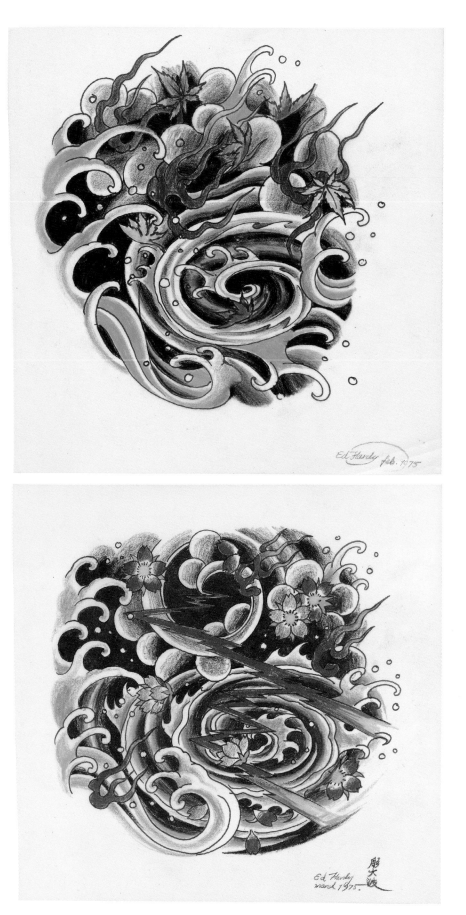

74 ABOVE
Cherry Blossoms/
Waves (tattoo design
for left buttock), 1975.
Black ink and colored
pencil on paper, 11 x
11 in. (27.9 x 27.9 cm)

75 BELOW
Maples/Whirlwinds/
Fire (tattoo design for
right buttock), 1975.
Black ink and colored
pencil on paper, 11 x
11 ¾ in. (27.9 x 29.8 cm)

76 OPPOSITE
Untitled (Swimming
koi) (tattoo design for
full chest), n.d. Colored
pencil on tracing paper,
38 x 24 in. (96.5 x 61 cm)

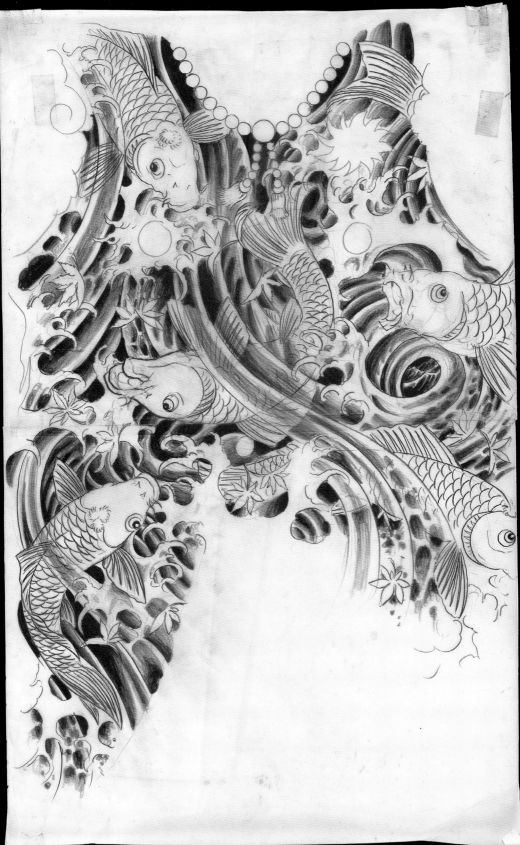

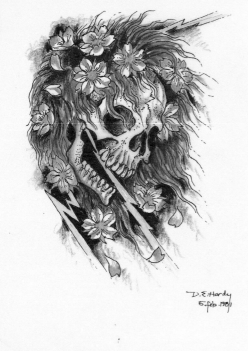

77 LEFT
Redhead (tattoo design for right pectoral), 1981. Black ink and colored pencil on tracing paper, 12 x 9 in. (30.5 x 22.9 cm)

78 RIGHT
Untitled (Skull with skin patch) (tattoo design for left pectoral), 1990. Black ink and colored pencil on tracing paper, 9 x 12 in. (22.9 x 30.5 cm)

79 OPPOSITE
Belly Protector (tattoo design for abdomen), 1980. Colored pencil and porous-point pen on tracing paper, 14 x 17 in. (35.6 x 43.2 cm)

"In the Belly of the Beast"

The Maid of Orleans
30 may 1431
for Mollis Fletcher of
New Orleans 1 may 1982

D.E. Hardy

80 OPPOSITE
The Maid of Orleans
(tattoo design for shin
to top of foot), 1982.
Black ink and colored
pencil on tracing paper,
19 x 12 in. (48.3 x
30.5 cm)

81
Rocket Girl (tattoo
design for rib), 1991.
Black ink and colored
pencil on tracing paper,
32 x 14 in. (81.3 x
35.6 cm)

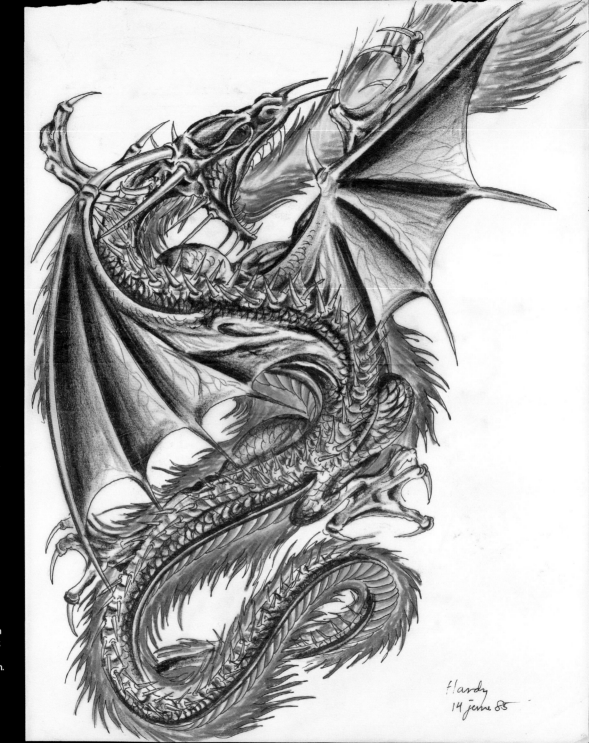

82
Black Western Dragon (tattoo design for rib), 1985. Black ink and colored pencil on tracing paper, 14 x 11 in. (35.6 x 27.9 cm)

83 OPPOSITE
Magician and Dragon (after Hokusai) (tattoo

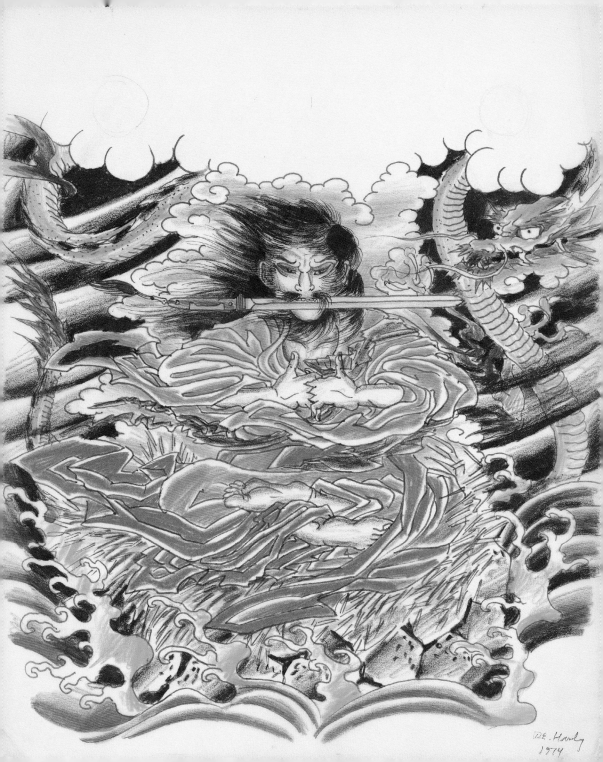

"I thought I shouldn't touch tattoos in my artwork, that it would undermine some kind of legitimacy or purity that I stupidly felt. But this imagery that I have been drawing since I was ten years old was part of my artistic DNA. Once I understood that, I knew I could make art with anything."

Themes and Variations

By the mid-1980s,

REALISTIC TATTOO STUDIO and Hardy's other tattoo enterprises were successful enough that he could take some time to reconnect with his personal art. After experiencing some uncertainty about how to begin (and determined to avoid tattoo-related imagery), he decided that the visual language of tattooing was so ingrained in his consciousness that it could serve as a starting point for compositions in the watercolors, acrylic paintings, and eventually prints that he wanted to create. However, thousands of hours of doing prepared drawings for custom tattoos and the laborious work techniques inherent in using tattoo machines left him hungry for spontaneity, so he adopted a looser style of execution. Hardy also reconnected with Western art history, taking particular interest in Northern European medieval art and its themes and combining them with Asian motifs to create a unique visual vocabulary. Throughout the 1990s he exhibited in galleries across the United States and also co-curated exhibitions that showcased tattooing. A return to printmaking in 1995 at Black Cat Press, in Chicago (fig. 41; pl. 87); Shark's Ink, in Boulder and now Lyons, Colorado (figs. 14, 43; pls. 96, 98); and Paul Mullowney's Kurumaki Studio, in Nara, Japan (figs. 44, 45; pl. 106), resulted in some of his most exuberant and colorful images of the decade.

The range of Hardy's art in the 1990s, whether in painting, drawing, printmaking, or three-dimensional work, reveals themes and motifs rooted in traditional American tattoo flash: skulls and skeletons, tigers, red devils (after the comic book character Hot Stuff), ships and rocks, the "butterfly woman," and the World War I nurse dubbed Rose of No Man's Land. These classic subjects sometimes appear in Hardy's Asian-inspired treatments and also in gothic tableaus such as *Hides* (pls. 113, 114). In this series of paintings on handmade paper, skeletons with halos function as memento mori, forming surrealistic combinations with quasi-abstracted elements from Hardy's visual memory, such as the lines that reference the stiff drapery folds he had observed in medieval prints.

@@@

Butterfly
Woman

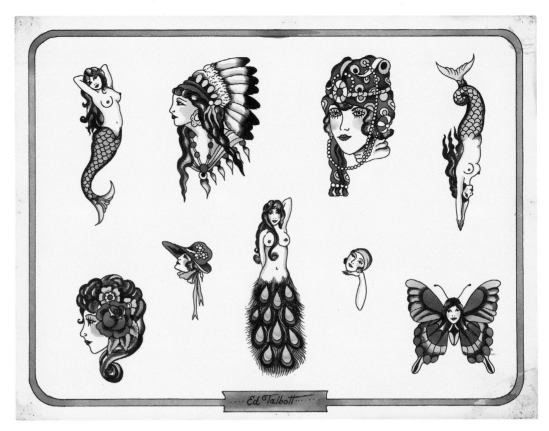

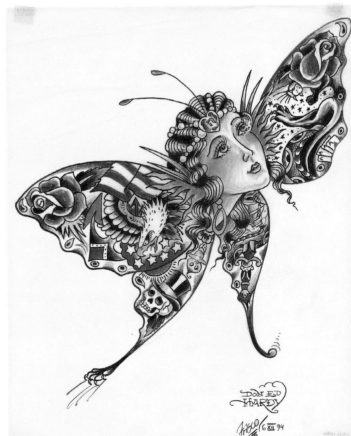

84 ABOVE
Untitled tattoo designs,
1968. Black ink and
watercolor on paper
board, 15 x 20 in. (38.1 x
50.8 cm)

85 BELOW
*Untitled (Butterfly
lady)* (tattoo design for
upper back and
shoulder), 1994. Black
ink and colored pencil
on tracing paper, 17 x
14 in. (43.2 x 35.6 cm)

86 OPPOSITE
Tattoo on woman's
upper back and upper
shoulder, 1995

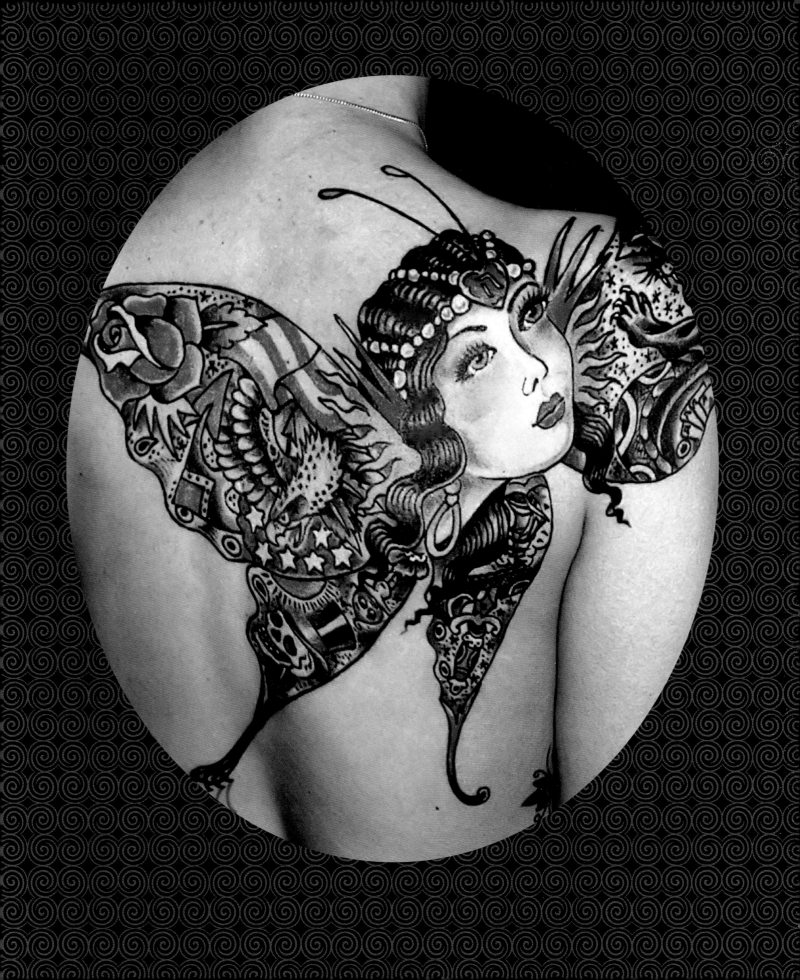

Lupe's Feast D.E. Hardy '92

37
Lupe's Feast, 1992.
Etching, plate: 8 x
9 ⅞ in. (20.3 x 25.1 cm)
FINE ARTS MUSEUMS OF
SAN FRANCISCO, GIFT OF
THE ARTIST, 2017.46.62

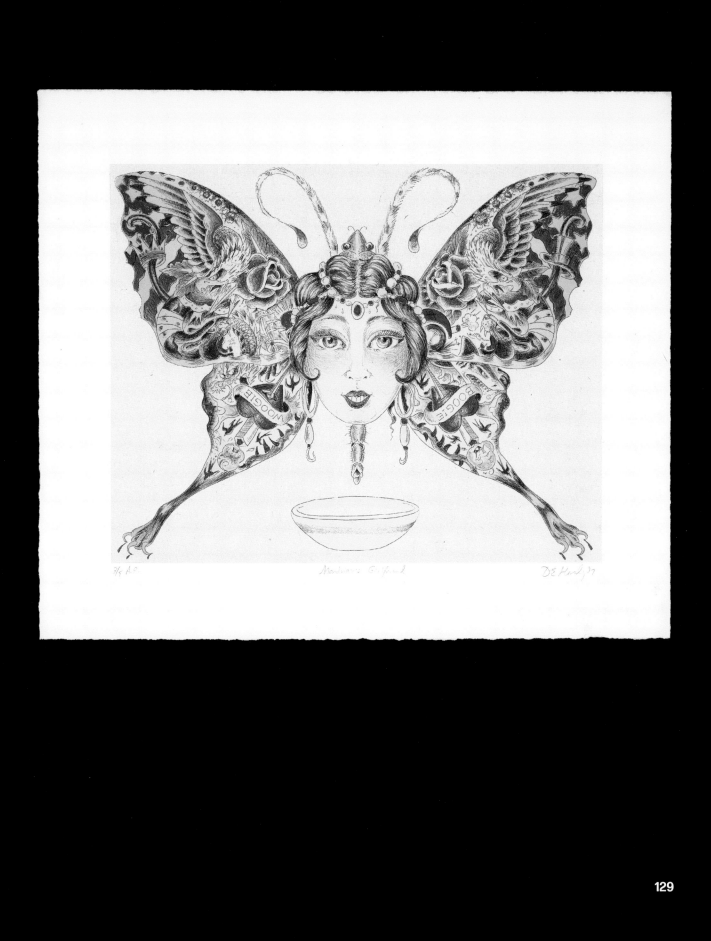

Rose of
No Man's
Land

89
Untitled tattoo designs, 1967. Black ink and watercolor on paper board, 15 x 20 in. (38.1 x 50.8 cm)

90 OPPOSITE ABOVE
Untitled (Rose of No Man's Land and cutting-skin dagger) (tattoo design for lower leg/calf), 1991. Graphite on tracing paper, 17 x 14 in. (43.2 x 35.6 cm)

91 OPPOSITE BELOW
Untitled (Rose of No Man's Land and cutting-skin dagger) (tattoo design for lower leg/calf), 1991. Black ink and colored pencil on tracing paper, 17 x 14 in. (43.2 x 35.6 cm)

92 OPPOSITE RIGHT
Tattoo on man's lower leg/calf, 1991

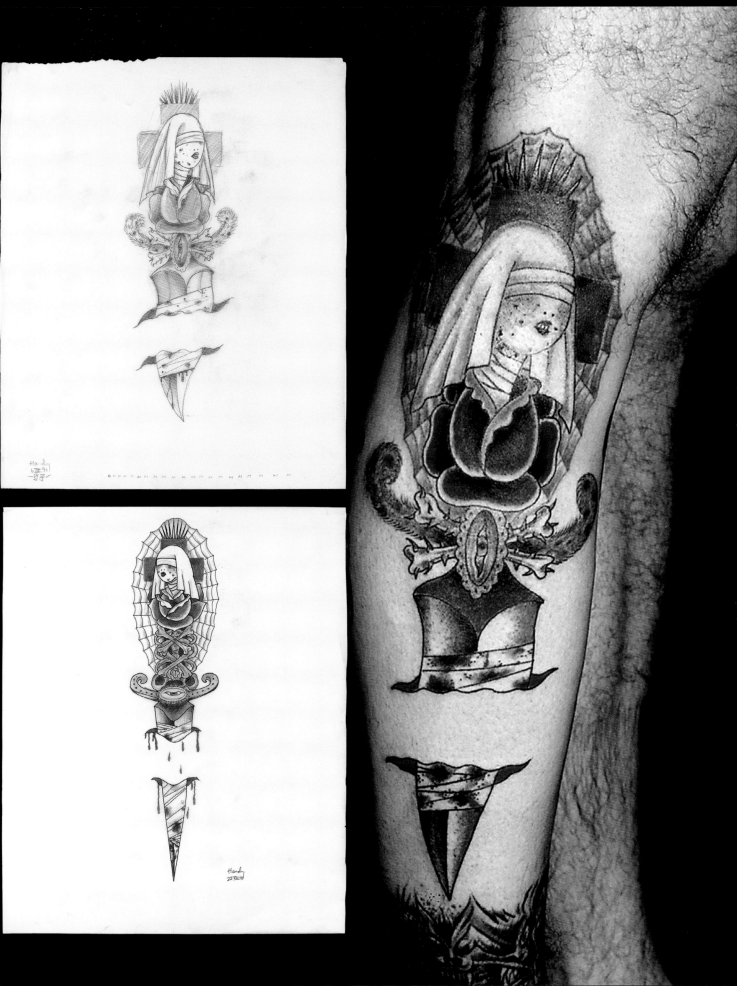

93
Forgive, 1995.
Acrylic on canvas,
47 ½ x 46 ⅜ in. (120.7 x
117.8 cm)

94 OPPOSITE
Forget, Hell!, 1995.
Acrylic on canvas,
46 ⅛ x 47 ¾ in. (117.2 x
121.3 cm)

133

95
Rose of No Man's Land, 2006–2008. Hand-painted porcelain vase, height: 12 in. (30.5 cm); diameter: 4 ¾ in. (12.1 cm)

96 OPPOSITE
Nurse Mercy, 1995. Color lithograph, sheet: 30 x 22 ⅝ in. (76.2 x 57.5 cm)
FINE ARTS MUSEUMS OF SAN FRANCISCO, GIFT OF THE ARTIST, 2017.46.118

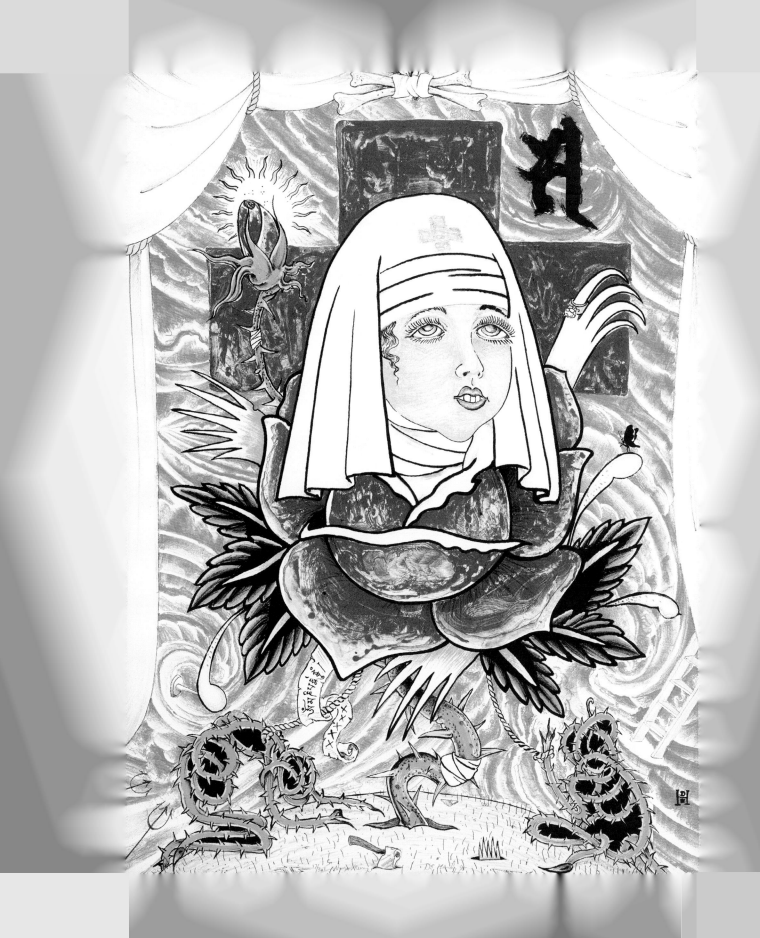

Devils

97
Untitled tattoo designs, *109*, 1969. Black ink and transparent and opaque watercolor on paper board, 15 x 12 in. (38.1 x 30.5 cm)

98 OPPOSITE
Prince Buster, 1995. Color lithograph, sheet: 30 x 22 ⅝ in. (76.2 x 57.5 cm)

FINE ARTS MUSEUMS OF SAN FRANCISCO, GIFT OF THE ARTIST, 2017.46.119

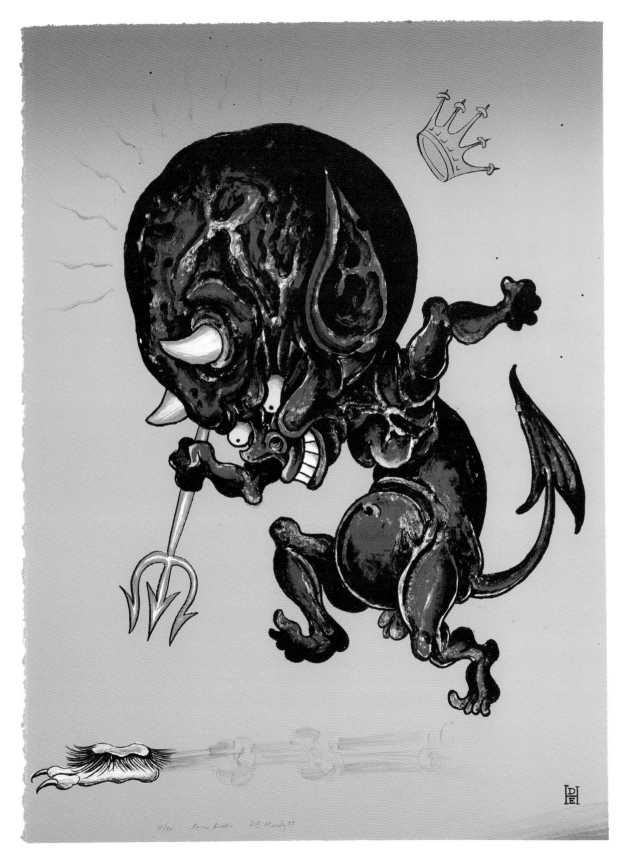

99
Faughan, 1996. Black ink and acrylic on handmade red paper, 13 ⅛ x 9 ¾ in. (33.3 x 24.8 cm)

100 OPPOSITE
Surf or Die, 2004. Color lithograph with metallic gold powder, sheet: 30 ⅜ x 22 ½ in. (77.2 x 57.2 cm)
FINE ARTS MUSEUMS OF SAN FRANCISCO, GIFT OF THE ARTIST, 2017.46.132

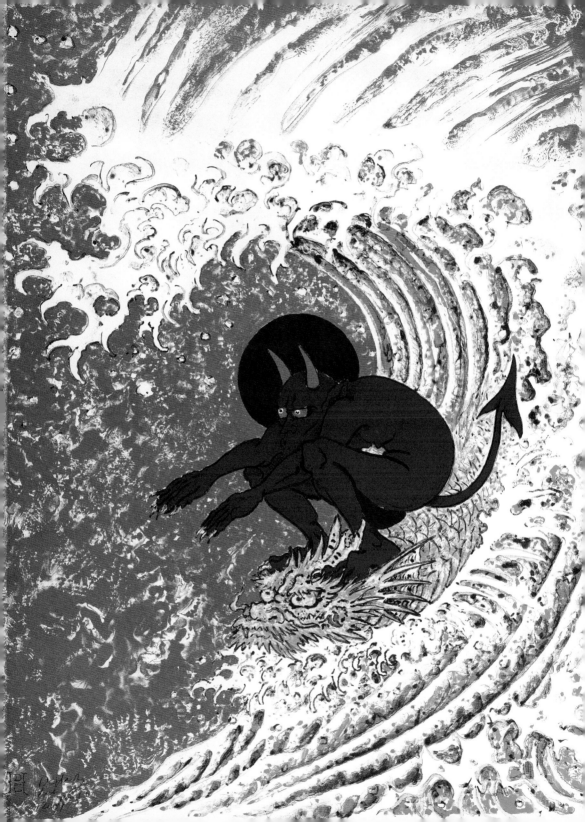

101
History Surfer, 2007.
Oil paint, digital print,
and resin on panel,
62 x 26 x 2 in. (157.5 x
66 x 5.1 cm)

102 OPPOSITE
Red Demon Eyeball,
2007–2008.
Hand-painted porcelain
vase, height: 12 ½ in.
(31.8 cm); diameter:
6 ½ in. (16.5 cm)

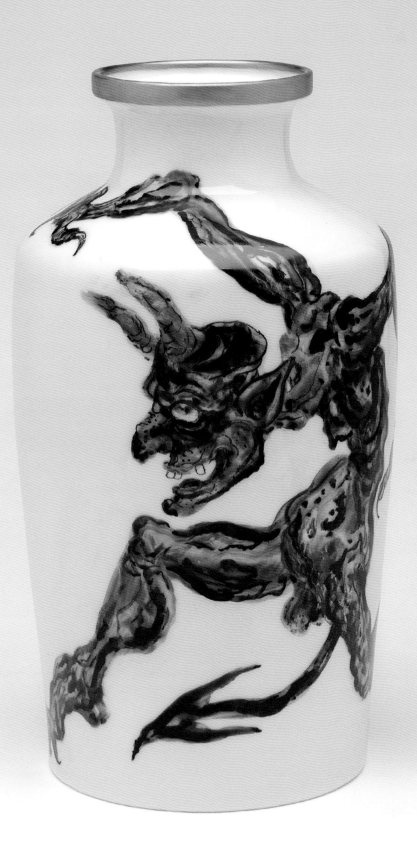

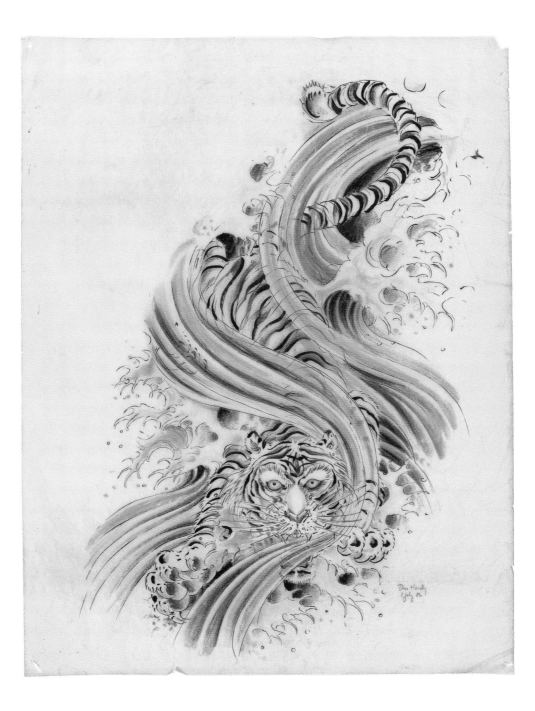

103 OPPOSITE
Untitled tattoo designs,
B9, 134, 1968. Black
ink and watercolor on
paper board, 13 ½ x
18 ½ in. (34.3 x 47 cm)

104
*Untitled (Tiger in
waterfall)* (tattoo
design for chest and
ribs), 1986. Black ink
and colored pencil on
tracing paper, 24 x
19 in. (61 x 48.3 cm)

105
Untitled (Tiger in a waterfall) (tattoo design), n.d. Black ink and colored pencil on tracing paper, 12 x 9 in. (30.5 x 22.9 cm)

106 OPPOSITE
Sacred Tiger Ascending, from the set *The Mysterious East*, 1995. Color etching, sugar-lift aquatint, spit-bite aquatint, aquatint, and drypoint, plate: 24 ½ x 19 ½ in. (62.2 x 49.5 cm). Printed by Paul Mullowney

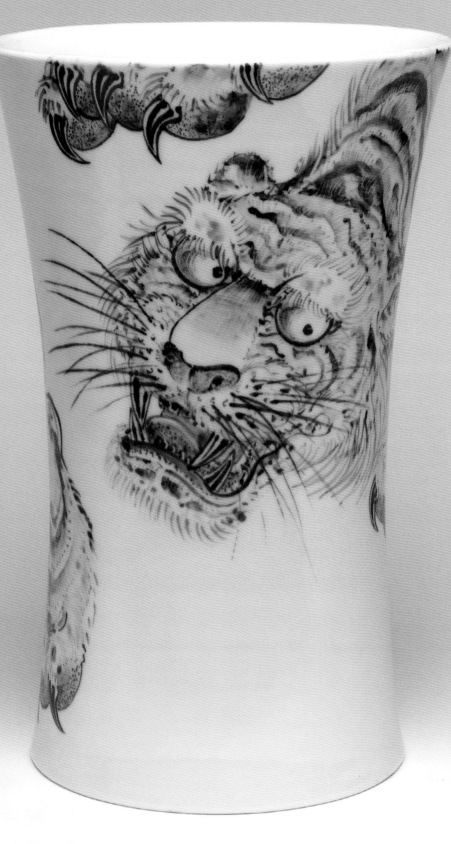

107 OPPOSITE
Red Wind Tiger,
2010. Oil, digital print,
and resin on panel,
58 ¼ x 41 x 2 ¾ in.
(148 x 104.1 x 7 cm)

108
Wild Tiger, 2006.
Hand-painted porcelain
vase, height: 13 ¼ in.
(33.7 cm); diameter:
8 ½ in. (21.6 cm)

109
Climber, 2011. Color
lithograph, sheet:
40 x 26 ¼ in. (101.6 x
66.7 cm)
FINE ARTS MUSEUMS OF
SAN FRANCISCO, GIFT OF
THE ARTIST, 2017.46.141

110 OPPOSITE
Rose, 2015. Jacquard
tapestry, 105 x 70 in.
(266.7 x 177.8 cm)

Skulls and Skeletons

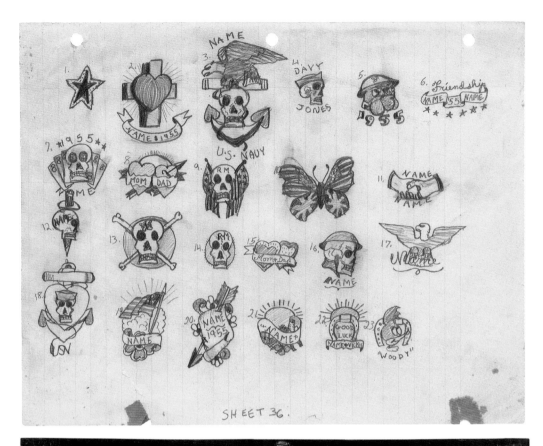

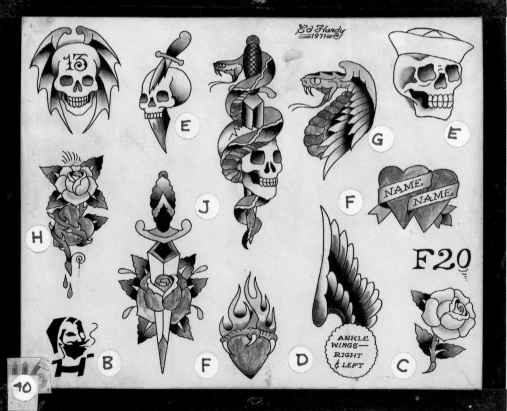

111 ABOVE
Untitled tattoo designs,
36, 1955. Graphite on
ruled paper, 8 ½ x 11 in.
(21.6 x 27.9 cm)

112 BELOW
Untitled tattoo designs,
F20, *46*, 1971. Black ink
and watercolor on
paper board, 12 x 15 in.
(30.5 x 38.1 cm)

113 OPPOSITE ABOVE
*Conversations with
Grampy*, 1996. Acrylic
on *amate* paper,
46 ⅜ x 59 ½ in. (117.8 x
151.1 cm)

114 OPPOSITE BELOW
Let's Go, 1997. Acrylic
on *amate* paper, 29 ¾ x
49 ⅝ in. (75.6 x 126 cm)

115 ABOVE LEFT
Spoiler, 2007. Oil and resin on disk, diameter: 12 in. (30.5 cm)

116 BELOW LEFT
Dead Boy Blues, 2007. Oil and resin on disk, diameter: 12 in. (30.5 cm)

117 ABOVE
Old Tex, 2008, Hand-painted porcelain platter, diameter: 18 in. (45.7 cm)

118 OPPOSITE
Twins, 2007–2008. Oil, digital print, and resin on panel, 41 x 29 in. (104.1 x 73.7 cm)

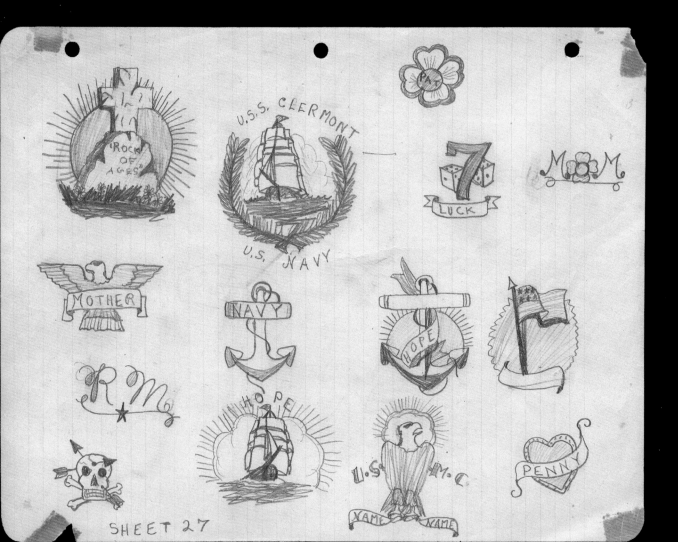

SHEET 27

119 OPPOSITE
Untitled tattoo designs,
Sheet 27, ca. 1955.
Graphite on ruled
paper, 8 ½ x 11 in.
(21.6 x 27.9 cm)

120
Untitled tattoo designs,
90, 1972. Black ink
and watercolor on
illustration board, 10 ½ x
13 ½ in. (26.7 x 34.3 cm)

121 OPPOSITE
Untitled (Rock of Ages) (tattoo design for upper arm), 1988. Graphite on tracing paper, 14 x 11 in. (35.6 x 27.9 cm)

122
Rocko (recto), 2007. Oil, acrylic, digital print, and resin on panel (boogie board), 42 x 22 x 2 ¾ in. (106.7 x 55.9 x 7 cm)

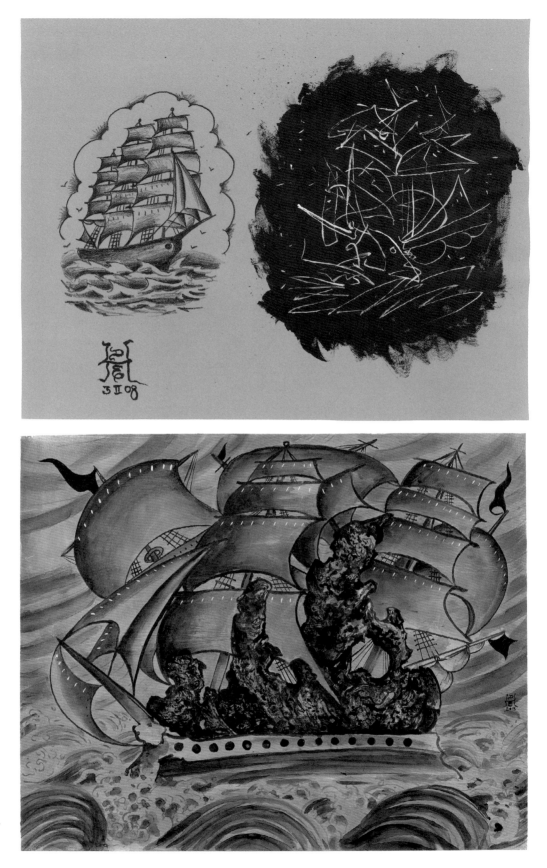

123 ABOVE
The Next World,
2008. Acrylic and
colored pencil on pink
paper, 19 ¾ x 25 ½ in.
(50.2 x 64.8 cm)

124 BELOW
Full Sail, 2013. Acrylic
on paper, 19 x 24 in.
(48.3 x 61 cm)

125 OPPOSITE
Mi Fu's Vacation,
2008. Acrylic on Tyvek,
48 ½ x 36 in. (123.2 x
91.4 cm)

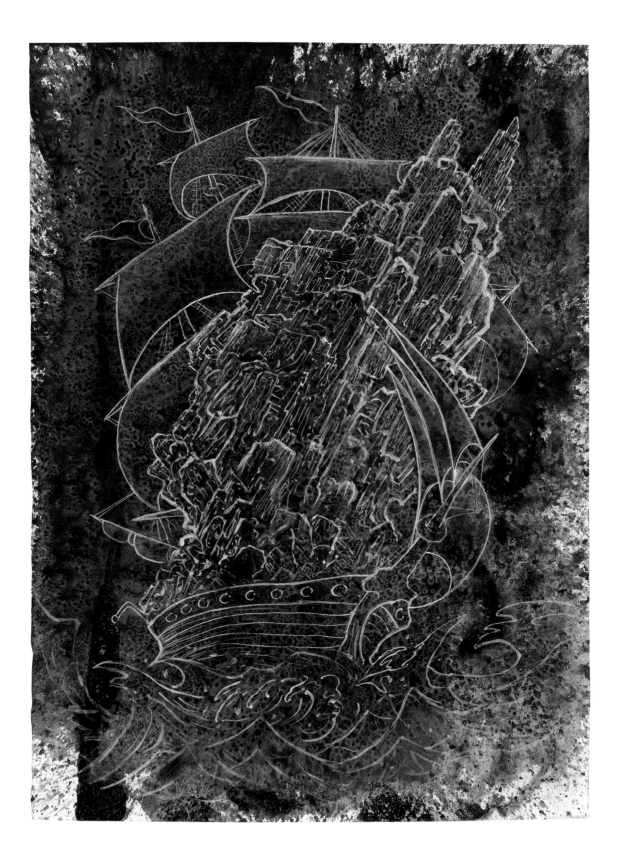

126 LEFT
Deep Six, 2018. Ink
and colored pencil on
black paper, 12 ⅝ x 9 ½
in. (32.1 x 24.1 cm)

127 RIGHT
Splitsville, 2018. Ink
and colored pencil on
black paper, 12 ⅝ x 9 ½
in. (32.1 x 24.1 cm)

128 OPPOSITE
Titan, 2014. Acrylic
on Tyvek, 34 x 25 in.
(86.4 x 63.5 cm)

160

Mash-Ups

129
Panther Rose, 1991.
Black ink and
transparent and
opaque watercolor on
paper board, 15 x 9 in.
(38.1 x 22.9 cm)

130 OPPOSITE
Virile Music, 1992.
Black ink and
transparent and
opaque watercolor
over graphite on
paper board, 20 x 15 in.
(50.8 x 38.1 cm)

163

131
Back in the Saddle,
1990. Black ink and
transparent and
opaque watercolor on
paper, 14 x 11 in. (35.6 x
27.9 cm)

132 OPPOSITE
*New Bodhisattvas:
The Educated
Savage Offers a
Solution for the
Self-Destructive
Aggression of Two
Overdeveloped
Rivals*, 1990. Black ink
and transparent and
opaque watercolor on
paper, 14 x 11 in. (35.6 x
27.9 cm)

164

165

Ghosts

"I tried to return to what drew me to tattoo designs in the first place, the kind of beauty that they had, the kind of specific, unique stories that they told, and began to mix those with completely unrehearsed ideas."

DEATH IS CERTAIN

LIFE IS NOT

DEATH OF LOVE

6

Hardy is uncertain

"I just drew it because I thought, 'This is a weird form that I like . . . it kind of looks like a dripping paintbrush. It also looks like an udder.'" Recently he realized that the image might have been triggered by a childhood memory: seeing rubber gloves hung upside down in his parents' photo studio. The forms appear in 1998 in a series of paintings on paper, mostly painted pink, with evocative titles such as *Weaner* and *Stretched Out* (pls. 134, 135). Never included in his tattoo inventory, the ghosts almost always contain or are surrounded by traditional tattoo images recognizable from his tattoo work.

In 2008, almost a decade after Hardy introduced the ghosts into his painting and drawing repertoire, he collaborated with longtime friend and renowned sculptor Ron Nagle to reproduce them as small porcelain sculptures (pls. 137, 138). Hardy took the model form to the Risogama kiln, in Japan, where he had previously produced a line of painted vases and platters, and had several fabricated there. Before glazing, he painted each one with a unique and enigmatic design that further obscured the shape's meaning.

The ghost forms reappeared in a 2018 series of drawings on black paper (pls. 141, 142). In these recent works, they hover behind images of garden trellises that, like the classic tattoo images in his paintings, are reconstructions of forms from Hardy's past. The structures are based on the painted wooden trellises that adorned his childhood home in Corona del Mar that he previously depicted in a 1960s series of prints and drawings (pls. 139, 140). Today the paintings and drawings of ghost forms and trellis images adorn a wall in his studio that serves as a kind of active springboard for new ideas.

133 OPPOSITE
*Embarrassing
Butchie*, 1998. Black
ink and acrylic on
amate paper, 34 ¼ x 24
in. (87 x 61 cm)

134
Weaner, 1998. Black
ink and acrylic on
amate paper, 20 x 27 ½
in. (50.8 x 69.9 cm)

135
Stretched Out,
1998/2018. Black ink
and acrylic on *amate*
paper, 23 ¾ x 15 ¼ in.
(60.3 x 38.7 cm)

136 OPPOSITE
Rosie, 1999. Color
lithograph, sheet:
31 ½ x 23 ⅝ in. (80 x
60 cm)

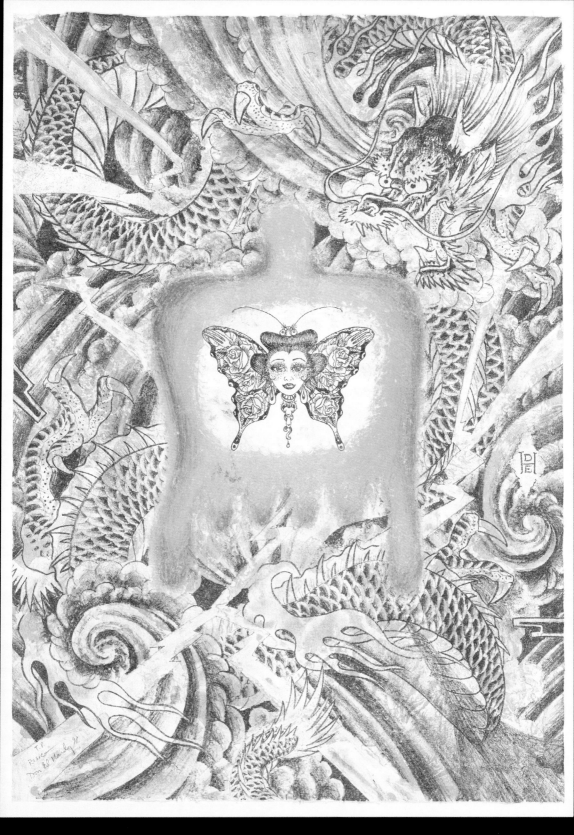

137
Veterano, 2008.
Hand-painted
porcelain, 13 ¾ x 9 x
1 ⅞ in. (34.9 x 22.9 x
4.8 cm)

138 OPPOSITE
Donor, 2008.
Hand-painted
porcelain, 13 ¾ x 9 x
1 ⅞ in. (34.9 x 22.9 x
4.8 cm)

139
Trellis, 1966. Black ink
on paper, 17 ¾ x 15 in.
(45.1 x 38.1 cm)

140 OPPOSITE
Trellis, 1967. Black ink

Hurley 1967.

175

141
Surveillance, 2018.
White ink and colored
pencil on black paper,
18 x 12 in. (45.7 x
30.5 cm)

142 OPPOSITE
Specimen for A.D.,
2018. White ink and
colored pencil on black
paper, 11 ⅝ x 8 ¼ in.
(29.5 x 21 cm)

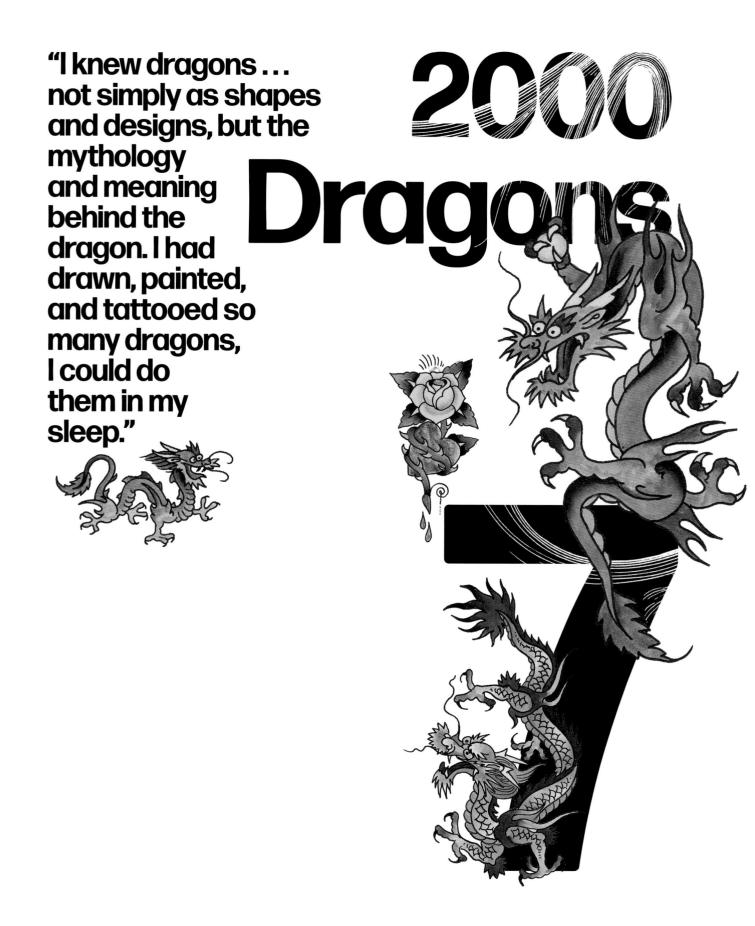

"I knew dragons ...
not simply as shapes
and designs, but the
mythology
and meaning
behind the
dragon. I had
drawn, painted,
and tattooed so
many dragons,
I could do
them in my
sleep."

2000 Dragons

In the millennial year 2000,

THE YEAR OF THE DRAGON in the East Asian calendrical system, Hardy began a commemorative work depicting two thousand dragons on a two-thousand-foot-long surface (pl. 151). Inspired after seeing Chen Rong's masterpiece, *Nine Dragons* (dated 1244; fig. 18), at the Museum of Fine Arts, Boston, he decided on a scroll format for his work, selecting Tyvek, a strong, lightweight material available in long rolls. Over a period of seven months of sporadic studio work, painting about five feet of scroll at a time, he carefully numbered each of the dragon images in Chinese characters. He also kept a journal recording his thoughts and the music that inspired him at each session (an eclectic mix that included Pink Floyd, George Frideric Handel, the Beatles, and the Gyuto monks, of Tibet) (fig. 48).

Dragons had long fascinated Hardy; from childhood he had drawn, painted, and later tattooed thousands of them (pls. 143–147). He studied their shapes and designs and also their significance in Eastern and Western mythology. Large and small, most of the dragons in the scroll were inspired by Asian depictions of dragons, although Hardy added a large Quetzalcoatl, the feathered serpent, to represent Maya and Aztec art.

Painting the scroll allowed Hardy to work with more spontaneity on a large scale—an approach he found an exhilarating change from the tight, close work of tattooing. The paintings and drawings that followed, including a series of dragon images he created for 2012, another dragon year, are notable for their large scale, dramatic color combinations, and energetic brushwork (pls. 148–150).

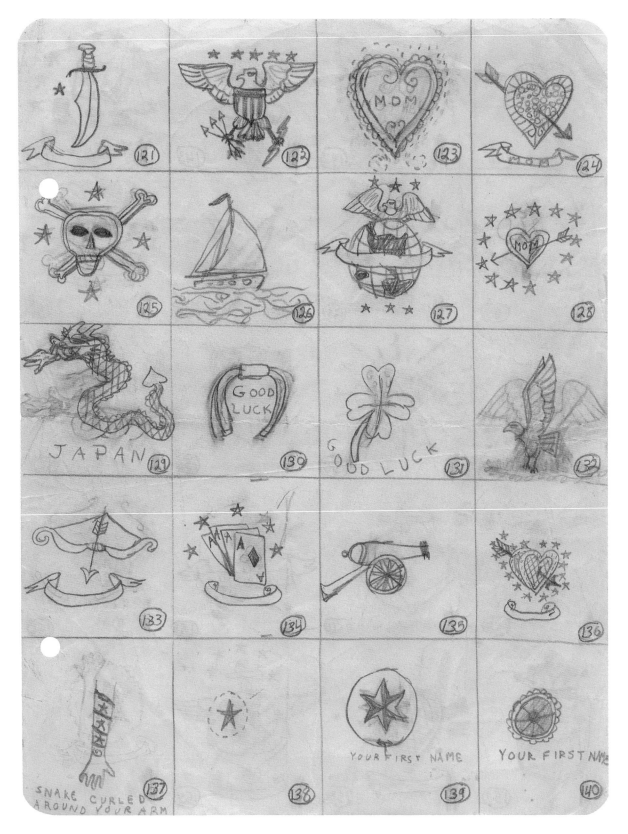

144 LEFT
Untitled tattoo design,
1968. Black ink on
paper, 9 x 6 in. (22.9 x
15.2 cm)

145 RIGHT
Untitled tattoo design,
1968. Black ink on
paper, 9 x 6 in. (22.9 x
15.2 cm)

143 OPPOSITE
Untitled tattoo designs,
121–140, ca. 1955.
Graphite on paper,
10 ½ x 8 ¼ in. (26.7 x
21 cm)

146
Untitled (tattoo design for a back), 1976. Black ink and watercolor on paper board, 20 x 15 in. (50.8 x 38.1 cm)

147 OPPOSITE
Untitled (tattoo design for an arm), 1991. Black ink and colored pencil on tracing paper, 17 x 14 ⅛ in. (43.2 x 35.9 cm)

182

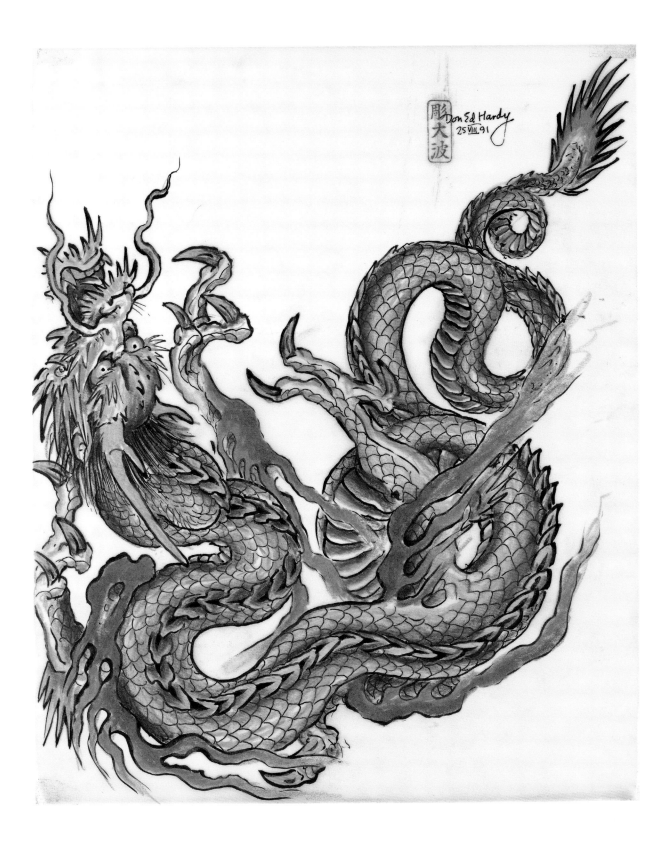

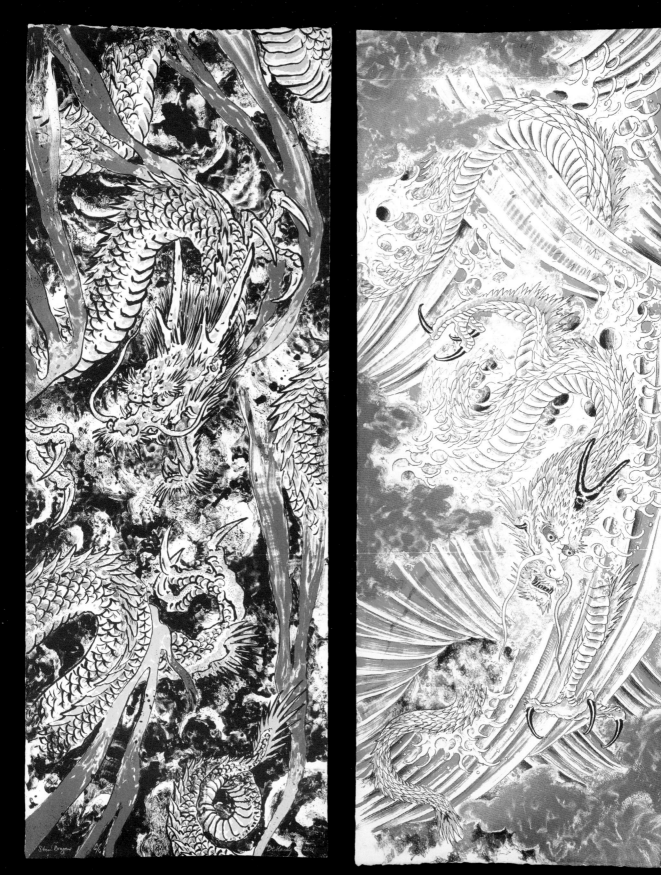

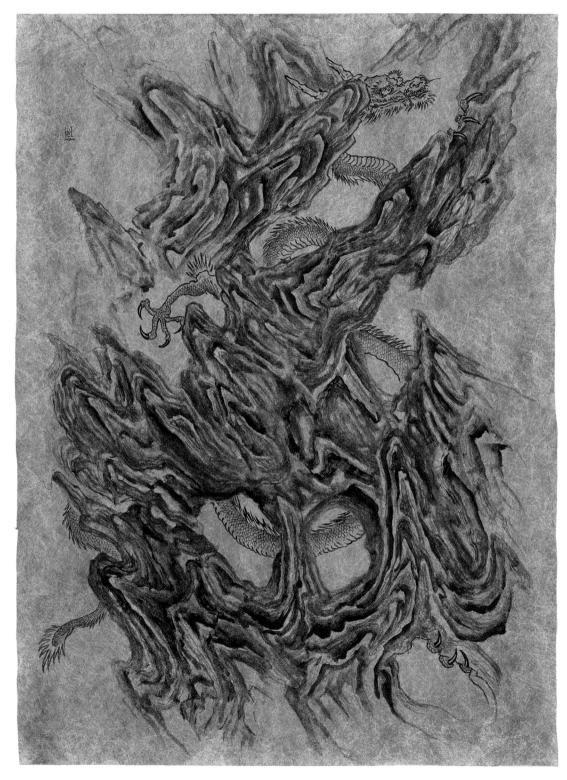

148 OPPOSITE LEFT
Storm Dragon, 2001.
Color lithograph, sheet:
47 ½ x 18 in. (120.7 x
45.7 cm)
FINE ARTS MUSEUMS OF
SAN FRANCISCO, GIFT OF
THE ARTIST, 2017.46.129

149 OPPOSITE RIGHT
Sea Dragon, 2001.
Color lithograph with
metallic powder, sheet:
47 ½ x 18 in. (120.7 x
45.7 cm)
FINE ARTS MUSEUMS OF
SAN FRANCISCO, GIFT OF
THE ARTIST, 2017.46.128

150
Pirate's Cove, 2012.
Acrylic on Tyvek,
48 ¼ x 36 ⅛ in.
(122.6 x 91.8 cm)

151 FOLLOWING PAGES
2000 Dragons
(details), 2000. Acrylic
on Tyvek, 51 in. x 500 ft.
(1.3 x 1,524 m)
FINE ARTS MUSEUMS OF
SAN FRANCISCO, GIFT OF
THE ARTIST, 2019.34

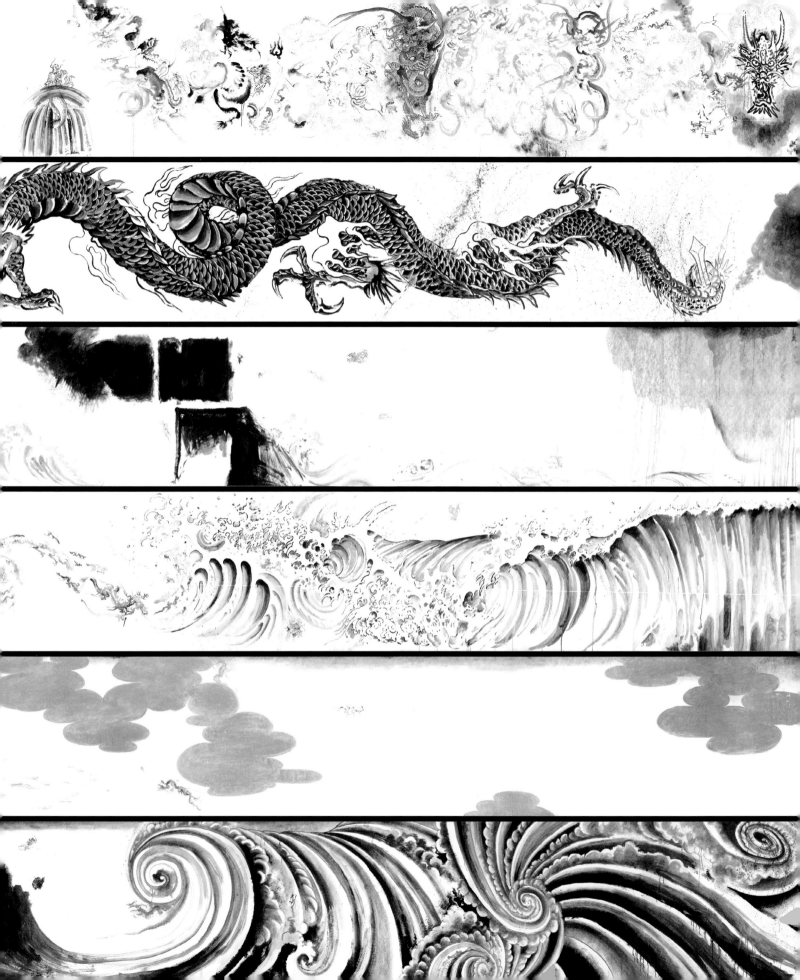

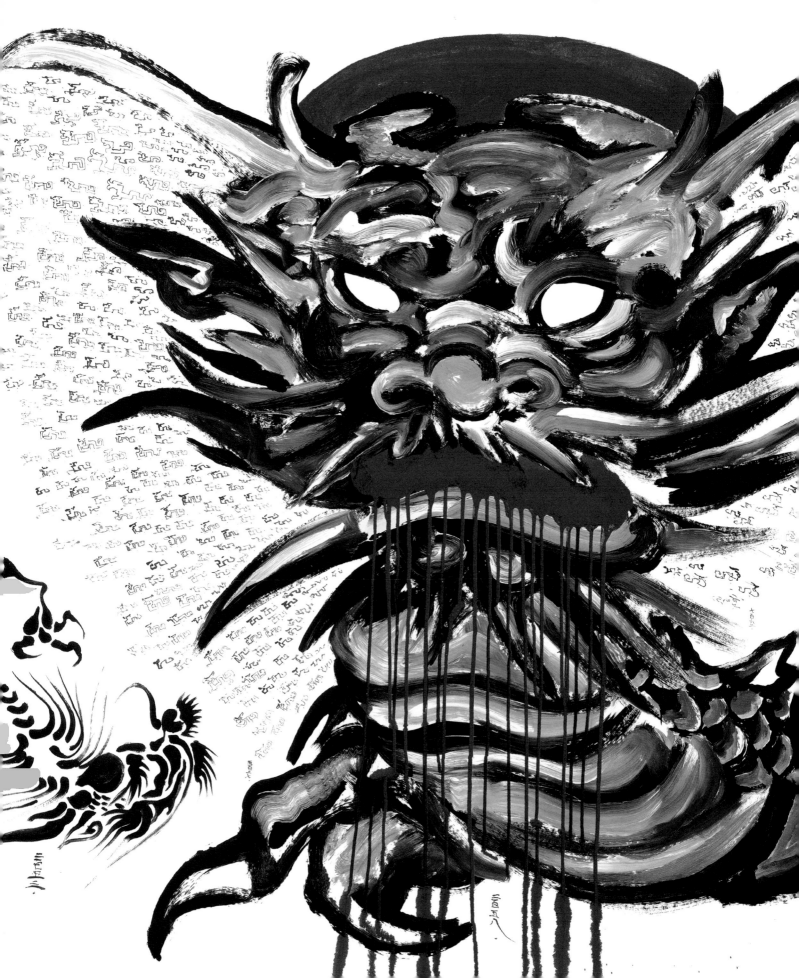

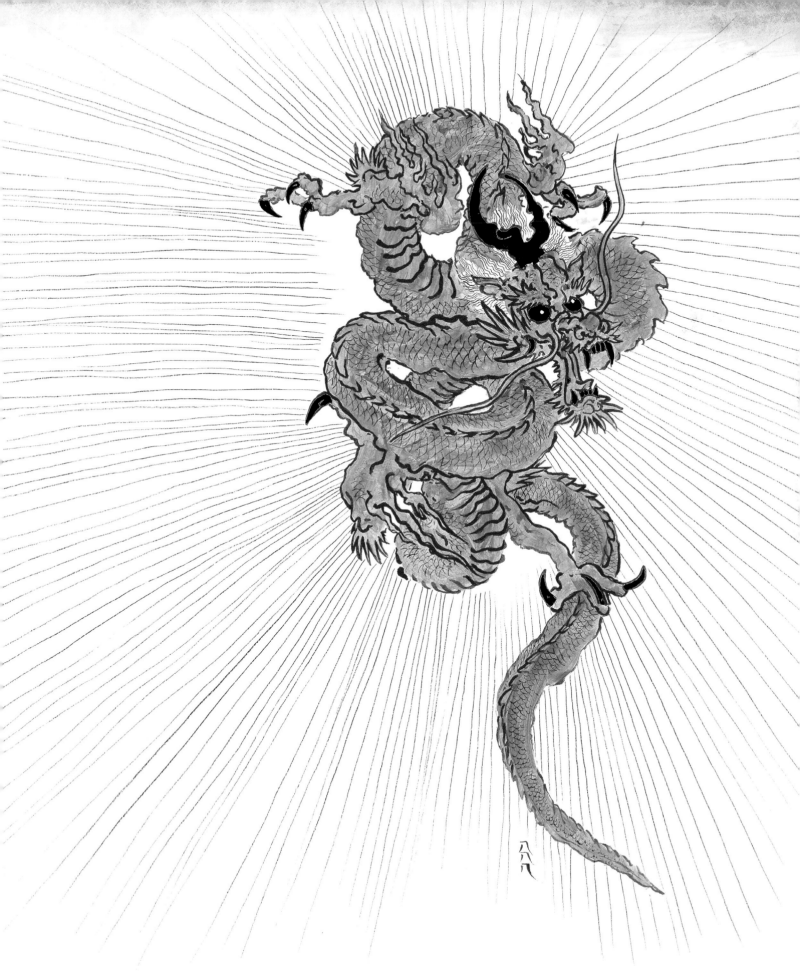

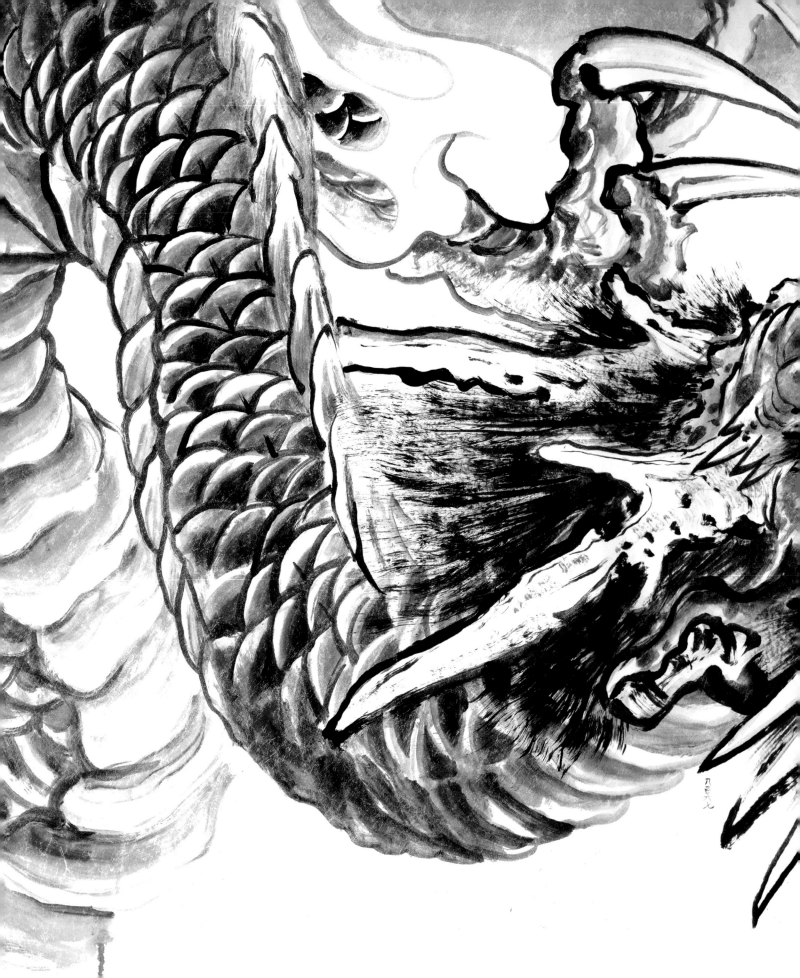

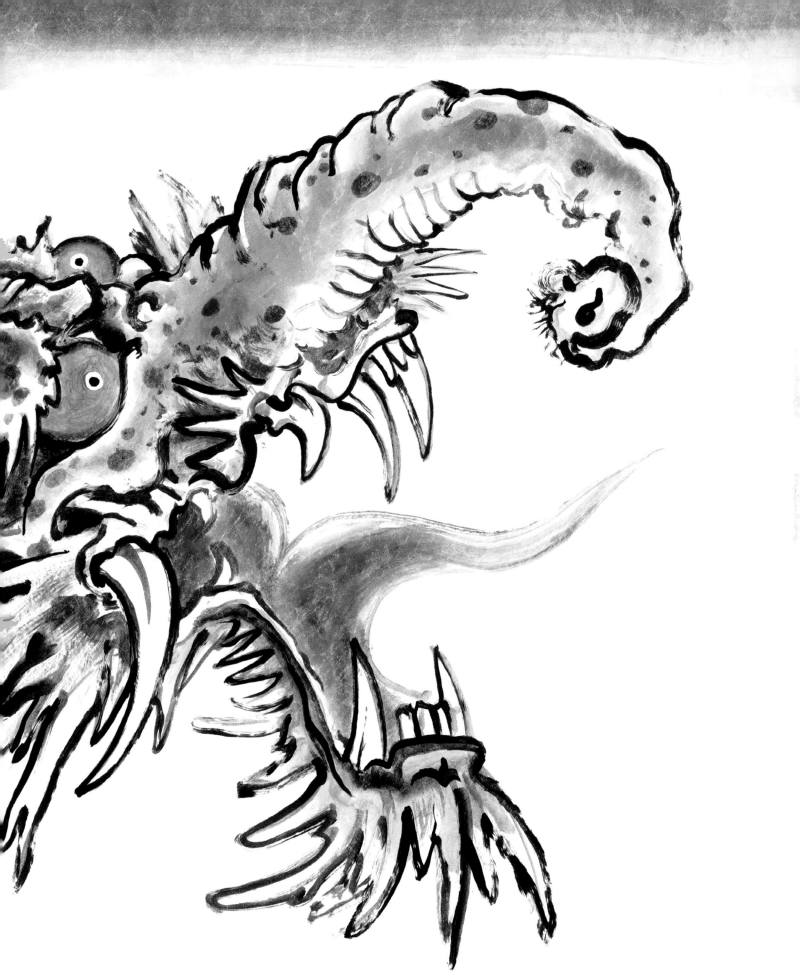

The immortals

8

"Painting *2000 Dragons* changed me in a funda- mental way, opening possibilities I didn't know I could explore. From then on, I was . . . working larger, looser, expanding the spontaneity I'd begun exploring when we moved to Honolulu."

Using Tyvek,

A SYNTHETIC MATERIAL marketed in large rolls, opened up new possibilities for Hardy's art making, enabling him to paint on long or tall sheets. In addition, his experience of making *2000 Dragons* over seven months with no preplanned composition freed him to explore purely abstract elements. Retiring from tattooing in 2008, Hardy spent the next decade making works that fuse Western tattoo imagery with creatures and symbols from Asian art iconography, painting them in brushstrokes inspired by the Abstract Expressionist artists he had admired in his youth. Of his motivation for creating these large, loose paintings, Hardy said that his goal was to surprise himself, to dive in without a predetermined direction, with the same kind of open mind that he had in his art-school days.

The *Immortals* series (pls. 152–159) is named for the Taoist immortals, who are frequently depicted in Chinese art in stylized mountain settings. In Hardy's versions, the settings are strange, otherworldly environments in which tattoo imagery appears alongside scholar's rocks of all shapes, black boulder-like images that Hardy dubs "Old Sarge." The forms are surrounded by conventional butterflies, bamboo, peonies, and mushrooms. In a nod to the music he listened to while creating the works, Hardy gave many of the *Immortals* titles that reference songs, such as *Walking after Midnight, Back in Baby's Arms*, and *That Old Devil Moon* (pls. 152, 153, 156).

◎◎◎

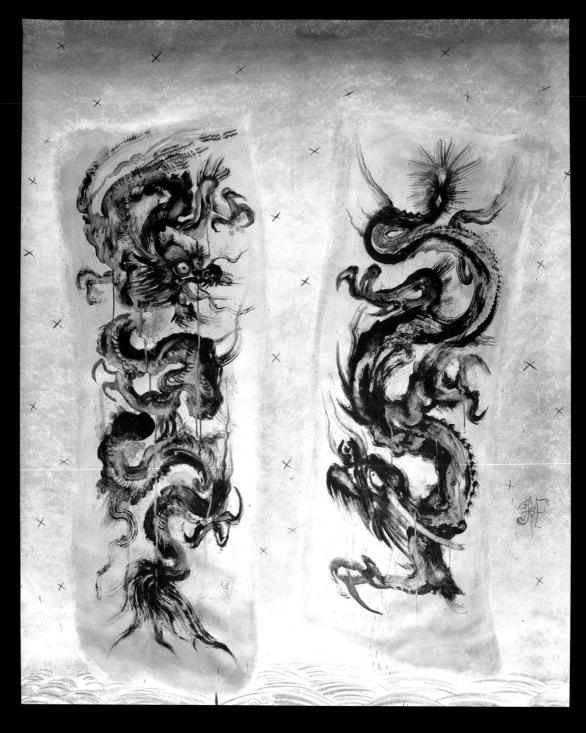

152
Walking after Midnight, 2000. Acrylic on Tyvek, 69 ¼ x 51 ¼ in. (175.9 x 130.2 cm)

153 OPPOSITE
Back in Baby's Arms, 2000. Acrylic on Tyvek, 60 ⅛ x 51 ⅛ in. (152.7 x 129.9 cm)

198

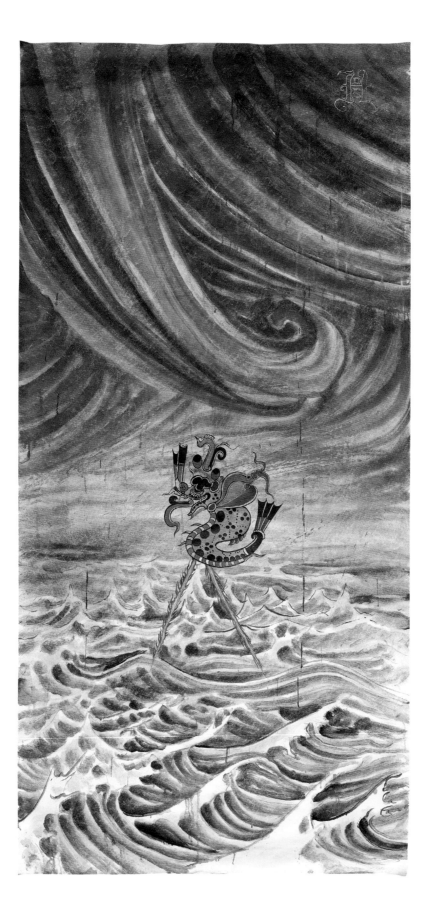

154
Gilded Splinters,
2000. Acrylic on Tyvek,
105 ¼ x 51 ⅛ in. (267.3 x
129.9 cm)

155 OPPOSITE
Thunderhead, 2000.
Acrylic on Tyvek,
123 ½ x 51 ¼ in. (313.7 x
130.2 cm)

201

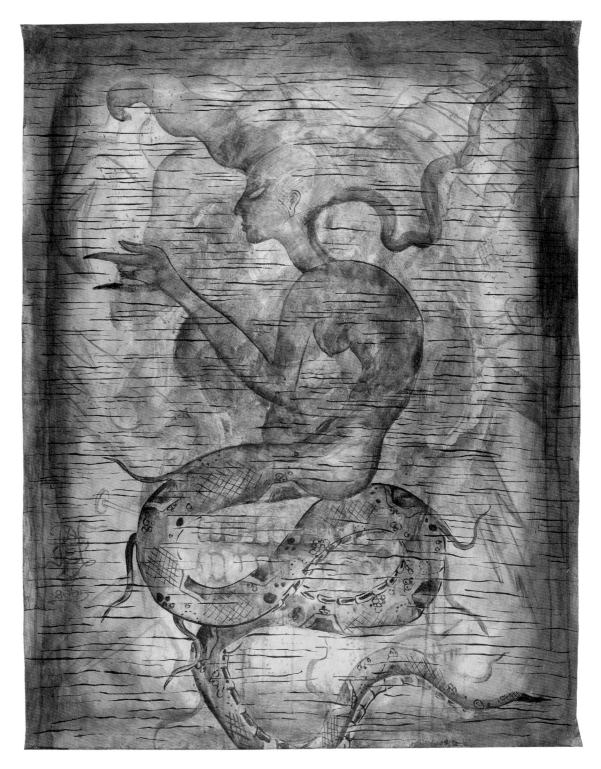

156 OPPOSITE
*That Old Devil
Moon*, 2002. Acrylic
on Tyvek, 51 ⅜ x 41 ½
in. (130.5 x 105.4 cm)

157
Atlantis, 2005. Acrylic
on Tyvek, 51 ¾ x 41 ½ in.
(131.4 x 105.4 cm)

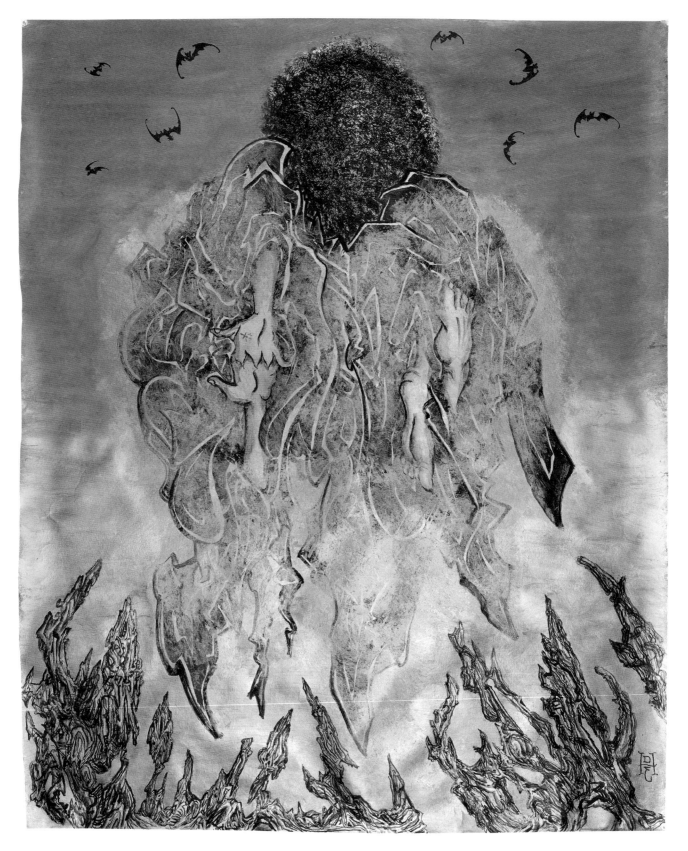

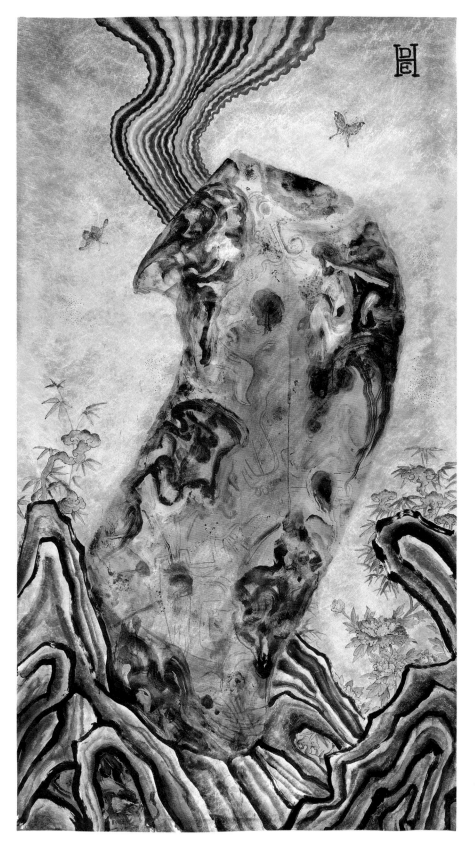

158 OPPOSITE
The Wizard Vanishes,
2016. Acrylic on Tyvek,
48 ½ x 40 ⅛ in. (123.2 x
101.9 cm)

159
*Elephant's
Graveyard*, 2001.
Acrylic on Tyvek,
92 ¼ x 51 ¼ in. (234.3 x
130.2 cm)

"Tattoos were always more than a way to make a living to me. From the beginning, tattoos were a mission and I was an evangelist. I wanted to expand the possibilities of the medium, and I wanted to elevate the art form."

Life of a Tattooer

As a young artist

IN 1966, ED HARDY ANNOUNCED his belief that the tattoo form should be elevated from its outsider, subculture status. Not necessarily a declaration of a one-man quest to change an established American practice, the statement, couched in the zeitgeist of that counterculture era, qualified as a sincere aspiration. Today, more than fifty years after Hardy first formulated that ambitious dream, he is internationally known and acknowledged as the father of modern tattoo culture. It was not Hardy's intention to single-handedly achieve this, and he relied on the advice, training, and wisdom of mentors like American tattooers Bert Grimm, Phil Sparrow (Samuel Steward), and Sailor Jerry (Norman Collins), as well as master Japanese tattooer Horihide (Kazuo Oguri). Building on their knowledge, Hardy transformed their old-school tattoo world with his progressive ideas about the form and his efforts to revitalize what he saw as a stagnant, tradition-bound culture. He brought new life and ideas to the art form while preserving relevant aspects of tattoo as a unique form of expression.

When he started, Hardy was one of the first fine art–trained tattooers in a world largely populated with self-trained practitioners whose repertoire consisted of traditional, timeworn designs, cartoon characters, and military generics. He was the first American tattoo artist to work in Japan in order to more deeply understand the themes and imagery of Japanese tattoo culture. He brought that aesthetic into his Western practice, thereby introducing it into the American tattooing vernacular. Hardy was also the first American to open an appointment-only tattoo studio where he devised tattoo compositions based on his clients' own designs and inspirations.

Hardy's artwork, with tattoo imagery at its core, resists to being labeled or positioned within the contemporary art canon. "My work is a hybrid," he has said. "Either you get it and it draws you in and hypnotizes you or it doesn't, whether it's a drawing, a tattoo, a print, a painting, a porcelain vase, or a piece of clothing. Today, there is an incredible magnetism to tattoos and tattoo-based imagery, and for me trying to explain why isn't important. What's important is making the art."

160
El Tigre, 2009. Acrylic
on digital print, 16 x
13 ⅛ in. (40.6 x 33.3 cm)

161 OPPOSITE
*Young American
Dream*, 2009. Acrylic
on digital print, 16 x
13 ¼ in. (40.6 x 33.7 cm)

162 OPPOSITE
Monkey Man II,
2009. Acrylic on digital
print, 16 x 13 ⅛ in.
(40.6 x 33.3 cm)

163
Ship Head, 2009.
Acrylic on digital print,
16 x 13 ¼ in. (40.6 x
33.7 cm)

164
Untitled, 2009. Acrylic
on digital print, 16 x
13 ½ in. (40.6 x 34.3 cm)

165 OPPOSITE
Batty, 2009. Acrylic on
digital print, 16 x 13 ¼
in. (40.6 x 33.7 cm)

Appendices

Art for
Life:
An Interview
with
Ed Hardy

Karin Breuer

K: You've spoken about the importance of drawing in your artistic life. Talk a little bit about developing that skill as a youth and as a maturing and mature artist.

E: Drawing for me is like breathing. I have always been able to draw—it's an essential method to reflect and record the world and my experiences in it, actual or imagined. I didn't try to consciously develop it but just used it as a way to record or expand upon things I observed or imagined.

When my mother recognized that I could draw and saw that I was excited about it, she encouraged me, and she saved all those early drawings of mine. So it seemed like a very important way to document one's course in life. [My drawing] became a visual diary of things that I was interested in, whether I was drawing what I was observing or drawing things out of my own imagination.

But being exposed to art before going to art school—I went to a lot of galleries and

26
Ed Hardy working on
his print *Floater* at
Shark's Ink, Lyons,
Colorado, 2007
PHOTOGRAPH BY BUD
SHARK

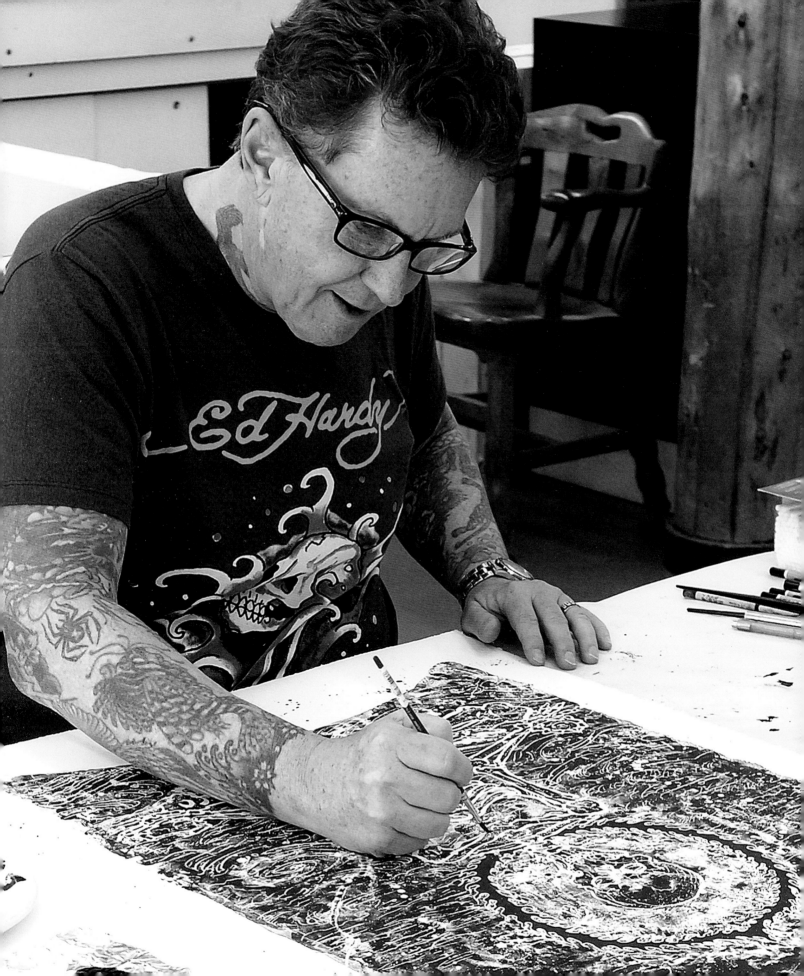

museums in Los Angeles—and steeping myself in art history, both old masters and contemporary work, when I got to the San Francisco Art Institute [SFAI], those experiences gave me confidence in my artistic abilities. Then encountering teachers like Gordon Cook, who had this incredible deep devotion to close seeing and close looking and transcribing life in a really accurate way—that obviously resonated with me.

Drawing is the basis of everything [in art], and it always gets back to drawing, even if you're working with different mediums. If you can't capture your feelings about the world or transcribe these things with simple lines, then you don't have any real basis. All the great painters I admire were terrific draftsmen, especially the artists in the twentieth century and late nineteenth century. That was the basis of their work, no matter how spectacular their paintings became or their works in other media.

Did being practiced at drawing help you as a tattoo artist?

Absolutely, of course. When I started, very few tattooers had a formal art education, but a lot of them had natural ability and developed terrific styles. Very few people had gone to art school—you could name them on one hand. It was the exception rather than the rule that tattooers could originate images in their own style. Of course, a lot of them did develop terrific, powerful styles because they were naive and weren't sullied by too much art education; they just pursued what they thought was right. "Lew the Jew" Alberts, Charlie Wagner—they were just powerful folk artists.

In the exhibition we've featured some amazing etchings that you produced in the 1960s when you were a student majoring in printmaking at SFAI. In your mind, was there a connection between the etched line and the black outlines of a tattoo? How about the fact that making an etching requires a tool called a needle to draw on a metal plate?

Absolutely, it's a completely logical connection—the necessity for precision of execution [in both] and the [similar] look of a freshly printed stencil line and a tattoo line. When I got into etching, I loved the way a fresh print just pulled off a plate has the look of a tattoo before it's healed on the skin. I might not have been conscious of it, but it definitely made a connection to me. Tattooing is really hard to get into. It's a hands-on thing. It's the touch.

I loved the democracy of printmaking, the fact that it's a multiple original. I was a big one on art that it is an art for everybody, non-elitist.

I was trying to connect whether the re-emergence of your attraction to tattooing, at the end of your time at SFAI, and your decision to embrace it as a profession were stimulated by the zeitgeist of 1967 and the rise of the counterculture that reached a culmination that year with the Summer of Love. You were in your twenties and living in San Francisco, after all!

It did tie in to whatever everybody was doing then, and what was going on here changed things enormously. I understood it—as you saw these things happening, it really opened it up. Anyone could be tattooed. Lyle [Tuttle] recognized then that tattooing was something that appealed to

these people who wanted to express themselves, as corny as that sounds. Everybody was searching for something new to break out of the accepted way we were supposed to live or the goals we were supposed to aim for.

But the overall thing was I was on that track; I could've gone to Yale. I could have been in the "high mucky-muck" realm of art, but at that period, color-field painting and Conceptual art were coming in, and I thought, "I can't go pursue this as a career. What about tattooing? Nobody's really explored this."

So, my decision to reconnect with tattooing—my destiny—was entirely due to my unease with pursuing a graduate degree and eventually teaching art, in light of the art-world climate of that time. For me, tattooing embodied the heart and soul of human mark making, was devoid of commodification, fashion, and general misuse as a human activity. I realized that becoming a tattooer would allow me independence from any control system. I thought, "If I can make this work, I don't have to answer to anybody." And since then, it's been wonderful!

You have a reverence for artists in the Western art history canon, past and present, and you frequently mention several who have profoundly influenced you, including your teachers at SFAI. Could you identify some of those artists whose lessons you carry with you?

Some of my earliest inspirations, when I began getting serious about making art, came from the work of [Pablo] Picasso. It made perfect sense [to me] to not have one style but just move freely as one's perceptions developed. A bit later, I was mightily impressed by Max Ernst, who also worked in a wide range of styles, and [Yves] Tanguy. Aspects of some of the Surrealists' work attracted me but not their embarrassing posturing and self-importance. Others who I have passionately followed and referred to since my student days are [Francis] Bacon, [James] Ensor, [Albert Pinkham] Ryder, [J. M. W.] Turner, [Giorgio] de Chirico, [Pierre] Bonnard, [Franz] Kline, and [Willem] de Kooning.

Probably my leading twentieth-century art hero is Philip Guston. I saw his first retrospective museum exhibition in Los Angeles around 1962 and have been obsessed with him ever since. His deep introspection and endless questioning of what making art is all about continue to resonate with me.

I should also stress what a great inspiration the work of contemporary ceramic artists was and continues to be: Peter Voulkos (whom I met when I was seventeen), Ron Nagle, and Richard Shaw. Their work, in a medium largely regarded in the West as craft, something lesser than painting and sculpture, was exciting and revolutionary and continues to inspire me. Overall, their avoidance of pretension and overblown posturing as self-conscious artists has been a beacon of sanity and inspiration. Of course, included in this group are, above all, Gordon Cook and Joan Brown [his teachers at SFAI].

You've always been curious about art and from a young age have visited galleries and museums for enjoyment and also inspiration. What visits may have inspired you in your tattoo practice? In your art practice?

A museum show that particularly struck me was *J. M. W. Turner: Painting Set Free*, at the de Young, in 2015. As I think you know, he is perhaps my greatest art hero, and that show featured his *Peace - Burial at Sea* [1842], from which I did the spinoff homage paintings of the black sails. I may have seen that work in London; we always go to the Tate to view the Turner rooms when we're there . . . anyway, I discovered him when I was in art school and had a small color reproduction of his *Rain, Steam and Speed* [1844] tacked up next to my bed—first thing I saw every morning—when I was in the tiny apartment on North Point Street, where I did the first *Backyard* etching (pl. 26).

From the first time I discovered Turner's work, I was fully magnetized by it. To me, it is still the most powerful and sublime evocation of natural forces ever created.

Overall, I think the transcendent qualities that feed us in the art that really moves us are so crucial to our existence—it's kind of ironic, as I've spent so much of my life's focus on tattooing, guaranteed to be ephemeral, but just looking at art and being involved in all this is such a great gift. I can't thank you, and the museum, enough for enabling the exposure of my efforts in such august quarters.

You've acknowledged that you've been drawn to the work of Japanese artists for inspiration in tattooing and in your own art. But when you were a student at SFAI, you looked upon ukiyo-e prints with some disdain. Why?

I didn't understand why they drew things that way! Basically, it was like I knew that there was this deep, incredibly sophisticated culture, but it was literally a foreign visual language. What caused them to go down that road of that kind of stylization?

I was embarrassed about it. Even though I'd been exposed to Asian thought and, to a degree, Buddhism and Taoism early on, but not in any deep way, when the light bulb went on, it just engulfed me. I became obsessed with Asian culture, especially Japanese culture.

When did that happen?

When I really got into tattooing. I started looking at things and studying and paying attention to Kuniyoshi and looking at the roots of what triggered the whole tattoo renaissance in the West. So I started looking at some of these artists—Hokusai, Kuniyoshi, Yoshitoshi, Kyosai—and realizing how powerful they were. I started to see their incredibly complex iconography and deep aesthetic and not only the themes but also the reasons why, what caused these styles to emerge, the kinds of emphasis they put on things. It was a completely different channel than Western realism. As much as I loved the great Western painters, the Japanese stuff was so distinct, and it's just really tied into their worldview.

"Wear your dreams" was the motto of the Realistic Tattoo Studio that you opened in 1974 as a private, commissions-only shop. In this practice, you obviously had to collaborate with an individual in the visual interpretation of their "dreams." Could you walk us through that process and explain how your aesthetic came into play, or how the ideas for the commissions may have stimulated your own artistic juices?

By establishing the first all-appointment, private studio that encouraged people to dictate the images they wanted to wear, the entire concept of tattooing changed globally. It seemed absurd that someone wishing to be tattooed had to select an image codified in the current folk-art tradition. Few tattooers had the skill set or interest to execute unique commissions. I often likened this to the question, "What if any restaurant you chose was a repeat of Denny's?"

By becoming an illustrator for these people's notions, my own concepts and capabilities radically expanded. Of course, most of my career was involved in "art to order," via commissioned tattoos. But these incoming requests extended my capabilities far beyond what might occur in the solitude of one's studio.

You've done some strange and very personal tattoos for clients who had specific requests: a baked potato (pls. 68, 69), a bullfighter and a bull (pls. 65–67), a nineteenth-century hot-air balloon (fig. 6). Did you find those kinds of requests appealing or appalling?

All these surprising commissions broadened my awareness and skills as a tattooer. It was a great honor.

For the exhibition, you've generously loaned a quantity of your preparatory drawings for tattoo commissions. Some are very elaborate, and almost all are on tracing paper. Could you explain how they were used in the tattoo studio?

Normally a traced area was done to show the placement and boundaries of an image. This linear piece was either scribed into an acetate stencil that was then rubbed with powdered charcoal and then printed on the skin into a thin coat of Vaseline. This then had to be carefully followed with an outliner machine from one corner up.

Sailor Jerry [Norman Collins] improved this technique by using hectograph dye pencils on Japanese paper. This was printed onto dampened skin and was not as fragile to follow with an outliner.

I also created unique custom commissions by freehand-drawing the image directly onto the skin and occasionally freehanding with the machine.

You've spoken about the resurgence of old-school imagery in contemporary tattooing. These are images that, for the most part, you've revered since childhood and have tattooed thousands of times during the 1960s and early 1970s. Some have endured to become regular themes in your art, even evolving and meshing with Asian imagery. Could you identify these designs and how powerful and symbolic they have become?

For example, the tiger (pls. 103–110).

Tigers were powerful folk images, and I was just attracted to them for their formal qualities—their light and dark stripes. When you extend it out and realize that these kinds of images are vehicles to expand upon with just the formal elements of the figure—the positive and negative values—and then see the animation to it, they just appealed to me as really powerful images to work with.

My biggest interest in my personal art is taking these things and mashing them up, expanding them, and taking them beyond what they were or have been as classic tattoos.

The "butterfly woman" (pls. 84–88)?

The earliest I've been able to trace that image back was in some examples in very old photographs of maybe some drawings of early tattoo work when Japan first opened to the West. [In 1629 Japan adopted a "closed-door" policy that permitted only limited contact with other countries. After American Commodore Matthew C. Perry convinced the country to open its ports in 1854, foreigners were more freely allowed to enter Japan.] I think the whole idea of it came from Japanese tattoos. If you really want to go out on a limb and consider Buddhist and Taoist thought about combinations of species, it makes sense. By the late nineteenth century, versions of the forms were seen in flash sheets.

The dragon (pls. 143–151)?

It was from Japan and China. When Japan opened to the West, and Westerners like sailors and whaling people were coming back to the West with these kinds of images as tattoos, more dragons began to appear there. Westerners like those in the book *Longfellow's Tattoos*—they all got heavy amounts of tattoos. [Christine Guth's 2004 book relates the story of Charles Longfellow, who traveled in Japan for two years in 1871 and returned with a "collection" of body tattoos.] They were excited about it as an expressive art form.

There's one piece in the show, *Black Western Dragon* (1985; pl. 82), that doesn't look like an Asian-inspired dragon form.

Generally Western dragons tend to be more like terrible lizards with big bat wings and fat bellies. I think the idea of winged dragons was more a development in Western iconography, from medieval art. I was fascinated with the art that I studied when I was hanging out at the Achenbach looking at older prints [as a student at SFAI]. What these artists regarded as exotic themes from other cultures or something that didn't really exist in real life, but they would put it down, draw it.

I was always crazy about that kind of art, and it feeds back to when I was a kid. The tattoo designs, monster art, hot-rod culture—these fusions of things that didn't exist in real life but were expressions of what could be.

You had an aha moment in the late 1980s, a time when you turned from full-time tattooing to concentrate on your fine art practice, something you hadn't been able to do for many years. At first you struggled, trying to find new inspirations, but you then came to an important realization. What was it?

I was fortunate to be busy and successful in developing the largely unexplored, expressive medium of tattooing. The wide variety of my work—the styles, the subjects—was greatly enabled by the clients who approached me to illustrate their ideas in ways I never would have attempted alone in my studio.

But when I was able to step back from my constant installation of tattoos, dividing my time between San Francisco and Honolulu, I realized I'd become wholly dependent on my clients' ideas. For a brief period, I struggled with finding subject matter absolutely unrelated to any

tattoo imagery I had dealt with—and eventually realized that such false distinctions are meaningless. A particular style, topic, or content has to succeed or fail on its own, free of preconceived associations.

Advice for a young tattooer today?

Good luck!

Chronology

Compiled by
Timothy N. Brown

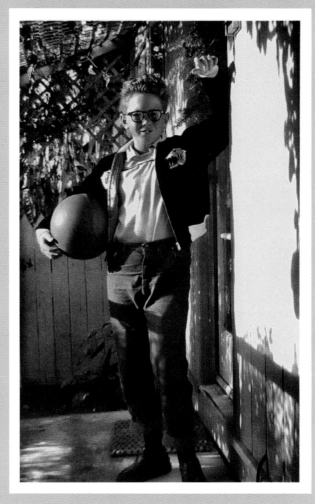

27
Ed Hardy wearing tiger
souvenir jacket, 1954
COLLECTION OF DON ED
HARDY

28
DON ED HARDY
Untitled, ca. 1955–1956.
Black ink and colored
pencil over graphite on
paper, 3 ½ x 7 in. (8.9 x
17.8 com)
COLLECTION OF THE
ARTIST

29
DON ED HARDY
Airbrushed sweatshirt,
1958. Textile dye on
sweatshirt
COLLECTION OF THE
ARTIST

1945

⊚⊚⊚ Born Donald Edward Talbott Hardy on January 5 in Des Moines, Iowa, to Wilfred Ivan Samuel "Sam" Hardy (1905–1995), a photographer and engineer, and Mildred Sandstrom Hardy (1910–1975).

⊚⊚⊚ Mother lives with her parents in Des Moines while father is in Europe with US Army during World War II.

1946–1954

⊚⊚⊚ Family returns to Southern California.

⊚⊚⊚ Hardy begins drawing at age three.

⊚⊚⊚ Returns with mother to live in Iowa with maternal grandmother and grandfather; the latter is in poor health and dies in 1950.

⊚⊚⊚ Interest in Japan is sparked when father takes job as an engineer in Japan in 1951 and sends him souvenirs, including jackets with exotic designs (fig. 27).

⊚⊚⊚ Returns to Corona del Mar with mother and maternal grandmother. Lives with them in family house on Goldenrod Avenue.

1955–1958

⊚⊚⊚ Intrigued by tattoos on father of friend Len Jones, at age ten begins drawing tattoo designs and tattooing friends using colored pencils and Maybelline eyeliner. Turns den of house into makeshift tattoo parlor and buys tattoo equipment and flash from mail-order supplier (fig. 28).

⊚⊚⊚ Visits tattoo shops at Long Beach Pike, a boardwalk amusement area. Renowned tattooer Bert Grimm, who has shop on the Pike, allows Hardy to observe and copy his designs.

⊚⊚⊚ Reads *Memoirs of a Tattooist* (1958), by British tattoo artist George Burchett.

1958–1962

⊚⊚⊚ At thirteen, gives up tattooing friends and begins airbrushing shirts with designs inspired by Southern California hot-rod and custom-car art. Mother is impressed with money he makes selling such shirts during summers (fig. 29).

⊚⊚⊚ Mother hires neighbor to give him watercolor lessons.

⊚⊚⊚ Starts surfing and creates surf art during first three years at Newport Harbor High School. Sells drawings to schoolmates to earn gas money for surfing trips.

⊚⊚⊚ Discovers Beat Generation writers.

⊚⊚⊚ Encouraged by high school art teacher, Shirley Rice, becomes passionate about art around age sixteen. Begins to study art history and explore LA art scene.

1963

◎◎◎ In January, begins two semesters of studying art history and creating etchings and monoprints under Bruce Piner at Orange Coast College.

◎◎◎ In September, moves to San Francisco and enrolls in San Francisco Art Institute (SFAI), where he studies drawing with Joan Brown, sculpture with Manuel Neri, and lithography with Richard Graf. Favorite teacher is Gordon Cook, a typesetter by trade who teaches intaglio printmaking on nights and weekends. Cook becomes Hardy's mentor. Works on SFAI maintenance crew and later in school library.

1962

◎◎◎ In April, Shirley Rice submits his artworks to national Scholastic Art Awards. Several pieces win awards (fig. 30).

◎◎◎ In June, graduates from Newport Harbor High School.

◎◎◎ Over summer, exhibits and sells pieces at juried Laguna Beach Art Festival.

◎◎◎ Views Edvard Munch prints owned by local collector Adele Ipsen and creates somber prints and drawings in response.

◎◎◎ During fall, lives with friend Ken Connor while attending the La Jolla School of Arts. Connor introduces him to LA gallerist Rex Evans, who exhibits Hardy's work in his eponymous gallery.

◎◎◎ Hardy discovers art of José Luis Cuevas, which becomes a major influence (fig. 31).

1964

◎◎◎ Continues at SFAI. On assignment from Gordon Cook, creates 24-by-30-inch etching of the view of San Francisco from Twin Peaks. Frequents North Beach bars with SFAI faculty members and fellow students and reads books at City Lights bookstore.

32
Douglas Hardy's christening, Grace Cathedral, San Francisco, November 1966
LEFT TO RIGHT: Ken Conner, Joan Brown, Ed Hardy, Christine Podolak (holding Douglas Hardy), and Jim Podolak
COLLECTION OF DON ED HARDY

At Cook's urging, repeatedly visits Achenbach Foundation for Graphic Arts at the Legion of Honor, where curator E. Gunter Troche introduces him to old master prints by such artists as Albrecht Dürer, Francisco Goya, and Rembrandt. Studying such prints and the history of printmaking profoundly affects his subsequent art.

1965

Continues studying at SFAI in spring.

Spends summer in Guam, where his father is working.

Returns to SFAI in fall.

In December, marries former high school classmate Christine Podolak.

1966

Starts working swing shift at Rincon Annex Post Office, in San Francisco.

Son Douglas born on July 9 and baptized at San Francisco's Grace Cathedral. Ken Conner and Joan Brown are godparents (fig. 32).

Applies to graduate schools and is accepted to master of fine arts program at the Yale University School of Art.

In fall, completes class project on tattooing as a forgotten American folk art, rekindling his childhood interest.

Meets Phil Sparrow (Samuel Steward), a retired DePaul University professor who tattoos in Oakland. Receives tattoo from Sparrow and reads his copy of *Irezumi*, a book on Japanese tattooing by Ichirō Morita and Donald Richie that opens Hardy's eyes to the possibilities of the medium.

1967

During winter, Hardy convinces Phil Sparrow to give him lessons in tattooing.

Purchases a tattoo machine and does first tattoo on his own ankle.

Gets new job at US Postal Service mail room in US Customhouse on Battery Street in San Francisco.

In spring, decides to embark on career in tattooing rather than attend graduate school.

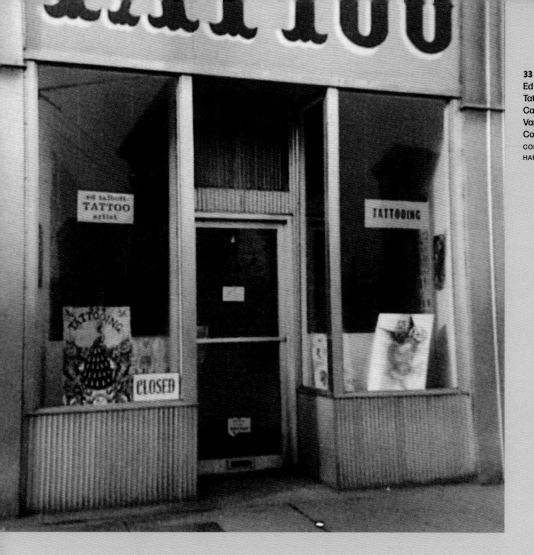

33
Ed Talbott's Dragon
Tattoo Shop, 207
Carrall Street,
Vancouver, British
Columbia, 1968
COLLECTION OF DON ED
HARDY

1968

ⓐⓐⓐ Tattoos a few friends at Sparrow's Oakland shop. Buys more equipment and sets up workspace on his back porch, where he tattoos some art-school friends.

ⓐⓐⓐ Chooses professional needle name Ed Talbott.

ⓐⓐⓐ Visits Southern California with wife Christine Podolak and son Doug to see extended family. Visits Bert Grimm's tattoo shop on Long Beach Pike.

ⓐⓐⓐ Creates *Future Plans* (pl. 29), a self-portrait with his upper body covered in tattoos, one of the last etchings he completes at SFAI, and exhibits it in student art show.

ⓐⓐⓐ In May, receives bachelor of fine arts degree in printmaking from SFAI.

ⓐⓐⓐ In spring, moves to Vancouver, British Columbia, and in March, opens Ed Talbott's Dragon Tattoo Shop at 207 Carrall Street (fig. 33).

ⓐⓐⓐ Soon realizes that in order to truly learn trade, he must work with an expert tattoo artist. Visits experienced tattooer Zeke Owen in Seattle several times and eventually convinces Owen to let him work in his shop.

ⓐⓐⓐ Closes Vancouver shop in October.

ⓐⓐⓐ Starts working for Owen in Seattle. After business slows during winter, decides to return to Southern California.

228

1969

◎◎◎ In January, moves to San Diego.

◎◎◎ Works for George L. "Doc" Webb for two years, tattooing classic American designs on sailors and marines using stencils designed by Webb. Develops Japanese designs and paints flash featuring them. Starts doing custom work on select customers. Begins to build strong client base. Surfs off Ocean Beach when not tattooing.

◎◎◎ In February, decides to contact renowned Honolulu tattoo artist Sailor Jerry (Norman Collins; fig. 34), known for his designs combining Japanese and American influences. Writes to Sailor Jerry, using Zeke Owen as reference, including photos of his own tattoo designs. The two begin regular correspondence.

◎◎◎ During summer, Hardy visits Owen at his home near Seattle; Owen counsels Hardy to open his own shop.

◎◎◎ In October, visits Sailor Jerry in Honolulu for a week and gets dragon tattoo from him.

1970

◎◎◎ Begins to develop clientele of affluent tattoo collectors.

◎◎◎ Receives favorable notice in Tattoo Club of America newsletter: "Sailor Jerry alerts us to Ed Talbott working at Doc Webb's in San Diego."

1971

◎◎◎ Opens Ichiban Tattoo Studio at 963 Columbia Street, San Diego.

1972

◎◎◎ During summer, Hardy corresponds with Michael Malone (who tattoos under name Rollo Banks) of New York, who is helping curate an exhibition on tattoos at the American Folk Art Museum. Hardy travels to New York, where he visits Malone and underground tattoo shop of Thom deVita (tattooing is then illegal in New York City).

◎◎◎ Accompanied by Malone, visits Sailor Jerry in Honolulu for a week over winter holidays. Meets Japanese tattoo artist Horihide (Kazuo Oguri), who is staying with Sailor Jerry. Makes plans to work with Horihide in Japan.

◎◎◎ Returns to San Diego and separates from wife Christine Podolak.

35
Ed Hardy with yakuza
client and Francesca
Passalacqua, Gifu,
Japan, 1973
COLLECTION OF DON ED
HARDY

1973

◎◎◎ In mid-January, begins dating customer and friend Francesca Passalacqua.

◎◎◎ In spring, visits San Francisco and lectures on tattooing at SFAI at invitation of friend and SFAI classmate Richard Shaw, now an instructor. Tattoos several students in twenty-person class.

◎◎◎ From May to September, Horihide visits San Francisco. Afterward Horihide and Hardy go to Japan. Hardy receives word that Sailor Jerry has died of a heart attack. Sailor Jerry's widow offers to sell his business to Hardy, who declines (Michael Malone later buys business). Hardy works from noon to midnight seven days a week with Horihide, tattooing mostly yakuza, or Japanese gangsters (fig. 35).

◎◎◎ Leaves Japan and returns to San Diego in October. Works for Zeke Owen at shop in Funland arcade doing standard tattoos on sailors and marines, hoping to earn enough money to move to San Francisco.

◎◎◎ Files for divorce from Christine Podolak and wins custody of their son, Doug (then eight years old).

1974

◎◎◎ In spring, moves to San Francisco with Passalacqua and Doug. Passalacqua urges him to open all-custom, appointment-only shop.

◎◎◎ In June, opens Realistic Tattoo Studio as an appointment-only shop, at 2535 Van Ness Avenue, in San Francisco. Decorates shop with eight paintings of backpieces. Does not display flash. Prints business cards with motto "Wear Your Dreams" (fig. 36).

◎◎◎ Receives favorable publicity from teenage-era friend Frank Robertson, who writes article about Hardy and Realistic Tattoo for Francis Ford Coppola's *City* magazine. Gets further exposure from writer Armistead Maupin's article in Marin County weekly *Pacific Sun*.

ED HARDY
REALISTIC TATOO STUDIO
"WEAR YOUR DREAMS"

BY APPOINTMENT ONLY
(415) 928-0910

2535 VAN NESS AVENUE
SUITE 5
SAN FRANCISCO 94109

A PRIVATE STUDIO OFFERING A TOTAL RANGE OF
TATTOOING. FROM MINIATURES TO LARGE COVERAGE.
ARTWORK DRAWING FROM AMERICAN, ORIENTAL
AND EUROPEAN TRADITIONS EXECUTED IN A FULL
COLOR RANGE BY THE ONLY WESTERN TATTOO
ARTIST EXTENSIVELY EXPERIENCED IN JAPAN.
THIS IS A STUDIO WHERE CONTEMPORARY TATTOO
STYLES ARE ORIGINATED, NOT IMITATED.

◎◎◎ Spends nearly three months tattooing an interlocking design of five dragons on torso of British tattooer Dennis Cockell, who visits San Francisco specifically for tattoo.

◎◎◎ In December, tattoos a coyote head on chest of actor and writer Peter Coyote. Coyote refers secretary of San Francisco chapter of Hells Angels, Sweet William (Bill Fritsch), to Hardy for tattoo with Buddhist imagery.

1975

◎◎◎ Hardy's mother, Mildred, dies of stroke.

◎◎◎ Passalacqua and Hardy begin making annual monthlong trips to Honolulu to work with Michael Malone, now tattooing out of China Sea Tattoo Co., Sailor Jerry's old shop.

1976

◎◎◎ In December, *In Celebration of Ourselves: California* opens at San Francisco Museum of Modern Art. Including works by Hardy, the exhibition is described by the museum as showing "contemporary folk art."

1977

◎◎◎ In January, opens a booth with Michael Malone at Tattoo 77, an international tattooing conference at the Holiday Inn in Reno. Some two hundred tattoo artists from ten countries attend the event, which is covered by the *Reno Gazette-Journal*, the *San Francisco Chronicle*, *Parade*, *Playboy*, and *Time*. At the convention Hardy meets Jack Rudy and "Good Time Charlie" Cartwright, East LA tattoo artists whose work draws from Chicano street culture.

◎◎◎ Hollywood tattoo artist Bob Roberts visits Realistic Tattoo Studio for a tattoo by Hardy.

◎◎◎ In spring, Hardy flies to Los Angeles to meet with Cartwright, Roberts, and Rudy and learn about their style of work.

◎◎◎ With Roberts, Hardy opens Tattoo City in San Francisco's Mission District to specialize in Chicano-style tattoos. Hires Chuck Eldridge and Jamie "La Palma" Sommers as apprentices.

◎◎◎ In October, buys Good Time Charlie's, Cartwright's East LA tattoo shop.

1978

@@@ A competitor buys East LA building housing Good Time Charlie's and evicts the business. Hardy buys nearby building at 6144 Whittier Boulevard and opens shop there, calling it Tattooland. Hires Jack Rudy and Freddy Negrete to work at new shop.

@@@ In June, Hardy's Mission District shop, Tattoo City, burns in an arson fire, an uninsured loss. Jamie Sommers begins to work with Hardy and Bob Roberts at Realistic Tattoo Studio.

1979

@@@ English tattoo artist Ron Ackers visits Hardy in San Francisco and invites him to England. Hardy travels to England, works in Ackers's shop in Portsmouth, and visits Dennis Cockell in London, where he also studies ukiyo-e prints by Utagawa Kuniyoshi at the Victoria and Albert Museum. Work trips to England follow in 1980, 1981, and 1983.

1980

@@@ In July, takes son Doug (then fourteen) on work trip to England. In London visits ska and punk clubs and draws portraits of people he sees there, his first drawings since 1967 not commissioned by a customer.

@@@ In August, *Skins & Skulls*, an exhibition of Hardy's London drawings, opens at Barbary Coast Gallery, San Francisco (fig. 37). Poster designer Leo Zulueta arranges for twenty-eight of the drawings to be reproduced in bound volumes for sale.

38
Cover of *Tattootime
No. 1: The New
Tribalism*, 1982
COLLECTION OF DON ED
HARDY

1981

◎◎◎ In January, marries Passalacqua in San Francisco.

◎◎◎ In May, Marcia Tucker, founder of the New Museum of Contemporary Art, New York, publishes "Tattoo" in *Artforum*. Article discusses history of tattooing and contemporary tattoo artists, concluding that "tattooing is finally once again coming into its own as another aspect of the fine arts."

◎◎◎ Leo Zulueta introduces Hardy to traditional tribal tattoos of South Pacific islands and to new designs based on their aesthetic.

1982

◎◎◎ Hardy and New Jersey tattoo artist and equipment supplier Ernie Carafa decide to create magazine on tattooing. With input from Leo Zulueta, Hardy decides to focus first issue on the "new tribalism" (fig. 38). Hardy writes majority of issue; Zulueta provides design assistance; writer and publisher V. Vale gives advice; Carafa provides funds. *Tattootime* is published by a Bay Area press.

◎◎◎ Makes plans to hold tattoo convention aboard steamship *Queen Mary*, docked in Long Beach Harbor.

◎◎◎ In June, Emiko Omori shows her short film on Hardy, *Tattoo City*, at Cinematheque at SFAI.

◎◎◎ Hardy forms Hardy Marks Publications with Passalacqua to publish future works.

◎◎◎ In November, Carafa, Hardy, and San Francisco silkscreen printer Ed Nolte hold Tattoo Expo '82 aboard *Queen Mary*, where they introduce *Tattootime No. 1: The New Tribalism*. Event includes discussions, slideshows, and a lecture by University of California, Los Angeles, art historian Dr. Arnold Rubin. Invites Japanese tattoo artist Horiyoshi II (Tomotsu Kuronuma), who does not attend. Horiyoshi II's publisher, Kunihiro Shimada, attends event and agrees to introduce Hardy to Horiyoshi II in Japan.

1983

◎◎◎ During spring, Italian television producers and journalists Simona Carlucci and Giorgio Ursini ask Hardy to co-curate tattoo exhibition in Rome the following year. Carlucci and Ursini assume responsibility for funding and organizing.

◎◎◎ In spring, goes to Japan to meet with Shimada and Horiyoshi II. Visits Donald Richie, co-author of *Irezumi*, sparking a close friendship with Richie. With friend Dan Thome, travels to Palau, where Hardy sets up makeshift tattoo operation on beach near capital of Koror.

◎◎◎ Visits Japan and takes apartment in low-rent Tokyo residential hotel, where he tattoos for long hours. Visits Yokohama and meets Horiyoshi III (Yoshihito Nakano). Will travel to Japan once or twice a year until early 1990s.

◎◎◎ In October, publishes *Tattootime No. 2* and *No. 3*, *Tattoo Magic* and *Music & Sea Tattoos*, respectively.

1984

◎◎◎ Sells Tattooland, his East LA tattoo parlor. Passes on furnishings and name to Jack Rudy.

◎◎◎ Hires cartoonist Bill Salmon and poster designer Greg Irons to work at Realistic Tattoo Studio.

◎◎◎ Simona Carlucci and Giorgio Ursini advise Hardy that the Cultural Arts Council of the City of Rome will sponsor and fund tattoo exposition there.

◎◎◎ In September, visits Hong Kong and Japan with son Doug, now almost eighteen. Pinky Yun (Bing Kuan), of Hong Kong and Alameda, California, acts as host and tour guide. Visits Horiyoshi III in Yokohama and invites him to participate in Rome exhibition.

◎◎◎ In November, after working at Realistic Tattoo for a month, Irons travels to Asia and is killed by city bus in Bangkok. Hardy hires Freddy Corbin, Daniel Higgs, and Dan Thome, originally from Guam, to work at shop.

39
DON ED HARDY
Rockabilly-style tattoo
on woman's arm,
Tokyo, Japan, 1991
COLLECTION OF THE
ARTIST

◎◎◎ Spends much of December organizing Rome tattoo exposition, selecting participants and soliciting catalogue essays.

1985

◎◎◎ In May, *L'Asino e la Zebra* (*The Donkey and the Zebra*) opens in Mercato di Traiano (*Trajan's Market*), in Rome, for monthlong run. Drawing some thirty thousand visitors, exposition features tattoo artists working in open air, displays of flash and photographs, and stages on which people display their tattoos.

◎◎◎ In August, goes to Japan with Passalacqua and rents apartment. Discovers strong demand among young Japanese for tattoos with rockabilly and East-West fusion designs (fig. 39). Returns to San Francisco to learn that mentor Gordon Cook has died of heart attack at age fifty-seven.

1986

◎◎◎ Visits San Diego tattoo convention with Horiyoshi III. The two travel to Honolulu to visit Michael Malone. Hardy surfs off Waikiki Beach. Upon returning to San Francisco, orders surfboard and starts surfing off San Francisco's Ocean Beach. Moves to Honolulu by December.

235

40
DON ED HARDY
Freeway Panther
(tattoo on man's back),
1991
COLLECTION OF THE
ARTIST

1990

◎◎◎ In February, gives lecture "Tattoos in History and Today" at Fort Mason Center, San Francisco.

◎◎◎ In November, one of Hardy's works is included in *Artists of Hawaii*, an annual juried exhibition of work by artists living in Hawaii, at Honolulu Academy of Arts (renamed Honolulu Museum of Art in 2012).

1987

◎◎◎ In February, begins work on small acrylic paintings of albino gorillas and later paints in watercolor. Makes his first *Rock of Ages* watercolor, repurposing classic tattoo design.

◎◎◎ In December, publishes *Tattootime No. 4: Life & Death Tattoos*.

◎◎◎ Starts decadelong practice of tattooing while in San Francisco and Tokyo and painting his own work and publishing books through Hardy Marks while in Honolulu.

1991

◎◎◎ Does last tattoo at Realistic Tattoo Studio. Closes shop and opens new Tattoo City on Columbus Avenue, in San Francisco's North Beach neighborhood. Executes what he considers one of his most extraordinary tattoos, *Freeway Panther*, on back of Don Pugsley, who visits San Francisco from Chicago expressly for tattoo (fig. 40).

◎◎◎ In June, publishes *Tattootime No. 5: Art From the Heart*, the magazine's last issue.

1989

◎◎◎ In October, *Día de los Muertos*, a group exhibition that includes Hardy's drawings and watercolors, opens at Galería de la Raza, in San Francisco's Mission District.

◎◎◎ In late October, lectures on tattooing in history, culture, and modern life in connection with *Modern Primitives*, a photography exhibition featuring images of body modifications organized by V. Vale and Andrea Juno and held in Southern Exposure Gallery at Project Artaud, San Francisco.

1992

◎◎◎ Visits New York and sees exhibition of etchings by Chicago artist Tony Fitzpatrick. Purchases one of Fitzpatrick's works and arranges to meet the artist in Chicago.

◎◎◎ Lectures at University of Wisconsin– Green Bay, at invitation of art professor Davey Damkoehler, who uses *Tattootime* as textbook.

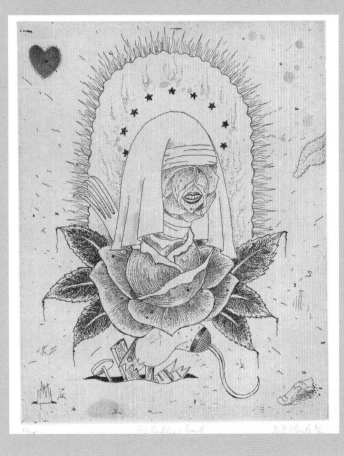

41
DON ED HARDY
The Endless Event,
1992. Etching, 18 ⅛ x 15
in. (46 x 38.1 cm)
FINE ARTS MUSEUMS OF
SAN FRANCISCO, GIFT OF
THE ARTIST, 2017.46.61

◎◎◎ Meets Fitzpatrick in Chicago and later begins etching at Fitzpatrick's Big Cat Press with master printer Steve Campbell, creating works in style akin to tattoo flash (fig. 41).

◎◎◎ In March, *Forever Yes: Art of the New Tattoo*, an exhibition of tattoo photographs, opens at Bryce Bannatyne Gallery, Santa Monica, co-curated by Bannatyne and Hardy. Hardy Marks publishes catalogue. Show travels to Academy Art Center at Linekona.

◎◎◎ In September, curates *Rocks of Ages* at La Luz de Jesus Gallery, Los Angeles. Exhibition includes contemporary works by Hardy and other tattoo artists and historic versions of rock of ages images. Hardy Marks publishes catalogue in form of hymnal. Rock of ages tattoo designs, executed by Hardy on paper, are included in one hundred copies of catalogue.

◎◎◎ Son Doug moves to Honolulu to tattoo with Michael Malone at China Sea Tattoo Co.

◎◎◎ In November, *Death or Glory*, Hardy's first solo art exhibition, opens at Fitzpatrick's World Tattoo Gallery, Chicago.

1993

◎◎◎ In March, *Drawings that Last a Lifetime*, an exhibition of recent prints by Hardy, opens at Janet Fleisher Gallery, Philadelphia, alongside *White Circus*, an exhibition of drawings and prints by Tony Fitzpatrick.

◎◎◎ In April, Hardy's solo exhibition *Death or Glory* opens at La Luz de Jesus Gallery, Los Angeles.

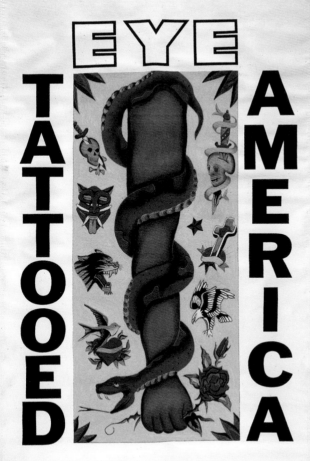

42
DON ED HARDY
*Eye Tattooed
America* banner, 1993.
Acrylic on canvas
COLLECTION OF THE
ARTIST

1994

⌾⌾⌾ Loans various flash to *Flash from the Past*, an exhibition of early twentieth-century tattoo flash at Hertzberg Circus Museum, San Antonio, Texas. Catalogue published by Hardy Marks.

⌾⌾⌾ Supervises publication of *Freaks, Geeks, and Strange Girls*, by Jim Secreto, Teddy Varndell, Johnny Meah, and Randy Johnson. Book on banner painting in America is Hardy Marks's first publication not related to tattoos.

⌾⌾⌾ Has solo exhibitions at Cavin-Morris Gallery and Edward Thorp Gallery, both in New York City.

⌾⌾⌾ In December, *Sensitive Issues*, an exhibition of new work by Hardy, opens at La Luz de Jesus Gallery, Los Angeles.

1995

⌾⌾⌾ In March, creates *Tattoo Royale Suite*, seven lithographs based on classic tattoo imagery, with printer Bud Shark at Shark's Ink, a fine-art printer in Boulder, Colorado (now in Lyons, Colorado)(fig. 43). Creates *Frontier Justice* at Shark's Ink in honor of father. Goes on to create lithographs with Shark in 1999, 2001, 2005, 2007, 2009, 2011, and 2016.

⌾⌾⌾ In June, co-curates *Eye Tattooed America* with Ann Nathan (fig. 42). Exhibition of tattoo-inspired art opens at Ann Nathan Gallery, Chicago, and travels to University of Iowa Museum of Art, Iowa City (1994); Milwaukee Institute of Art and Design, Wisconsin (1994); Virginia Beach Center for the Arts, Virginia (1995); and Laguna Art Museum, Laguna Beach, California (1995). Catalogue published by Hardy Marks.

⌾⌾⌾ In November, Hardy's works included in annual *Artists of Hawaii* exhibition at Honolulu Academy of Arts.

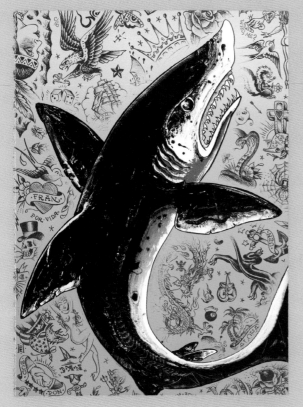

◎◎◎ In May, travels to Japan with Passa-lacqua. Creates *The Mysterious East*, a set of eight color etchings based on Japanese mythology, traditions, and iconic imagery, with printer Paul Mullowney at Kurumaki Studio in Nara, Japan (figs. 44, 45; pl. 106). While there Hardy learns that his father, Sam, has died.

◎◎◎ In July, *Flash Art Paintings* opens at Ruth Braunstein's Braunstein/Quay Gallery, San Francisco, featuring works by Hardy, Tom Bolles, and Richard Carter.

◎◎◎ In September, *Drawings that Last a Lifetime* opens at Janet Fleisher Gallery, Phila-delphia, including prints by Hardy. An exhibition of tattoo drawings by Sailor Jerry and Rosie Camanga runs concurrently.

◎◎◎ In September, *Lasting Impressions: Tattoo Imagery in Fine Prints*, featuring prints by Hardy and Fitzpatrick, opens at Quartet Editions gallery, New York.

◎◎◎ In September, *Pierced Hearts and True Love: A Century of Drawings for Tattoos*, an exhibition of tattoo art organized by Hardy and cultural anthropologist and tattoo artist Mike McCabe, opens at the Drawing Center, New York. Opening draws overflow crowd, and atten-dance is strong throughout exhibition's run. The *New York Times* publishes review titled, "Tattoo Moves from Fringes to Fashion. But Is It Art?" Exhibition travels to Williams College Museum of Art, Williamstown, Massachusetts (1995); Museum of Contemporary Art, North Miami, Florida (1996); Yerba Buena Center for the Arts, San Francisco (1996); Contemporary Arts Center, Cincinnati, Ohio (1996); Vancouver Art Gallery, British Columbia (1997); and Edmonton Art Gallery, Alberta (1997).

◎◎◎ In November, Hardy's work appears in *Artists in Hawaii* exhibition at Honolulu Academy of Arts.

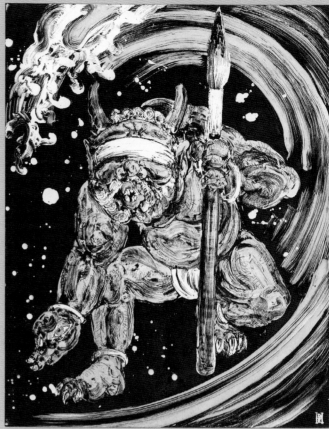

@@@ In December, *In the Light of Goya*, featuring prints by Francisco Goya and work by contemporary artists inspired by his work, opens at University of California, Berkeley Art Museum and Pacific Film Archive. Includes works by Enrique Chagoya, Hardy, Nathan Oliveira, and other Bay Area artists.

1996

@@@ In February, gives talk at SFAI.

@@@ In July, *Out of the Skin: Work by Tattooers*, featuring work by Hardy, Michael Malone, Bob Roberts, and others, opens at Braunstein/Quay Gallery, San Francisco.

@@@ *World Art* magazine publishes "Adventures in the Skin Trade," by Alice Joanou, an analysis of the work of Joan Brown, Gordon Cook, and Hardy that notes the influence of Brown's and Cook's "blue collar" aesthetic on Hardy's paintings and tattoos.

1997

@@@ Hardy Marks publishes *My Face for the World to See: the Diaries, Letters, and Drawings of Candy Darling*, featuring materials created by transgender actress who appeared in Andy Warhol's films.

@@@ Hardy's work included in group exhibition *Art and Provocation: Images From Rebels*, at Boulder Museum of Contemporary Art, Colorado.

@@@ Los Angeles artist Manuel Ocampo introduces Hardy to television writer Tom Patchett, owner of Track 16 Gallery, Santa Monica. Patchett and Track 16 curator Laurie Steelink visit San Francisco to see Hardy's work, and Patchett offers him joint exhibition with Ocampo at his gallery.

⊚⊚⊚　In September, *Permanent Curios* opens at Track 16 Gallery. Hardy and Ocampo design show around tattoos and construct small structure in gallery that mimics tattoo shop. Hardy contributes text to exhibition catalogue titled *Permanent Curios: Memories of a Beautician.*

⊚⊚⊚　In September, exhibition of Hardy's new paintings on paper opens at Braunstein/Quay Gallery, San Francisco, alongside works by Houston artists Jack Massing and Michael Galbreth, known collectively as the Art Guys.

1998

⊚⊚⊚　*Panoply of Wonders*, a solo exhibition of Hardy's work, opens at Art Guys Gallery, Houston. At gallery Hardy meets curator Walter Hopps, formerly of Los Angeles's Ferus Gallery and art hero to Hardy in his youth. Hopps purchases Hardy etchings, and the two remain close until Hopps's 2005 death.

⊚⊚⊚　*Some Weird Beauty*, a solo exhibition of Hardy's work, opens at Boulder Museum of Contemporary Art, Colorado.

⊚⊚⊚　In November, *Bibelots*, an exhibition of Hardy's paintings and prints, opens at Catharine Clark Gallery, San Francisco, alongside paintings by Travis Somerville.

1999

⊚⊚⊚　In August, exhibits acrylics on paper in *New Religion*, an exhibition at Tacoma Art Museum, Washington.

⊚⊚⊚　Michael Malone calls with news that Philadelphia clothing merchant Larry McGearaty, who sells American clothing in Japan, wants to license Sailor Jerry's designs. Malone asks Hardy to help arrange transaction.

⊚⊚⊚　Hardy starts creating *Ghost Writer* paintings. The white images on dark backgrounds are inspired by Morris Graves's light-on-dark paintings and an image from Hardy's childhood.

⊚⊚⊚　In November, *Tattooing the Invisible Man: Bodies of Work, 1955–1999*, a solo retrospective exhibition curated by Laurie Steelink, opens at Track 16 Gallery, Santa Monica. Featured works range from flash drawings from Hardy's childhood to his most recent paintings. Also includes photographs of his tattoo commissions. Hardy Marks and Smart Art Press, Santa Monica, copublish illustrated catalogue with text by Hardy (fig. 46).

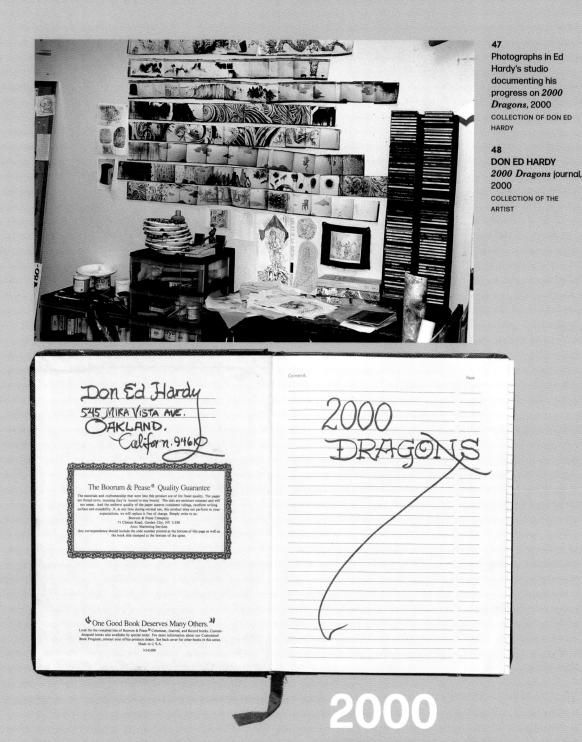

47
Photographs in Ed Hardy's studio documenting his progress on *2000 Dragons*, 2000
COLLECTION OF DON ED HARDY

48
DON ED HARDY
2000 Dragons journal, 2000
COLLECTION OF THE ARTIST

2000

◎◎◎ In December, Oakland mayor Jerry Brown appoints Hardy to Oakland Cultural Affairs Commission. *San Francisco Chronicle* publishes editorial "Tattoos Are Art, Too." Meets Oakland artist Hung Liu, who also serves on commission, which Hardy resigns from after ten months.

◎◎◎ On January 1, begins painting *2000 Dragons* on a 500-foot-long roll of Tyvek in small studio. Continues to tattoo four days a week at Tattoo City. Keeps journal detailing progress of *2000 Dragons*, recording how many dragons and feet of Tyvek he has painted each day and photographing his progress (figs. 47, 48).

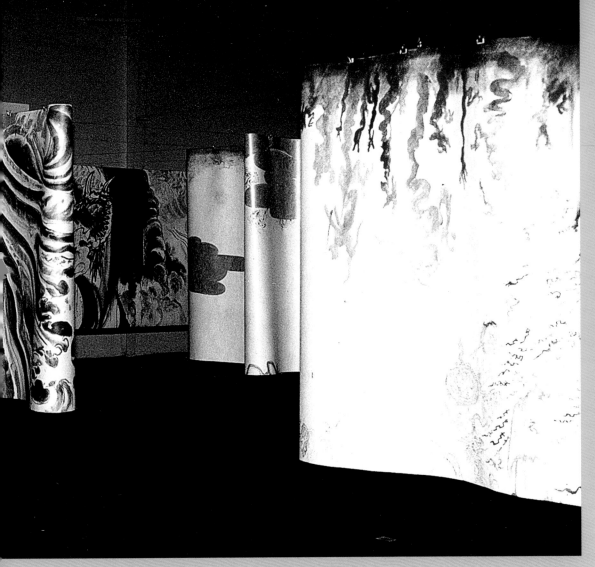

49
DON ED HARDY
Installation at Track 16
Gallery, Santa Monica,
California, 2000. *2000
Dragons*, 2000. Acrylic
on Tyvek, 51 in. x 500 ft.
(1.3 x 1,524 m)
FINE ARTS MUSEUMS OF
SAN FRANCISCO, GIFT OF
THE ARTIST, 2019.34

◎◎◎ In May, receives honorary doctorate degree from SFAI.

◎◎◎ In July, lectures at SFAI on influence of Japanese and other Asian cultures on current American tattooing. Talk sponsored by the Japan Society.

◎◎◎ In late July, finishes *2000 Dragons* (pl. 151) after fifty-two days of painting over seven-month period.

◎◎◎ In November, *2000 Dragons & Related Paintings* opens at Track 16 Gallery, Santa Monica, alongside works by Enrique Chagoya. Curator Laurie Steelink hangs dragon scroll from overhead in serpentine design (fig. 49). Hardy and Steelink co-author accompanying catalogue. *2000 Dragons* travels to Museum of Contemporary Art Denver and is chosen to represent United States in Cuenca (Ecuador) Biennial. Also exhibited in Guayaquil and Quito, Ecuador. Travels to Yerba Buena Center for the Arts, San Francisco (2002); Academy Art Center at Linekona (2004); and DiverseWorks, Houston (2012).

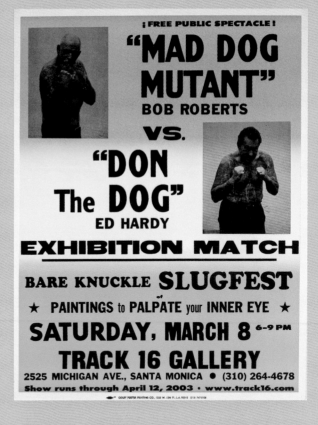

2001

◎◎◎ In January, solo exhibition of works on paper, *New Gods*, opens at Catharine Clark Gallery, San Francisco.

◎◎◎ In September, solo exhibition of paintings, *Asian Waves*, opens at Babilonia 1808, Berkeley.

2002

◎◎◎ In May, solo exhibition *The Elephants' Graveyard: Paintings & Prints* opens at Frederick Spratt Gallery, San Jose.

2003

◎◎◎ In March, *Exhibition Match*, an exhibition of paintings by Hardy and Bob Roberts styled as a boxing match between the two artists, opens at Track 16 Gallery, Santa Monica (fig. 50). *Juxtapoz* runs feature on exhibition that includes photographs of paintings and an article on Hardy and Tattoo City.

◎◎◎ After reading *Juxtapoz* article, fashion designer Tatsuro Ishihara contacts Hardy. With Steven Hoel, Ishihara runs KU USA, which markets a line of Asian-influenced casual wear sold on Hollywood's Melrose Avenue and in Tokyo. Hardy licenses some tattoo designs to KU USA.

◎◎◎ In October, *Global Elegies: Art and Ofrendas for the Dead*, featuring works by Hardy and José Guadalupe Posada, opens at Oakland Museum of California.

2004

◎◎◎ French fashion designer Christian Audigier sees Ed Hardy shirts in KU store in Hollywood and contacts Steven Hoel about licensing designs to Audigier's company, Nervous Tattoo, Inc. Hardy, Hoel, and Ishihara form limited liability company, Hardy Life LLC, which licenses Hardy's designs to Nervous Tattoo.

◎◎◎ Oceania Gallery in Honolulu mounts *Recent Paintings*, a solo exhibition of Hardy's works.

In April, *Post-Tattoo: Works by Kandi Everett, Don Ed Hardy, and Mike Malone*, including Hardy's acrylic paintings on paper and on Tyvek, opens at the Contemporary Museum, Honolulu.

2005

In February, *Ghost Writers and Automatics*, including Hardy's recent paintings, opens at Track 16 Gallery, Santa Monica.

In February, clothing with Ed Hardy designs is a big hit at Las Vegas trade show. Nervous Tattoo markets wide array of Hardy-branded merchandise globally, and brand becomes very successful (fig. 51).

Indelible Voyage, a solo exhibition of Hardy's works, opens at Instituto de Artes Gráficas, Oaxaca, Mexico.

In August, *Wood Skin Ink: The Japanese Aesthetic in Modern Tattooing* opens at Hui No'eau Visual Arts Center, Makawao, Maui, Hawaii. Includes works on paper by Hardy and four other American and Japanese tattoo artists and selections of ukiyo-e prints from Japan's Edo period. Hardy leads walk-through of exhibition with scholar Roger Keyes and gives lecture, "Ukiyo-e: Nineteenth-Century Japanese Art Floating in Twenty-First-Century Bodies" during three-day conference.

In November, *Recent Paintings, Drawings, and Prints: Don Ed Hardy and Michael Krueger* opens at Dennis Morgan Gallery, Kansas City, Missouri.

2008

⊚⊚⊚ Completes his last tattoo at Tattoo City: a dragon on Tattoo City tattoo artist Mary Joy.

⊚⊚⊚ Visits Arita, Japan, again to make hand-painted vases and *Ghost* porcelains.

⊚⊚⊚ In May, *West Meets East*, a solo exhibition of acrylic and mixed-media paintings, opens at Track 16 Gallery, Santa Monica.

⊚⊚⊚ Hardy Marks publishes *2000 Dragons*, which reproduces entire scroll in a series of plates printed from high-resolution digital photographs made with the assistance of David Salgado, of Trillium Graphics, Brisbane, California.

⊚⊚⊚ In July, *Creature Feature*, with acrylic paintings by Hardy and works by John Bankston, Rupert Garcia, and others, opens at Rena Bransten Gallery, San Francisco.

⊚⊚⊚ Filmmaker Emiko Omori releases feature-length documentary *Ed Hardy: Tattoo the World*. Film premieres at 2009 Honolulu International Film Festival and is also shown at Ashland Independent Film Festival, Oregon; Mill Valley Film Festival, California; San Francisco's DocFest; Hammer Museum, Los Angeles; Honolulu Academy of Arts; Museum of Modern Art, New York; and the de Young, San Francisco.

2006

⊚⊚⊚ In March, Ed Hardy–brand clothing and merchandise are featured at 2006 MAGIC apparel show, in Las Vegas.

⊚⊚⊚ Hardy visits Arita, Japan, to make hand-painted porcelains at Risogama studio (fig. 52).

⊚⊚⊚ In October, lectures about his art at Mills College Concert Hall, Oakland.

2007

⊚⊚⊚ Begins creating hand-painted porcelain in traditional Japanese forms and as a series of small, oddly shaped forms that he calls *Ghosts*.

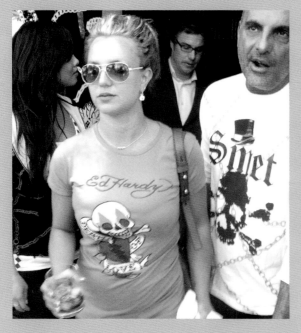

⑨⑨⑨ The Ed Hardy brand continues to grow in popularity, bolstered by Christian Audigier's marketing strategy of giving free Ed Hardy clothing to celebrities and having them photographed wearing it (fig. 53).

⑨⑨⑨ Creates a series of resin-coated paintings on panels, disks, and boogie boards at Trillium Graphics, in Brisbane, California.

⑨⑨⑨ In December, *Duo Mysto*, featuring tattoo art by Hardy and ceramic sculptures by Ron Nagle, opens at Rena Bransten Gallery, San Francisco. Exhibition explores influence of American pop culture and Japanese traditions on the two artists' work.

2009

⑨⑨⑨ TeNeues Publishing Group publishes *Ed Hardy: Beyond Skin*, by Alan Govenar and Don Ed Hardy (fig. 54).

⑨⑨⑨ In December, *The Beats and Popular Culture: Don Ed Hardy, Tattooing, and the Beat Generation* opens at the Beat Museum, San Francisco, with reception and book signing by Hardy.

2010

⑨⑨⑨ In June, *Art Shack* opens at Laguna Art Museum, Laguna Beach, California. Sponsored by surf brand Hurley, exhibition includes work by Sandow Birk, Hardy, and Travis Somerville that explores the concept of the "shack." Hardy contributes *Tat Cat Shack (Tattoo Hut)* (2010), a tattoo parlor in a shack, complete with tattoo machine.

⑨⑨⑨ In November, *Beyond Fashion: The Personal Art of Ed Hardy*, featuring Hardy's paintings, drawings, etchings, and ceramics, opens at Robyn Buntin of Honolulu Gallery.

2011

⑨⑨⑨ In June, *The Unruly Art of Don Ed Hardy* opens at San Francisco Museum of Modern Art's Artists Gallery, at Fort Mason Center.

⑨⑨⑨ In July, Hardy hires author and *San Francisco Chronicle* music critic Joel Selvin to co-author memoir.

⑨⑨⑨ In November, *Don Ed Hardy: New Works*, including paintings and sculpture, opens at Rena Bransten Gallery, San Francisco.

2012

🌀🌀🌀 In April, exhibits work in *Biennial of Hawai'i Artists X*, at Honolulu Museum of Art (formerly Honolulu Academy of Arts).

🌀🌀🌀 In April, *Art for Life* opens at B. Sakata Garo Gallery, Sacramento, California.

🌀🌀🌀 In June, *More Works*, an exhibition of paintings, opens at Art Guys Gallery, Houston.

🌀🌀🌀 In June, *Including, But Not Limited To: The Art of Don Ed Hardy* opens at Bolinas Museum, California.

2013

🌀🌀🌀 Thomas Dunne Books/St. Martin's Press, New York, publishes *Wear Your Dreams: My Life in Tattoos*, Hardy's memoir written with Joel Selvin (fig. 55).

🌀🌀🌀 In September, *Don Ed Hardy Paintings*, including series *12 Dragons for 2012 (Spectrum)*, is on view for three days at Originality Square Metal Warehouse gallery, in Beijing's 798 Art District, a large group of former military factories converted into galleries, shops, and cafes. Hardy Marks publishes catalogue.

🌀🌀🌀 In October, lectures at ninth annual Bay Area Convention of the Tattoo Arts, held at Hyatt Regency San Francisco Airport, Burlingame, California.

2014

🌀🌀🌀 Receives Helena Modjeska Cultural Legacy Award for lifetime achievement from Arts Orange County, Costa Mesa.

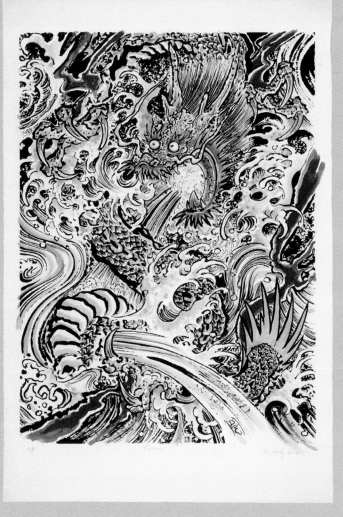

2015

In May, *Tatoueurs, Tatoués (Tatooists, Tattooed)* opens at the Musée du Quai Branly, Paris. Exhibition explores history and evolution of tattooing over five thousand years. Includes works by Hardy and letters written to him from Sailor Jerry. Retitled as *Tattoos: Ritual. Identity. Obsession. Art.*, the exhibition travels to Royal Ontario Museum, Toronto (2016); Field Museum, Chicago (2016–2017); and Natural History Museum, Los Angeles (2017–2018).

Creates two prints, *Cosmo* and *Turner*, at Magnolia Editions, Oakland (figs. 56, 57).

Hardy Marks publishes *"Lew the Jew" Alberts: Early 20th Century Tattoo Drawings.* With an essay by Hardy, the book chronicles life of New York tattoo artist Albert Kurzman, the first to design and market sheets of flash for other tattoo artists and a designer of electric tattoo machines.

In May, exhibits works in *Pictures of the Gone World: Don Ed Hardy & Co.*, at Kings Avenue Tattoo, New York City.

In October, *Ed Hardy: Visionary Subversive*, featuring multiple large-scale paintings, opens at Varnish Fine Art gallery, in San Francisco.

Creates two tapestry editions, *Rose* and *Face*, each in an edition of six, with Magnolia Editions, Oakland, California. Both tapestries feature designs inspired by tiger skins and Tibetan tiger rugs.

In December, *Inside Magnolia Editions: Collaboration and Innovation*, featuring works by Hardy, opens at Sonoma County Museum, Santa Rosa, California (now the Museum of Sonoma County, 2018).

2016

In February, Hardy and master printer, friend, and collaborator Paul Mullowney present lecture in Doris Duke Theatre of the Honolulu Museum of Art to kick off *88th Annual Honolulu Printmakers Juried Exhibition*, at Honolulu Museum of Art School. Hardy creates *Dreamer* (2016) as the limited-edition gift print to be sold to benefit the Honolulu Printmakers Collective.

2017

In April, SFAI honors Hardy and five other visionaries at its annual gala fundraiser.

In October, donates 156 of his prints to Achenbach Foundation for Graphic Arts at Fine Arts Museums of San Francisco.

2018

In July, the Contemporary Jewish Museum, San Francisco, hosts *Lew the Jew and His Circle: Origins of American Tattoo*, featuring drawings, photographs, and artifacts from Hardy's collection.

2019

In July, the de Young hosts *Ed Hardy: Deeper than Skin—Art of the New Tattoo*, the artist's first museum retrospective (fig. 58).

Acknowledgments

Karin Breuer
Curator in Charge
Achenbach Foundation for Graphic Arts
Fine Arts Museums of San Francisco

I am pleased

TO ACKNOWLEDGE THE MANY INDIVIDUALS at the Fine Arts Museums of San Francisco and beyond who generously contributed their time and efforts to make the preparation of the exhibition and this catalogue a memorable and gratifying experience. First among these persons is Don Ed Hardy, who spurred institutional thinking about a retrospective with the 2017 donation of his own print oeuvre (152 prints ranging in date from 1962 to 2016). He also made his extensive personal archive available to the Museums for exhibition planning and selection. Don spent countless hours identifying tattoo designs for a wide-eyed curator and conservators, and he also carefully explained the various media used to draw traditional tattoo flash preparatory drawings, as well as the unusual papers and materials used in his fine art practice. One of these was Tyvek, the synthetic material produced in rolls that he used to create *2000 Dragons* (2000), the epic, 500-foot-long scroll that he generously donated to the Museums this year, and which will be a highlight of the show. Additionally, he shared the many archival photographs used throughout this publication, answered countless queries, and made himself readily available to work with all staff during the preparation of our project together.

I thank my colleague in the Achenbach Foundation for Graphic Arts, associate curator Colleen Terry, who first catalogued the Don Ed Hardy print donation, and provided much-needed support during the exhibition planning. Special thanks are offered to paper conservator Victoria Binder, who enthusiastically embraced this project from its beginnings by assessing works in Hardy's studio, overseeing necessary treatments in the conservation lab, and preparing models for the innovative installation of diverse support materials such as tracing paper, *amate*, and Tyvek. She was joined in her efforts by paper conservation graduate intern, Allison Brewer. Essential advice and guidance was provided by our head of paper conservation, Debra Evans. I further thank Sarah Gates, head of textile conservation; Tricia O'Regan, paintings conservator; and Jane Williams, head of objects conservation, for their work with the textiles, paintings, and three-dimensional works in the program. Additionally, Abigail Dansiger, head of library and archives, provided the necessary volumes for deeper research into the art of the tattoo.

A major exhibition of this scale would not be possible without the support of many of our staff members in the exhibitions and registration departments. I extend my gratitude to Krista Brugnara, director of exhibitions; Caroline McCune, senior exhibitions coordinator; Tristan Telander, exhibition designer; and Kate Agarwal, exhibition graphic designer. Further appreciation is given to Ryan Butterfield, chief preparator; Don Larsen, senior museum technician; Osvaldo Ruiz, senior museum technician; and Polixeni Theodorou, museum technician. A key team of museum registrars was enlisted during the organization of this 350-object exhibition. Nadia Ghani, museum registrar; Douglas DeFors, associate registrar; Rebecca Drudge, assistant registrar; and Egle Mendoza, assistant registrar, provided transportation logistics, cataloguing, and on-the-ground expertise during all

phases of the exhibition preparation. Outside of the Museums, I am grateful to Paul Mullowney, of Paul Mullowney Press in San Francisco, and Bud Shark, of Shark's Ink in Lyons, Colorado, who both provided insights into Hardy's work in prints since 1995. Craig Okino, of Okino Graphics in Honolulu contributed valuable digital files from previous Hardy monographs and publications.

I acknowledge with thanks the essay authors for this volume: Sherry Fowler with Dale Slusser, Jeff Gunderson, and Joel Selvin. Their contributions have enabled us to present the work of Ed Hardy in a new and exciting scholarly light. I am further grateful to Timothy N. Brown, who compiled and prepared the extensive chronology found in these pages. I owe a debt of gratitude to Leslie Dutcher, the Museums' director of publications, who managed the concept and overall production of this catalogue. She was ably assisted by Victoria Gannon, editor, who oversaw the editorial program, along with help from Trina Enriquez, editor, and Kate Bove, associate editor. José Jovel, publications assistant, coordinated the catalogue photography. For new imagery, Sue Grinols, director of photo services, made all the necessary arrangements; Randy Dodson, head photographer, created fresh photography; and Robert Carswell, digital assets and rights manager, handled the particulars to share the imagery across the institution. Martin Venezky of Appetite Engineers, San Francisco, provided the innovative book design that is truly a wonderful tribute to Hardy's art. The beautiful color reproductions were created by Rusty Sena and Carlos Rangel of ArtProduct, Los Angeles. The fine printing and binding of this volume was done by Dr. Cantz'sche Druckerei Medien GmbH, Germany, under the meticulous guidance of Klaus Prokop. This book is distributed in the trade by Rizzoli Electa. There, I am immensely appreciative of the many publishing insights brought to us by their team, including Charles Miers, publisher, and Margaret Rennolds Chace, associate publisher, along with their colleagues Jennifer Duardo, Klaus Kirschbaum, and Loren Olson. This catalogue is published with the support of the Andrew W. Mellon Foundation Endowment for Publications.

This project was originally endorsed by Max Hollein, our former director and CEO, and it was championed through to its completion by Thomas P. Campbell, our new director and CEO, who has been a tremendous support in its creation. I am further grateful to our Board of Trustees, led by Diane B. Wilsey, along with Ed Prohaska, chief financial officer; Megan Bourne, chief of staff; and Melissa E. Buron, director of the art division, for their advocacy. Elsewhere in the Museums, I extend my heartfelt thanks to: Linda Butler, director of marketing, communications, and visitor experience; Sheila Pressley, director of education, and Emily Jennings, director of education, school and family programs; Amanda Riley, director of development; Stuart Hata, director of retail operations, and Tim Niedert, book and media manager; Jason Seifer, director of finance; Jenny Sonnenschein, executive assistant to the director and CEO; and Lexi Paulson, administrative assistant for the art division. Last of all, I thank The Herbst Foundation, Inc. for its major support of the presentation.

◎◎◎

About the Authors

Karin Breuer IS THE CURATOR IN CHARGE of the Achenbach Foundation for Graphic Arts at the Fine Arts Museums of San Francisco. Her recent publications include *Japanesque: The Japanese Print in the Era of Impressionism* (2010) and *Ed Ruscha and the Great American West* (2016).

Sherry Fowler IS A PROFESSOR of Japanese art history, with a specialization in Japanese Buddhist art, at the University of Kansas, Lawrence. Her publications include *Murōji: Rearranging Art and History at a Japanese Buddhist Temple* (2005) and *Accounts and Images of Six Kannon in Japan* (2016).

Jeff Gunderson IS THE LIBRARIAN AND ARCHIVIST at the San Francisco Art Institute. He has written on the history of California photography and the San Francisco art scene of the 1940s, and contributed, most recently, to *Black Power / Flower Power: Photographs by Pirkle Jones and Ruth-Marion Baruch* (2012).

Joel Selvin IS AN AWARD-WINNING JOURNALIST who covered pop music for the *San Francisco Chronicle* from 1970 to 2009 and has written sixteen books on the subject. Selvin contributed to *Summer of Love: Art, Fashion, and Rock and Roll* (2017) and coauthored Ed Hardy's memoir, *Wear Your Dreams: My Life in Tattoos* (2013).

Dale Slusser, AN EXPERT ON JAPANESE ARTS, is currently the associate vice-president of development for the KU Endowment, in Lawrence, Kansas.

◎◎◎

Credits

Text

CATALOGUE CITATIONS: The catalogue citations are from Don Ed Hardy and Alan B. Govenar, *Ed Hardy: Beyond Skin* (Kempen, Germany: TeNeues, 2009). **p. 167:** *Beyond Skin*, 178; and **p. 207:** *Beyond Skin*, 26.

DECORATIVE QUOTATIONS: Unless otherwise noted, all decorative quotations are from Joel Selvin and Don Ed Hardy, *Wear Your Dreams: My Life in Tattoos* (New York: Thomas Dunne Books/St. Martin's Press, 2013). **Back cover:** *Wear Your Dreams*, 281; **p. 1:** M. Revelli, "Don Ed Hardy," *Juxtapoz Art & Culture Magazine*, June 2011, 42; **p. 50:** *Wear Your Dreams*, 279; **p. 58:** *Wear Your Dreams*, 57; **p. 72:** *Wear Your Dreams*, 138; **p. 96:** *Wear Your Dreams*, 7; **p. 124:** *Wear Your Dreams*, 228; **p. 166:** *Wear Your Dreams*, 229; **p. 178:** *Wear Your Dreams*, 256; **p. 196:** *Wear Your Dreams*, 257; and **p. 207:** *Wear Your Dreams*, 6.

Art

All works of art by Don Ed Hardy are copyright © 2019 Don Ed Hardy.

FIGURE ILLUSTRATIONS: **1:** Courtesy of Don Ed Hardy; Photograph by Kay Talbott; **2–3:** Courtesy of Don Ed Hardy; Photograph by Don Ed Hardy; **4, 7, 13, 16–17, 25, 28–29, 31, 36–38, 41–46, 48, 54–58:** Fine Arts Museums of San Francisco / Photograph by Randy Dodson; **5–6, 8–10, 15, 33–35, 39–40:** Courtesy of Craig Okino, Okino Graphics, Honolulu; **11, 49:** Photograph by Mary Lynn Price; **12:** Getty Images; Photograph by Niki Nikolova; **14, 26:** Courtesy of Shark's Ink, Lyons, Colorado; Photograph by Bud Shark; **18:** Photograph © 2019 Museum of Fine Arts, Boston; **19, 24, 27, 47:** Courtesy of Don Ed Hardy; **20:** Courtesy of the Estate of John Altoon and Kohn Gallery, Los Angeles; **21:** Courtesy of the San Francisco Art Institute Archives; **22:** © Estate of Gordon Cook; Photograph by Randy Dodson, FAMSF; **23:** © The Joan Brown Estate; Photograph by Randy Dodson, FAMSF; **30, 32:** Courtesy of Craig Okino, Okino Graphics, Honolulu; Photograph by Mildred Hardy; **50, 52:** Courtesy of Track 16 Gallery, Los Angeles; **51:** Alamy Stock Photo; Photograph by Francis Specker; and **53:** Courtesy of X17online.com.

PLATE ILLUSTRATIONS: Unless otherwise noted, all plate images are Fine Arts Museums of San Francisco / Photograph by Randy Dodson. **3:** Courtesy of Don Ed Hardy; Photograph by Arvo Haapa; **4:** Courtesy of Don Ed Hardy; Photograph by Kay Talbott; **21:** © 2019 Artists Rights Society (ARS), New York / SIAE, Rome ARS; Photograph by Randy Dodson, FAMSF; **23:** © Estate of Gordon Cook; Photograph by Randy Dodson, FAMSF; **56–57, 60, 62–63, 67, 69, 86, 92:** Courtesy of Craig Okino, Okino Graphics, Honolulu; and **151:** Courtesy of Don Ed Hardy.

DECORATIVE ILLUSTRATIONS: **p. 2:** *Future Plans Today*, 2009. Photograph of Don Ed Hardy by Alan Govenar; and **pp. 8, 48:** Don Ed Hardy, *2000 Dragons* (details of pl. 151), 2000. All flash art used throughout the inside and on the cover of the volume is by Don Ed Hardy.

☺☺☺

This catalogue is published by the Fine Arts Museums of San Francisco in association with Rizzoli Electa on the occasion of the exhibition **Ed Hardy: Deeper than Skin** at the de Young from July 13 to October 6, 2019.

This exhibition is organized by the Fine Arts Museums of San Francisco.

Major support is provided by The Herbst Foundation, Inc.

This catalogue is published with the assistance of the Andrew W. Mellon Foundation Endowment for Publications.

First published in the United States of America in 2019 by the

Fine Arts Museums of San Francisco
de Young, Golden Gate Park
50 Hagiwara Tea Garden Drive
San Francisco, CA 94118-4502
www.famsf.org

in association with

Rizzoli Electa, A Division of
Rizzoli International Publications, Inc.
300 Park Avenue South
New York, NY 10010
www.rizzoliusa.com

Leslie Dutcher, director of publications
Nikki Bazar, editor
Trina Enriquez, editor
Victoria Gannon, editor
Kate Bove, associate editor
José Jovel, publications assistant

Edited by Victoria Gannon
Picture research by José Jovel
Proofread by Susan Richmond and Cindy Trickel
Designed and typeset by Martin Venezky, Appetite Engineers
Color separations by ArtProduct, Los Angeles
Printing and binding by Dr. Cantz'sche Druckerei Medien GmbH, Germany

Library of Congress Cataloging-in-Publication Data

Names: Breuer, Karin. | M.H. de Young Memorial Museum, host institution.
Title: Ed Hardy: Deeper than Skin—Art of the New Tattoo / Karin Breuer; with Sherry Fowler, Jeff Gunderson, Ed Hardy, and Joel Selvin.
Description: San Francisco: Published by the Fine Arts Museums of San Francisco in association with Rizzoli Electa, 2019. | This catalogue is published by the Fine Arts Museums of San Francisco in association with Rizzoli Electa on the occasion of the exhibition Ed Hardy: Deeper than Skin at the de Young from July 13 to October 6, 2019. | Includes bibliographical references.
Identifiers: LCCN 2019017481 | ISBN 9780847867349 (paperback)
Subjects: LCSH: Hardy, Don Ed—Exhibitions. | BISAC: ART / Body Art & Tattooing. | ART / Individual Artists / Monographs. | ART / Collections, Catalogs, Exhibitions / General.
Classification: LCC N6537.H3475 A4 2019 | DDC 709.04/0752—dc23
LC record available at https://lccn.loc.gov/2019017481

ISBN: 978-0-8478-6734-9

Library of Congress Control Number: 2019939624